MATISSE

MATISSE

SARAH WILSON

Front cover:
Reader Against a Black Background. 1939 (fig. 142)

Page 30:
Five Female Heads. 1939.
Aquatint, printed in black, plate: 21/16 × 9¾ in. (5.1 × 24.8 cm).
Collection, The Museum of Modern Art, New York.
Peter H. Deitsch Bequest.

First published in the United States of America in 1992 by

RIZZOLI INTERNATIONAL PUBLICATIONS, INC.
300 Park Avenue South, New York, NY 10010

© *1992 Ediciones Polígrafa, S. A.*
Text copyright © 1991 by Sarah Wilson
© Succession H. Matisse/L.A.R.A., 1992
Designed by Jordi Herrero

Library of Congress Cataloging-in-Publication Data

Wilson, Sarah, 1956—
 Matisse / Sarah Wilson.
 p. cm.
 Includes bibliographical references (p.).
 ISBN 0-8478-1509-9
 1. Matisse, Henri, 1869-1954. 2. Artists—France—Biography.
I. Matisse, Henri, 1869-1954. II. Title.
N6853.M33W55 1992 91-50997
709'.2—dc20 CIP

Color separations by Reprocolor Llovet, S. A., Barcelona
Printed and bound by La Polígrafa, S. A.
Parets del Vallès (Barcelona)
Dep. Leg. B. 3.259 - 1992 (Printed in Spain)

CONTENTS

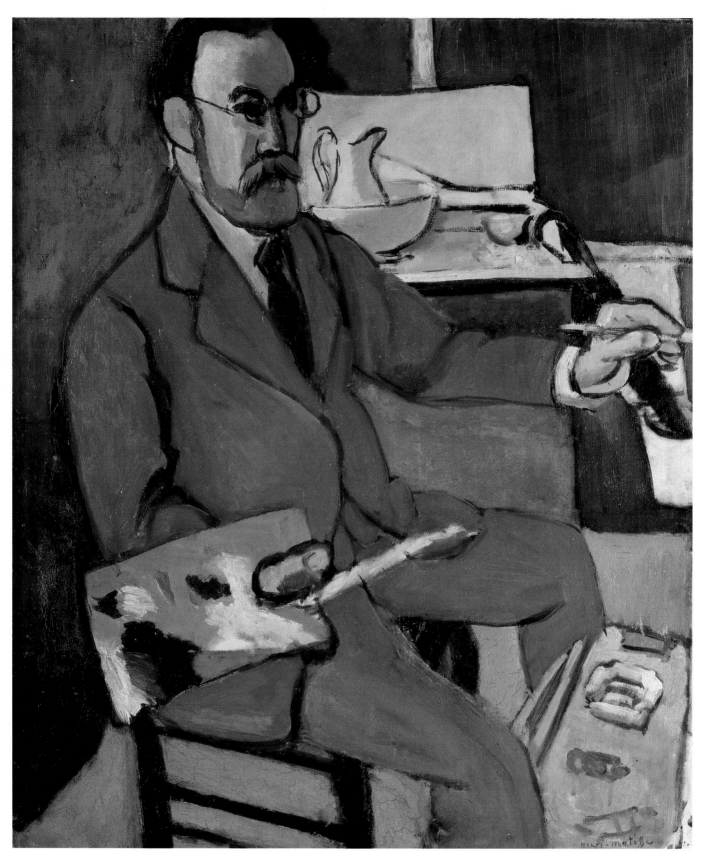

Self-Portrait. Nice, 1918.
Oil on canvas, 25⅝ × 21¼ in. (65 × 54 cm).
Musée Matisse, Le Cateau-Cambrésis.
Photothèque Henri Matisse.

Beginnings 1869–1895

Undoubtedly the most sensual artist and the greatest colourist of the twentieth century, Henri Matisse was born on December 31st, 1869 in Le Cateau-Cambrésis, a town in the north of France. His childhood, spent in the nearby village of Bohain-en-Vermandois was relatively happy: his father was a grain merchant, and his mother, who had trained as a milliner, was sensitive and artistic.

Matisse was educated at the lycée in Saint-Quentin, the nearest town, where he was solidly grounded in the classics. He left to study law in Paris, in 1887, returning with a diploma in 1888, and took up a post as a lawyer's clerk.

In *Jazz* of 1947, Matisse recalled those days, spent filling 'pages with the fables of La Fontaine... preparing official dossiers which no one read, not even the judge'. These were devised 'to use up a certain amount of official paper in accordance with the importance of the trial'. Diversion was provided by attending drawing classes before work at the École Quentin Latour. This was a region famed for its textiles, and many workers spent the winters weaving. The drawing school Matisse attended was for the training of textile designers; he conceived a sense of decorative pattern-making and a love of textiles and tapestries which would last all his life.

In 1890, stricken with appendicitis, Matisse faced a long convalescence. His mother gave him a little box of paints as a distraction; Matisse started copying 'chromos' of anodyne landscape scenes — but also studied a painting manual by F.A. Goupil. He would later remark, 'Once bitten by the demon of painting, I never wanted to give up...'

His first two original paintings of 1890 were still lifes with books, curiously signed with his name back-to-front: 'Essitam'. Paternal permission to go to study in Paris was at last forthcoming, and by early 1891 Matisse was once more in the metropolis, where he enrolled at the Académie Julian — a coaching establishment for the École des Beaux-Arts — under the prestigious academic Salon artist, Adolphe-William Bouguereau. He also attended evening classes at the École des Arts Décoratifs.

Academic training proved a shock and disappointment: throughout his life Matisse would rail against what he had experienced there, recalling with clarity in 1951 — sixty years later — how he found Bouguereau recopying a painting for the third time, sighing 'I am a worker, but life is hard...' These men were 'stamped by official art and the Institute', Matisse said. 'I could get nothing from them'.

However, their insistence on accurate drawing from the model, visible in Matisse's own *Standing Nude,* 1892, would be repeated by Matisse when he himself became a teacher in 1908, and the shaded drawings that he made of plaster casts were not only lessons in the construction of volume, but in a transposition from three to two dimensions that would fascinate Matisse when he began his own experiments in sculpture. In the models themselves, Matisse confronted the naked human figure, which, he said in 1908, 'best permits me to express my almost religious awe towards life'.

Failing the entrance examination to the École des Beaux-Arts in February 1892, Matisse started to frequent the Cours Yvon, the glass-enclosed courtyard of the École where, drawing from plaster casts, he hoped to attract the attention of a passing *maître*. His enthusiasm for his profession was completely rekindled in the summer, when he encountered Goya's *Old Women* and *Young Women* at the Musée des Beaux-Arts in Lille.

At last he was invited to go and work in the studio of Gustave Moreau, the celebrated symbolist painter who since 1892 had run one of the three studios which prepared students for the Prix de Rome. Here, Matisse found a congenially liberal approach. With fellow students Raoul Dufy and Georges Rouault, Matisse accompanied Moreau to the Louvre, and learned from the old masters — a deviation both from the Salon ethos and the *plein air* aesthetic of the time.

Copies were regularly produced by Beaux-Arts students, partly because Government purchases were a welcome source of income. Matisse recalled copying Raphael's *Portrait of Baldassare Castiglione,* Poussin's *Narcissus,* Annibale Carracci's *The Hunt* (the copy officially purchased and sent to Grenoble in 1896), and Philippe de Champaigne's *Dead Christ*. Matisse's free version of Chardin's *The Ray,* was particularly remarkable, as was the imposing *Still Life after de Heem's Dessert,* 1893, a copy generally faithful to all but the Dutch master's transparent glazes. The fruit, the shining vessels, the tablecloth folds would be transformed by Impressionism in 1897, by Cubism in 1915; Matisse would remain faithful to this important motif throughout his life.

In no way were students invited to imitate the exotic, orientalist reveries of Gustave Moreau. Matisse always maintained that it was 'perilous to fall under

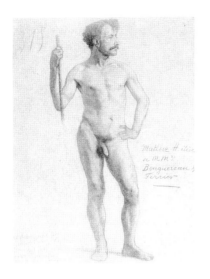

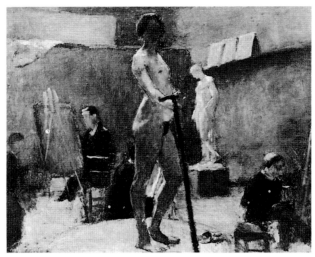

Standing Nude. 1892.
Charcoal on paper,
18¼ × 24⅜ in. (47.5 × 62 cm).
Musée Matisse,
Le Cateau-Cambrésis.

Gustave Moreau's Studio.
1894–95.
Oil on canvas, 25⅝ × 31⅞ in.
(65 × 81 cm).
Private Collection.

the influence of masters of my own epoch'. Orientalism, however, would be central to Matisse's work for many decades; the tracery with which Moreau overlaid his women's bodies would find its way into Matisse's fine line drawings of embroidered blouses in the 1930s. In more immediate terms, both Moreau's abstract oil sketches and certain pen and ink drawings demonstrated a freedom of technique that would be adopted by the future Fauve.

Having worked informally with Moreau for almost three years, Matisse was finally admitted to the École des Beaux-Arts and enrolled on April 1st, 1895.

Impressionism and Neo-Impressionism, 1896–1904

In 1896, a more personal style appeared in works such as *Interior with Top Hat,* where a still life of a bureau retains the mark of the personality of its sitter amid a disarray of books, papers, and favourite prints reminiscent of the portraits of Manet and Degas.

In 1896, Matisse went with his fellow painter Émile Wéry on his second summer trip to Belle-Ile in Brittany and at last the *plein-air* subjects beloved of the Impressionists entered his work. A beautiful painting, *Belle-Ile,* of 1896, with sculptured cliffs and a palette of silvery grey, blue and purple, nonetheless had more of Whistlerian 'harmony' about it than the rugged turbulence of a Courbet or the 'touch' of a Monet. That summer, however, Matisse met the Australian painter John Russell who introduced him to Van Gogh and Impressionism.

The painting holiday followed Matisse's first official success. Four of the seven paintings he submitted to Puvis de Chavannes' new Salon de la Champ de Mars were accepted, including an interior of Moreau's studio, and *The Reader* which was bought by Madame Félix Faure, wife of the President of the Republic.

The exhibition of the Caillebotte bequest at the Musée du Luxembourg in early 1897 — sixty-seven works by Manet, Degas, Cézanne, Renoir, Monet, Pissarro and Sisley, gave Matisse ample time to study the Impressionists' approach and technique. His studies were translated into his next major painting, *The Dinner Table* of 1897, a *contre-jour* scene of a table loaded with fruit, wine, shining silver, transparent glasses and decanters. While hardly impressionist, this was too

avant-garde for the Salon and had to be defended by Gustave Moreau who said the decanters were 'so solid he could hang his hat on them'. The large maid, almost pressed into the wall by the opulent feast, would reappear in Matisse's restatement of the dinner-table motif in 1908.[1]

Matisse took up Camille Pissarro's advice to study Turner while on a spring honeymoon spent in London in 1898, with Amélie, his new wife. (She would lovingly adopt Marguerite, the daughter born to Matisse by Caroline Joblaud in 1894.) The Matisses subsequently summered in Corsica. A brilliant *Sunset in Corsica,* painted after the revelation of Turner — Matisse's *passage* between tradition and modernity — also commemorates Matisse's first encounter with the piercing Mediterranean light of the South.

Back in Paris, Matisse continued to study Impressionism, painting views of a distant Notre-Dame from his studio window on the Quai Saint-Michel, but this mode was soon to be recast. In 1898, Paul Signac's *D'Eugène Delacroix au néo-impressionnisme* was serialised in the May to July issues of *La Revue Blanche* and published in book form the following year. Matisse's 1899 study of Delacroix is explicit in his rather passionate drawing of the *Abduction of Rebecca.* The colour theory presented was more important, however. Signac attempted to demonstrate the historical continuity of colour traditions stretching from Middle Eastern and 'Byzantine' prototypes, through to Veronese. The English colourists Constable and Turner were discussed, along with Delacroix, while the second

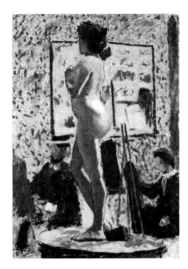

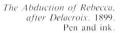

Standing Nude Seen from
the Back. 1901–3.
Pen and black ink on
paper on cardboard,
10⅝ × 7⅞ in. (27 × 20 cm).
Musée de Grenoble.
Photo: André Morin.

Albert Marquet.
Nude in the Studio
(Fauve Nude). 1898.
Musée des Beaux-Arts.
Bordeaux.

The Abduction of Rebecca,
after Delacroix. 1899.
Pen and ink.

and third parts of the book treated impressionist and neo-impressionist colour theory. Divisionism was presented as leading Impressionism back to the principles of order, clarity, and permanence, in short, back to the museum.

Colour burst into the academy. Alfred Barr dubbed the resulting works *proto-fauve*. Typical was Albert Marquet's so-called *Nude in the Studio (Fauve Nude)* in pink, green, and white, dating from 1898 — a dramatic change from previously dull-toned academic studies. Despite the fact that Signac's text denounced the neo-impressionist 'dot', Matisse's *Sideboard and Table* of 1899 is evidently a messy experiment in the divisionist mode, keeping the high viewpoint and the general motifs of *The Dinner Table* in a far simpler composition. *Still Life with Oranges* of the same year, reverts to an even more basic, frontal composition, but constructs a sense of space through flat planes of colour, bright, singing hues that would not reappear in his work until 1904. 'If Matisse's work can be compared with anything' the poet Apollinaire was to write in 1918 'one must choose an orange. Like an orange, Matisse's work is a fruit of brilliant light'.

Moreau died in 1898 and his successor, Cormon, expelled Matisse from the studio. The Académie Camillo (or Académie Carrière) he next frequented closed for lack of numbers. With friends from Moreau's studio,

Marquet and Manguin, he shared a model, and with Marquet in particular he practised drawing rapidly from life. Compare Matisse's *Standing Nude*, 1892, with the *Standing Nude Seen from the Back*, 1901–3. It demonstrates a new freedom with a nervous, almost electric line; it is one of the first 'Back' images which would obsess Matisse until 1930.

Matisse also took up a municipal evening course in sculpture, taking extra advice at the studio of Antoine Bourdelle. His first sculpture was a copy of Antoine-Louis Barye's *Jaguar Devouring a Hare* from the Louvre, a subject even more violent than the Delacroix abduction. Matisse's desire to understand the animal's structure led him to study the musculature of a flayed cat. He was given advice at this time by Rodin himself, and bought a plaster bust by Rodin of the head of Henri Rochefort.

Paradoxically, however, the Cézanne painting *Three Bathers* (c. 1881–84), purchased by Matisse at Ambroise Vollard's gallery, would vie with Rodin in terms of its influence on his sculpture. Vollard had held the first retrospective of Cézanne's work in 1895. The version of the 'Bathers' motif that inspired Matisse is an essentially triangular composition, with rough, audacious handling, the foreground divided from the background by water. Most important of all are two back views of the female nude: one standing and tense

Paul Cézanne. *Three Bathers*. 1879–82.
Oil on canvas, 20⅞ × 21⅝ in. (53 × 55 cm).
Musée du Petit Palais, Paris.

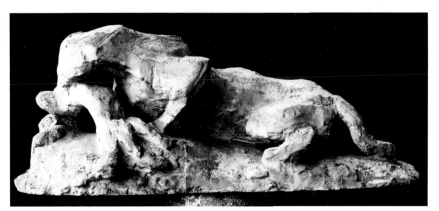

Jaguar Devouring a Hare. 1899.
Bronze, H. 9 in. (23 cm).
Musée Matisse, Le Cateau-Cambrésis.

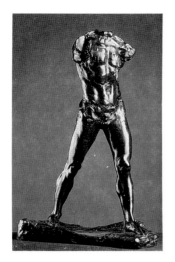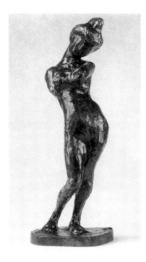

A. Rodin. *Walking Man*. 1877. Bronze, 33½×11×22⅞ in. (85×28×58 cm). Musée Rodin, Paris. Photo: Bruno Jarret (ADAGP).

Madeleine I. 1901. Bronze 3/10, 23¼×8¾×7⅛ in. (59.1×22.2×18.1 cm). The Baltimore Museum of Art: The Cone Collection, formed by Dr. Claribel Cone and Miss Etta Cone of Baltimore, Maryland.

on the left, the other seated, playing with her hair on the right.

Matisse's painting of the standing *Male Model*, 1900, shows the paramount influence of Cézanne in the constructive use of slabs of darkened colour, the expressive clumsiness of paint handling on the body, the ambiguous use of *passage* over areas of background, and the inclination of the studio stove-pipe. Yet the powerful Italian model, Bevilacqua, has been made to stand in the pose of Rodin's *Walking Man* of 1877. This presence is evident in Matisse's sculpture *The Slave*, which originally had arms and hands with clenched fists, visible in an early photograph. The title recalls the political dimensions of Rodin's enslaved *Burghers of Calais. Madeleine I,* a bronze of 1901 (which relates to Rodin's *Muse,* 1896) clearly demonstrates how Matisse exaggerated the sexual differentiation between male and female models. The classical *contrapposto* pose becomes in *Madeleine* a fragile, almost undulating, arabesque.

The material aspects of existence were now a serious problem. Matisse's life as a married man was increasingly beset by financial crises. Amélie Matisse's milliner's shop had closed in October 1899 with her second pregnancy; Matisse and Marquet ended up painting strips of canvas with garlands for the decoration of the Grand Palais at the Exposition universelle of 1900. Matisse's bronchitis, which forced him to leave this grueling job, finally entailed convalescence in Switzerland where he had hours of discussion with his father about his 'unrespectable' career as a painter. During this period, when it was very difficult to sell any work, Matisse nonetheless began experimenting with different media. Memories of Quentin Latour's portrait studies in pastels at the Musée Lecuyer in Saint Quentin must have surfaced as Matisse began to use pastels for many of his Notre-Dame views.

Portraiture would be another life-long preoccupation. The careful self-portrait of 1900–1903 showing Matisse engaged with a new tool — the engraver's burin — is a miniature which captures a precise likeness, while the humorous self-portrait of 1900 executed hastily in brush and ink is much more on the lines of his friend Albert Marquet's practice: to capture likeness and movement as quickly as possible, with Japanese fluency and exaggeration of character. The comparison of the two representations is revealing: as the poet Apollinaire was to put it later, there was a contrast between the *fauve* — the, wild, untamed, adventurous aspect of Matisse's character, and the *maître cartésien* — the sensible, cautious, thoughtful Matisse, soon called 'the professor' by his younger peer group.

In 1901, the Van Gogh retrospective at the Galerie Bernheim-Jeune was the first to be held since the death of the painter in 1892. André Derain, age twenty at the time, and like Matisse committed to learning his trade through copies of old masters, there introduced his friend to Maurice de Vlaminck, an anarchist in tendency, who professed, on the contrary, a desire to 'burn down the Louvre'. Vlaminck was however overwhelmed at the sight of the works of Van Gogh, a fellow northerner.[2]

The three principal protagonists of Fauvism had now met; Matisse admired the bright colour and the confident, brushy handling of the work of Derain and Vlaminck when he visited their studio at Chatou. Matisse bought a burial scene and snowscape by Derain, but only a wooden tie painted light blue with darker dots by Vlaminck, whose vehemence in life and art most probably repelled him.

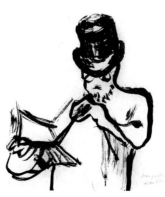

Self-Portrait. 1900–1903. Etching, 5⅞×7⅝ in. (14.8×19.5 cm).

My Portrait. 1900. Brush and ink, 9⅜×3½ in. (23.9×8.9 cm). Private Collection. Photo: Otto E. Nelson.

Notre-Dame in the Late Afternoon, 1902, its view from the window pulled flat by the blue strip of frame on the right, and *The Luxembourg Gardens,* 1901–2, show a new heightening of colour in Matisse's work — the latter has hints of Gauguin. However, his so-called 'dark period' which continued after meeting the Chatou artists, was partly to do with the price of paint. *Studio Under the Eaves,* in ochre hues, painted at Bohain-en-Vermandois, where Matisse was to spend much time between 1902 and 1903, would have been relatively cheap in terms of materials. The window motif, however, anticipates the more expensively sun-filled window frames at Collioure of 1905.

This period in Matisse's life came to a satisfactory close with the retrospective of forty-six paintings at Vollard's gallery in June 1904, including the *Dinner Table,* works from Belle-Ile and later developments, together with a catalogue prefaced by the well-known critic Roger Marx. Welcomed by the dealer of Cézanne and Van Gogh, Matisse's vocation was now confirmed.

Fauvism and After

The summer spent in Saint Tropez in 1904 — four months in the Mediterranean sunshine — gave Matisse an opportunity to talk at length with Paul Signac who, since Seurat's death and his own publication of 1899, was regarded as the grand old man of Post-Impressionism, as well as a notorious anarchist. The brilliant light and colour on sea and landscape corroborated Signac's promotion of primary colours and the division of tones, exemplified in his own sea and harbourscapes at the time. Matisse's chief work of that summer, which he exhibited at the Salon des Indépendants of 1905, had the Baudelairean title *Luxe, Calme et Volupté.*

By the Sea, a preliminary oil, is a simple, *plein air* painting of Amélie Matisse and their son Pierre, sitting on the beach in the setting sun, a large *contre-jour* tree in the foreground acting as a *repoussoir* similar to the *Notre-Dame* window frame. *Luxe, Calme et*

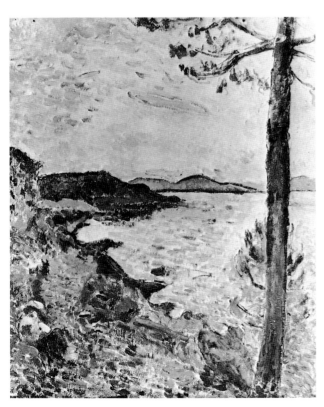

By the Sea. 1904. Oil on canvas, 19⅝×25⅝ in. (50×65 cm).
Old Collection McCormick, Chicago.

Volupté reverts to a horizontal format and is far stronger and more mannered. The diagonal shoreline and the boats are reminiscent of Van Gogh's *Saintes Maries de la Mer* of 1888. Into the landscape of Madame Matisse and Pierre, naked bathers intrude from Cézanne, while Matisse has undressed a figure of a girl combing her hair forward in front of her face, a motif borrowed from Henri-Edmond Cross' *Composition, Air of Evening,* 1893–94. It is a 'Golden Age' scene: while painterly precursors stretch back to Ingres and Poussin, Matisse's work is most closely related to Paul Signac's *In Times of Harmony,* 1893–95, which Signac proposed subtitling: *The golden age is not in the past, it is in the future.* The work was originally to be called *In Times of Anarchy,* and was to be a manifesto akin to the 'great poetic decor of Kropotkin à la Puvis de Chavannes', as Signac described the writings of his anarchist friend Jean Graves. Graves' vision symbolised 'the hope of this near future where, at last, every individuality will be free'.[3] Appropriating this genre from Signac, in a completely apolitical way, Matisse creates a peculiar confrontation of clothed and unclothed bodies, which seems to have lost its internal dynamic, far from both Cézanne and the eroticism of Manet's *Déjeuner sur l'herbe.*

Signac, however, was delighted at this confirmation of his colour theories and bought *Luxe, Calme et Volupté* immediately, taking it straight from the Salon des Indépendants back to Saint Tropez, whence it did not emerge until 1943. Yet for all its charm, its rainbow-coloured hues, it is an overrated work: Matisse's obvious difficulty in reconciling the post-impressionist *tache* with a sinuous contour would lead him to abandon Post-Impressionism, firstly in favour of 'construction through colour' in the *fauve* works of 1905 painted in Collioure, then in favour of flat areas of colour and the arabesque — the fluid silhouetting lines of the *Bonheur de Vivre* of 1906.

At the Salon des Indépendants of 1905 Matisse's new direction was corroborated by a retrospective of the works of Georges Seurat, but challenged by a retrospective of forty five of Van Gogh's works, with their flatter, bolder and more sinuous approach. André Derain's *Port du Pecq* and *The Old Tree,* Vlaminck's paintings of the Seine at Bougival and Dufy's flag-bedecked

yachts and harbour scenes from Honfleur, exhibited along with *Luxe, Calme et Volupté*, were all using a bright palette of complementary colours and a mixed technique.

The following summer, in 1905, Matisse was joined by André Derain in Collioure, a fishing village near the Spanish border. Here Matisse and Derain painted exactly the same motifs (such as *The Bell Tower*) in friendly competition. Matisse allowed the bare canvas to act as a colour and texture in his version which appeared even more 'unfinished' than Derain's. He retained an interest in the divisionist approach for far longer than Derain, but they were both affected by Van Gogh, and then by Gauguin again, when they were introduced to the painter and collector Georges Daniel de Monfreid. The flat, bright non-descriptive colour of Gauguin's *Oceania* pictures encouraged both artists to adopt a more synthetic approach. (The large Gauguin retrospective held at the Salon d'Automne in 1906 would confirm their new direction.)

The mixing of techniques and a new flatness appears in *The Open Window, Collioure,* Matisse's complex development of the 'Window' theme, which would provide the structure for so many important canvases. It is one of the clearest, yet most delicate statements on colour complementaries and reflected light: one flanking wall green, balanced by the red frame and salmon-coloured reflection; the opposite wall pink, with patches of green reflected in the window frames, which appear to swing into the room. The structuring bars of black at the top of the picture and the daubs to the left and right on the window panes, tighten a generally gay composition and are a gesture towards Manet, whose presence becomes overwhelming in the second *Open Window, Collioure* of 1914.

Woman with a Hat is perhaps an even more celebrated starting point for discussion of Matisse's new boldness. Called 'the nastiest smear of paint I have ever seen' by its ultimate purchaser, the American Leo Stein, it depicted a rather plaintive Madame Matisse, her face generally green and white, her hair and neck red, swamped by a hugely overdecorated hat, its burden of colourful fruit and feathers indistinctly rendered by Matisse's energetic brushstrokes. She wears the fichu and waisted blouse and holds the bamboo cane umbrella that were photographed in a portrait with Matisse at Ajaccio — and was indeed dressed in black for this portrait which transformed her into a scandalously harlot-like 'painted woman'.[4]

Madame Matisse: The Green Line, created later the same year, is emphatically calmer, a work with a much greater sophistication and confidence. The division of the background into three frankly decorative flat planes, pink above orange on the left, dark green on the right (the pink plane may or may not represent light falling from a window) is extraordinarily daring. As Matisse said later: 'Light is not supressed but expressed by a harmony of intensely coloured surfaces'. In complementary fashion, Amélie Matisse's face is divided literally in half by the thick green line running straight down the nose, each half a different colour and with a distinctly different expression, balancing the

overall mask-like effect. Here indeed is the 'exquisite spouse, who because he is a *fauve* has become a *fauvette*' as the poet Guillaume Apollinaire said in 1909. To become a *fauvette,* the hatted and corseted Amélie, who began to sport Japanese kimonos in Collioure, has adopted a simple robe and a loosely knotted coiffure; the style celebrated by couturiers such as Paul Poiret for the new, freer, twentieth-century woman.

The Open Window and *Woman with a Hat* were two of the paintings exhibited by Matisse at the Salon d'Automne of 1905. It is important to understand the scope and the revolutionary nature of the Salon d'Automne. The Salon des Indépendants, founded in 1884, had dispensed with a jury on principle; the Salon d'Automne reinstated a jury, holding its first exhibition at the Petit Palais in 1903, where Matisse exhibited two oils. The founder members, members of honour, and Committee included an important symbolist presence; poets such as Gustave Kahn and Emile Verhaeren and older artists such as Eugène Carrière met with Bonnard, Vuillard, and younger men such as Georges Rouault and Marquet. Cézanne was a founder member and indeed exhibited thirty-three works in 1904 in a special room; the space given to Puvis de Chavannes and the large retrospective of Odilon Redon and Toulouse-Lautrec that year can all be seen to have had some impact on the birth of Fauvism. André Methey, the ceramicist who would join forces with the Fauves, including Matisse, exhibited there too. By the time of the Salon d'Automne of 1905, Matisse had joined the exhibition committee. The Socialist deputy, Marcel Sembat, a champion of the new movement who would publish the first study of Matisse in 1920, had become a member of honour. There were over 1,600 works on view, but the organisers knew in advance that the room hung with works by Matisse, Derain, Marquet, Manguin, and Vlaminck would cause a scandal. The story of the baptism of Fauvism by the critic Louis Vauxcelles at the Salon has been told countless times. Upon seeing the brilliantly coloured paintings by Matisse and company, hung all in one room around a sculpture by Albert Marque, Vauxcelles exclaimed *Tiens! Un Donatello parmi des fauves!* — 'Donatello amid the wild beasts!' repeating his *bon mot* later in a review for *Le Gil Blas.*[5] The art historian Elie Faure pleaded in the Salon catalogue:

> We must have the liberty to hear and the will to understand an absolutely new language. We must remember that the hero is always jeered at; we must think and reflect before we laugh. Let us listen to these primitives who speak to us of the future...

Curiously at this moment of success and notoriety for the wild young painters, Matisse was contemplating the messages of Ingres, Manet, and Utamaro whose retrospectives were held concurrently at the Salon.[6] He was listening to the music of César Frank, Fauré, Ravel, Rimsky-Korsakov, and especially Debussy, all of whom were honoured with chamber concerts during the Salon. The next spring, at the Indépendants, Matisse exhibited a single canvas called *Le Bonheur de*

Vivre, joy of living, a composition both imaginary and monumental, separating himself in this one gesture from his fellow-Fauves, who exhibited over half a dozen small *plein-air* views each.

Le Bonheur de Vivre is a tribute to Stéphane Mallarmé's poem *L'Après-midi d'un Faune* (Afternoon of a faun). Indeed, the opening line: *Ces nymphes, je veux les perpetuer* ('I wish to perpetuate these nymphs') could be seen as the *leitmotif* for the rest of Matisse's career: the dance of nymphs and satyrs would be perpetuated from *The Dance* to the Barnes murals of 1930–32 and through to the drawings and paper cut-outs of the 1940s and 1950s. (Mallarmé's description of the '*fauve* hour' bestows on the word more of its fawn-coloured nature, its Golden Age intimations than the ferocity of the 'wild beast' translation of the term in English.)

The coloured crayon sketch for *Le Bonheur de Vivre* helps to give some idea of the grand oil, which disappeared from view when Leo Stein sold it to Dr. Alfred Barnes of Merion. (The doctor's lamentable eccentricities included an abhorrence of colour reproduction.) The colours are bright, almost acid, with expanses of lime green and lemon; contours in scarlet and viridian around the two central figures create a vibrant aura. The overall triangle of the composition relates to Cézanne's bather pictures (a source for Picasso's *Demoiselles d'Avignon* at roughly the same time). A figure from Ingres' *Turkish Bath* (exhibited in his 1905 retrospective at the Salon d'Automne) is recalled by the nude female on the left; the dancing circle of figures recalls Ingres' own *Golden Age* of 1862, other figure groupings evoke Poussin's *Bacchantes,* and in particular an engraving by Agostino Carracci, *Reciprocal Love,* but these references are obscured by the flatness, the thin, luminous paint, and conventions for rendering trees and tufts of grass and flowers taken from Persian miniatures.

While Claude Debussy's music for *L'Après-midi d'un Faune* was written in 1894, and there was a whole tradition of pastoral painting in the late nineteenth century, Matisse's painting is an extraordinary anticipation of the 'modern' visualisation of the theme danced by Nijinsky for the Ballets Russes against decors by Léon Bakst in 1912.[7]

Critics were aghast at the stylistic eclecticism of *Le Bonheur de Vivre,* though Leo Stein eventually bought it. Matisse, with the proceeds from a successful second exhibition, this time at Druet's gallery, went off to discover North Africa: Algiers, Constantine, Botna and Biskra, inspired by the tradition of artists such as Delacroix and the exotic and sensuous literature of his own contemporary, André Gide.

Matisse's growing interest in the 'primitive' was expressed on his return, not only by a collection of new artefacts from North Africa — carpets, bowls, jugs — but by a simplicity close to children's art that is clearly visible in *Pink Onions,* 1906. The work is poignantly bare: the lines of the underdrawing are clearly visible under the thin paint. The big painted jug, surely a local French piece, divides the two different halves of the background, while the darker jug with schematised camels brings an exotic, North African element into an otherwise purely domestic picture.

The importance of children's art at this time, for artists such as Matisse and Dufy, has been under-investigated. This simple pottery was, in France, decorated by what would now be considered child labour. Matisse was fascinated by his own children's drawings; moreover, school art manuals were attempting at the time to become more enlightened. By 1909 the Salon d'Automne would contain a section showing drawings and paintings from French primary schools based on the new manuals, with appliqué, lacework and pottery designed by ten- to fourteen-year-old children.

The ceramicist involved in the exhibition, André Methey, had persuaded Derain and Vlaminck as well as Matisse to collaborate with him. Matisse's plate with simple floral motifs dates from 1906; the more sophisticated *Plate with Nude Figure* is from 1907, while the elaborate *Osthaus Triptych* of 1907–8, drawn on tiles, again takes up the theme of nymphs and shepherds, anticipating both the theme and border decorations of large tapestry designs such as *Nymph in the Forest,* 1936–42, and Matisse's work with ceramic tiles in his final years for the Vence Chapel.

In response to the Cézanne memorial retrospective at the Salon d'Automne of 1907 (which turned Matisse's fellow Fauves, including Braque and Dufy, away from colour), and likewise in response to the *Bonheur de Vivre* which had dominated discussion in early 1906, Picasso produced the most revolutionary picture of the early twentieth century, the *Demoiselles d'Avignon.* While not publicly exhibited until 1916, it was seen immediately by Braque and Matisse, and was obviously a challenge to Matisse's leadership of the avant-garde.

Matisse's extraordinarily strong pastel and gouache study, *Seated Nude* of 1906, was partly a reply. The white, chalky body anticipates the Biskra *Blue Nude* of 1907, and while the use of brilliant blue and brown to electrify the contours recalls Picasso's sketches for the *Demoiselles d'Avignon,* the pose looks forward to Matisse's *Odalisques* of the 1920s.

Matisse's *Standing Nude,* 1907, has also been read as a reponse to Picasso's *Demoiselles d'Avignon.* How far removed, though, is Picasso's huge Africanised brothel fantasy, which had profound autobiographical resonances at the time, from Matisse's canvas. An attempt to develop a cruder, more direct and volumetric approach to the nude, *Standing Nude* had its genesis not in the confrontation with primitive sexuality, the power of a multiple, devouring representation of the Eternal Feminine, but in a demure and anonymous photograph. For both paintings and sculpture, Matisse often used photographs from semi-pornographic magazines such as *Mes Modèles,* a practice both cheaper and more practical than hiring a model.

With Picasso's challenge still in mind, Matisse painted *Blue Nude (Souvenir of Biskra)* — apparently in competition with André Derain — with its blue contours, the sketchy rendering of ferns in the background, and the uncomfortable, unnatural *contrapposto.* It

was seen to be so ugly when the painting was exhibited in Chicago, in 1913, at the second venue of the notorious Armory Show, that it was burned in effigy by students.

The pose itself was based on the sculpture *Reclining Nude,* and again, the very contorted pose provides a link with Rodin. Rodin had occasionally exhibited 'reclining' figures that had been sculpted as standing, their *contrapposto* creating exaggerated and unnatural effects when viewed horizontally. Matisse's *Blue Nude* contains this sense of sculptural contortion, distinguishing it from the lineage of nudes running from Titian's *Venus of Urbino* to Manet's *Olympia*, which was exhibited side by side with Ingres' *Odalisque* in 1905. (*Odalisque* was in fact the title of the *Blue Nude* as it appeared in Marcel Sembat's monograph of 1920.) It was Manet's influence that would now triumph in Matisse's two paintings of *Le Luxe*, 1907–8.

A comparison of the two completed versions of *Le Luxe* marks the transition from stippled painterliness, to a resolute flatness and bright, matt colour, with *cloisonné* contour-lines and a style that would be developed in 1908–9. The influence of Puvis de Chavanne's compositions and his melancholic atmosphere is apparent, together with that of Manet: Matisse quotes the servant girl proffering a bouquet from *Olympia*. But as with *Luxe, Calme et Volupté*, there is a curious pointlessness in the arrangement of borrowed figures. What could the servile blonde be doing to the standing figure's left foot, hidden in the drapery? Whence the bouquet? With the collapse of the Golden Age scenario, or any alternative narrative, these melancholic paintings hover between enigma and a perplexing formalism.

Logic is restored in the flat paintings of 1908, made after Matisse's summer visit to Italy, where he studied the Italian primitives. The *Bathers with a Turtle* are focused on the amphibious creature, a point of reddish-brown at the bottom of the three-banded composition whose flat colours represent grass, sea, and sky. The three young girls here are complemented by the three boys, equally rapt and attentive, in the companion piece *The Game of Bowls. Nymph and Satyr* of 1908–9, where red contours around the flesh clash violently against the lime-green grass, deploys this stark, flat mode to depict a theme that will continue in Matisse's work through to the war years: the Golden Age idyll becomes primitively sexual, Mallarmé's faun is about to seize his unsuspecting victim.

The *Nude in Black and Gold*, 1908, painted at roughly the same time, was considered by Matisse to be an important work. It was created in his new atelier on the Boulevard des Invalides, and reproduced in his first long and considered text, *Notes of a Painter*, published in *La Grande Revue* of December 1908. It exemplifies his discussion of painting and of sculpting the human body in this text and in amplifications in the notes taken by Sarah Stein (Mrs. Michael Stein), who with the German painter Hans Purrmann, helped Matisse to organise a school in 1907–8. (It catered largely to American, German, and Scandinavian students.) The *Nude in Black and Gold* was bought by Matisse's Russian patron Sergei Shchukin and exhibited and reproduced in Russia almost immediately — it appeared in the Moscow-based review *The Golden Fleece (Zolotoye Runo)* in June 1909 with the highly influential translation of Matisse's *Notes*.

The great advances made since the disconcertingly sketchy *Marguerite* of 1906 are apparent. The *Marguerite* of 1908, with its deliberately childish lettering, implying Marguerite's own 'signature', is so simple, yet so accomplished, that it was bought by Picasso for his personal collection. Matisse claimed to have introduced Picasso to African sculpture, and 1909 was the year in which Apollinaire described Matisse as surrounded with 'sculptures in which the negroes from Guinea, Senegal, and Gabon depicted their most terrified passions'.

In *The Dance*, 1907, Matisse had carved a circle of leaping females around a stump of polished wood, inspired not so much by African sculpture as by Gauguin's wooden pieces which lead both Picasso and Derain to experiment similarly with carving at this time. African sculpture was, however, a crucial catalyst for both ex-fauves and the cubists. Matisse's tendency was to develop an increasing 'primitivism' through working in series, despite abandoning the wood medium after this one experiment. For the heads of *Jeannette, I–V* (Jeanne Vaderin), five works executed between 1910 and 1913, he reverted to working in plaster as a prelude to bronze casting. From a sensitively-modeled, realistic head with a full chignon, a neckless version with simplified hairstyle evolved, more powerful in profile. Subsequently in three more brutally-worked pieces, volumes and facial characteristics are progressively exaggerated. One may compare these to Picasso's powerful, lumpy head of Fernande of 1909. Finally in *Jeannette V* (reworked by adding clay to a plaster cast of *Jeannette III*) the brow and nose become even more prominent as the chignon recedes. In these last three versions the breast area is incorporated with the upper part of the plinth, which has itself become part of the work. The recognizable portrait-sculpture is transformed in the *Jeannette* series into a mask-like, female representation with a rudely-featured, 'primitive' stare, and disconcerting dissymmetries — despite the noble western material, bronze, in which the finished versions are cast. The attempt at a primitivising simplification would be repeated with the three heads of *Henriette*, (Henriette Darricarrère) made in 1925, 1927 and 1929, the last version comparable with Picasso's well-known heads of Marie-Thérèse Walter, of 1930–31.

The relation between sculpture and painting was always of importance. For his series of sculptures *The Backs*, begun in 1909, Matisse turned again to his Cézanne painting for confirmation, in particular the left-hand standing figure whose back is divided into two volumes by a mane of dark-brown hair.

The sequence of *Backs* from 1909–31 shows Matisse at first monumentalising a solid female form. The left arm in *Back I* cups the head of the figure as though in shame or grief — a gesture typical of Cézanne's bathers. The figure becomes progressively

submerged in the bronze relief slab in *Back II* (1913) and *Back III* (1916–17). Simplifying again, the figure becomes almost rectangular in the impressive, trunk-like fourth state, (1930–31), in which the body is literally cleft apart by the weight of its own column of hair. The proposition that Matisse's drawings and sculptures are 'painter's work' is surely refuted by *Back IV*. After this achievement (concurrent with his work on the Barnes mural) Matisse donated his Cézanne painting to the Petit Palais (in 1936), as though its lessons had been finally exhausted.

Just as Matisse's painting itself swung between the formally exploratory and the purely decorative, his sculpture was co-opted into the latter mode. *Two Negresses* and *La Serpentine*, both produced during 1908 and 1909 and both inspired by photographs, were distorted to a point that contemporary critics found quite unacceptable. Both were incorporated as dark bronzes into exotic still lifes, just as the white plaster *Madeleine*, placed in the *Still Life in Venetian Red* of 1908, adds an erotic note. Her curves are echoed by the vessels placed on the carpet. Similarly, the sculpture related to the *Blue Nude* reappears in *Goldfish*, 1912, where the disparities of scale and the ambiguities of frozen mobility versus petrified plaster are more apparent.

The Grand Decorations, 1908–1912

Matisse now entered a phase of grand decorations, starting with the *Harmony in Red*, another variation of *The Dinner Table*, billed in the Salon d'Automne catalogue of 1908 as a 'Decorative panel for a dining room'. The rampant *toile de Jouy* textiles, evidence of a new, decorative craze, sprawl over tablecloths and walls, pushing the servant flat. Her table bears a sparse arrangement of vessels and fruit; the prevailing Oriental flavour is amplified by the conventions used for the trees in the landscape outside the window which makes a framed 'picture within a picture' itself.

The work was repainted several times, changing from an overall green to blue, exhibited, sold to Shchukin, then sent back to him bright red — a practice Matisse would continue, though not quite so dramatically, throughout his life (most notably for *The Roumanian Blouse* of 1940).

In February or March, 1909, on his return from the Mediterranean coast, Matisse painted *Dance I*. Against a blue sky, naked pink female figures dance in a ring on the grass. Audaciously enlarged from the small circle of dancers at the centre of *Le Bonheur de Vivre* they fill a canvas of almost three by four metres. Was *Dance I* shown to Shchukin in the hope of inspiring a large commission? Shchukin finally confirmed a commission for three works for his princely home, a former palace in Moscow. Matisse's plan was for a dance, a bather painting and a third on the subject of 'serenity'. Shchukin initially balked at the idea of primitive nudes hanging in his stairwell, but was won over. *Dance II* stretches the figures in the previous version out to the edges of the canvas. The work is altogether far more richly conceived. Now the downward-curving greensward representing the top of the earth is pounded by rampant maenads painted a brilliant red. Marcel Sembat declared: 'What intoxication! What Bacchic revels!' *Dance* embodied for him 'the orgiastic dithyramb where Nietzsche resumes the enthusiasm of the young Hellade.' Again, Matisse anticipated the ballet that would be the echo to his painting: Nijinsky produced Stravinsky's *Rite of Spring* in 1913.

The complementary composition *Music* is static, the figures androgynously male, separate. To the left of three singing figures hunched on the grass is a flautist recalling the goatherd with pan-pipes in *Le Bonheur de Vivre*; behind him stands a violinist, who first appeared in Matisse's *Music (sketch)* of 1907. It has been suggested that the violinist acts as a treble clef, the seated figures as notes disposed upon a melodic line. At all events, radiant, almost sonorous colour becomes the equivalent of music.

Just as the subject has become purely symbolic, the colours themselves lose their attachment to the material world of pigment. Matisse reverts from the chromatic hues of Chevreul's colour wheel (1839), the basis of the rainbow-coloured fauvist landscapes, to the light primaries, red, blue, green. He recalled in 1929:

> My picture, *Music* was done with a fine blue for the sky, the bluest of blues (the surface was coloured to saturation, that is to the point where the blue, the idea of absolute blue, was entirely evident), a tree-coloured green and violent vermilion for the figures... To be noted: the colour was proportioned to the form. Form was modified, according to the reaction of the adjacent areas of colour. For expression comes from the coloured surface, which the spectator perceives as a whole.

When exhibited at the Salon d'Automne of 1910, the two panels provoked a storm of abuse from both fellow artists and the newspapers. While Apollinaire was alone in defending his work, the Russian critic P. Strotsky, spoke of 'diabolical cacophony', 'shockingly hideous forms'. Worse, Yakov Tugenhold declared: 'Matisse americanises his colours. He transforms his panels into garish posters.' Shchukin rejected the commission again, only to change his mind. Bravely he faced the bewilderment of friends and connoisseurs in Moscow when the works were installed in 1912, with the genitals in *Music* painted out.[8]

In the summer of 1910, Matisse visited Munich for the second time with Hans Purrmann, a student from the academy. While Munich itself rivaled Paris as a centre for painting — Kandinsky and the *Blaue Reiter*

Raoul Dufy. *The Dance*. 1909–10. Printed and painted hanging,
85 × 94½ in. (216 × 240 cm).
Private Collection, Zurich.

group were evolving abstraction there at the time — the decorative *style munichois* was all the rage. The entire ground floor of the Grand Palais at the 1910 Salon d'Automne, was given over to an exhibition of decorative ensembles from Munich. Paul Poiret would popularise their textile and furnishing designs in his 'Martine' school, from April 1911. Raoul Dufy, working for Poiret, adapted *munichois*-style prints for dresses and for the decorative borders of his first *tentures* or wall hangings, such as *The Dance,* c. 1910. (All too soon this style would be stamped as *boche* — germanic — with the declaration of hostilities between the two countries.) Matisse went to Munich, however, specifically to see the huge Islamic exhibition there; he would pursue the influence of Islam in October, when he visited Seville, Granada, and Córdoba in Spain. Matisse would introduce the patterning and perspectival ambiguity of both the *munichois* style and of Islamic art into many of his interiors and still lifes.

A profusion of embroidered shawls flatten the space in Matisse's Spanish still lifes. These become the flat, rectangular arrangements that block out the centre of *Still Life with Aubergines,* painted in tempera in 1911,

the space made even more complex by the apparently empty frame on the wall and by the mirror. The preparatory watercolour shows clearly how the painting itself was supposed to look like an almost patchwork wall-hanging. The 'background' design of blue-purple flowers on brown, reduced to the simplest of petaled blobs, uniting 'floor' and 'wall' surfaces, was repeated with the colours reversed in a very broad, *tenture*-like border, which at some stage was cut off. The border material has the childlike simplicity of 'Martine' fabrics (these works designed by very young girls were commercially manufactured by Poiret). The *Large Nude* of 1911, in tempera, with a painted frame, again clearly designed to look like a *tenture,* was destroyed, although it appears clearly in the *Red Studio,* balanced by Matisse's ceramic plate in the foreground.[9] Matisse may have cut off the border himself to suggest the infinite extensibility of his image into a decorative universe: while his *Pink Interior* restores a sense of normal space with clear delineations of floor, wall, carpet, window, this idea of extensibility is central to the magnificent *Red Studio,* 1911, where paintings, sculptures, even the transparent chair, table, and clock, seem to float suspended in monochrome. It is a universe literally saturated with one colour. These 'pictures within pictures' bear a metonymic, as opposed to metaphoric relationship with real space: 'Instead of making a "window" out of the picture, Matisse makes a picture out of a window.'[10] The correlative of this idea, forcing reality itself to 'become' the picture Matisse painted, governed studio arrangements from the 1920s to the end of his life. These complicated poetics are to some extent lost in *The Painter's Family*: while patternings on carpets, rugs, and tiles predominate, Marguerite's stark and isolated figure in black on the right, and the sense of tension set up by the fireplace which divides the canvas into two, recall Degas' equally charged *Belleli Family,* 1860–62 — were it not for the almost comic substitution of the *paterfamilias,* in this case the painter, Matisse himself, with the sculpture of the virile, naked *Slave* centrally placed on the mantlepiece. Domestic tensions, apparent again in the splendidly iconic *Conversation,* were about to be relieved for Matisse by another important voyage, this time to Morocco.

Orientalism or Cubism?

It can be argued that the trip to Morocco was to some extent Matisse's deliberate distancing of himself from the challenge represented by Cubism. During the artist's spring visit, from January to April 1912, the Futurists exploded onto the Parisian scene at his own gallery, Bernheim-Jeune; Matisse's autumn visit coincided with the triumph of Cubism and Orphism at the Section d'Or exhibition in Paris; Albert Gleizes and Jean Metzinger were finishing their publication *Du Cubisme,* which would attempt to explain the new

movement to a large public. Despite Matisse's amicable exchange of ideas with Picasso in long walks undertaken in 1912 and 1913, Gertrude Stein could write:

The feeling between the Picassoites and the Matissites became bitter. Derain and Braque had become Picassoites and were definitely not Matissites.

Both Matisse and Picasso revolutionised the course of twentieth-century art by challenging the spatial

premises of art since the Renaissance: the box-like space with vanishing points that not only posited the 'picture as a window' onto a 'real' world, but reciprocally implied the controlling presence of the all-seeing spectator. Cubism's multiple viewpoints fragmented this world, in the context of the theories of Bergson, then Einstein. The collapse of the positive, humanist vision ultimately signified the collapse of the discourses of nineteenth-century Positivism, the notion of inevitable progress, the 'evolutionist' attitude whose triumph — and whose fragility — had been visibly demonstrated at the Exposition universelle of 1900.

The Salon des Indépendants of 1912 heralded the triumph of 'Salon Cubism': a host of lesser artists had now appropriated the cubist style. Matisse's option was different. On the one hand flatness itself can be equated with pre-Renaissance forms of depiction. Alternatively, however, flatness may be seen as the positing of a different system altogether: the 'temptation of the Orient'. Far more than the visit to the Munich exhibition, or to Spain in 1911, Matisse's two visits to Morocco in 1912 had a fundamental effect upon his work.

His three triptychs — one of landscapes, one made up of *The Moroccan Amido, Zorah Standing,* and *Fatima the Mulatto Woman,* and the better-known *Window at Tangier, Zorah on the Terrace,* and *The Casbah Gate* of 1912 — flood their orientalist subject matter with pale washed planes of coloured light; besides the more schematic works of 1909–10, these are his flattest works to date. Far from a mad 'rite of spring', they are contemplative in their calm equilibrium.

The *Window at Tangier,* is a simple view through a window bathed in blue afternoon light; in *Zorah on the Terrace* the pictorial space is divided by colour into three areas of cream, turquoise, and darker blue: Zorah's dress and slippers placed on the mat beside her add pattern to a very frontal arrangement. The simple stemmed bowl of fish creates a meditative atmosphere, suggesting slow, suspended movement. Sunlight becomes a pink and blue shaft in *The Casbah Gate.*

While Biskra may have afforded an encounter with the 'primitive', at a moment of sculptural activity inspired by 'negro' art in 1906, Morocco, the northern extremity of black Africa, is also the furthest extension of Islamic culture to the West. This visit was an encounter with an alternative spirituality, a culture 'which refused the power of mediation to artistic activity, granting the work of art the status of a decor, an abstraction, an autonomy: immediate sensual pleasure, not a speculation'.[11]

Matisse's art, while constantly aiming for an eastern spirituality through decoration and 'calm', is nonetheless overwhelmed with western orientalist fantasy. With 'immediate sensual pleasure' came notions of mastery, penetration, and possession, which would culminate in the *Odalisque* series of the 1920s. The act of figuration is against Islamic holy law, so that to depict Zorah in a quasi-religious pose on a prayer mat, albeit on a terrace — was an affront to religious propriety. Moreoever she is unveiled: no religious Moslem woman would have been available to model at all. Only prostitutes and Jewesses were exempt from the veil. As Delacroix had done, Matisse (with his friend Charles Camoin) encountered many difficulties procuring models, such as Zorah, with whom he created completely artificial scenes.[12]

Nor were stereotyped attitudes confined to the female. The painting of the male villager from the Riff mountains, exhibited at the Bernheim-Jeune gallery in 1913, gave rise to the following from Marcel Sembat:

> Now take that Riffian! a splendid specimen, this burly giant with his angular face and big, wide shoulders. As you look at this hulking barbarian you cannot help thinking of the warriors of past epochs. Weren't the Moors of the *Song of Roland* stamped with the same ferocity?

The *Arab Café,* however, was seen as a place of masculine repose — contemplation, the suspension of time, and literally, simplification. To quote Sembat:

> The shoes, the pipe and the facial features, the various colours of the burnooses had vanished. The more you look at it . . . the stronger is this feeling of dreamy contemplation that grips you.

The figures reduced to flat, squatting shapes recall the influence of the Persian miniatures seen in Munich and, in between Matisse's Moroccan trips, at the Musée des Arts Décoratifs in Paris. While the use of tempera and the painted, decorative, border gives the work the air of a *tenture,* the subject anticipates *The Moroccans,* the monumental composition of 1916. Planned in September 1913, *The Moroccans* was taken up again in late 1915 and is far more dynamic than the earlier paintings. The use of black paint for blinding light and the stark architectures of the white Marabout down below complement the simplified figures, who — far from languid chatter — are bent in prayer, their yellow-turbaned heads and green burnooses composing a foreground reminiscent of still life.[13]

During 1913 and 1914 Matisse experimented with varying methods and motifs that would later take on great importance: consider the *Still Life with Oranges* that Picasso ultimately bought, and the somber but sensual *Grey Nude with Bracelet.* Again Matisse took up engraving and made his first negative images — the fine white line on black of his minimal yet erotic monotypes, such as *Nude with a Ring.* (Gustave Moreau had said 'The more elementary are the means in art, the more apparent is the artist's sensibility'.)

The Portrait of Madame Matisse of 1913, blue and grey, with a white, mask-like face and the orange slash of scarf shows Matisse's decision to go back to Cézanne as a means of confronting Cubism. Another catalyst came in 1914, when Matisse met Juan Gris at Collioure. Gris's black contour lines are dramatically adapted by Matisse in the almost vicious *Head, White and Rose,* set against a stark, black ground. Marguerite's diamond drop choker, however, is as softly painted as in less angular contemporary portraits.

Revisiting his 1905 *Open Window,* Matisse painted another *Open Window, Collioure* in 1914, a profoundly more daring piece. Colouristically, with its black and emerald green, even spatially an homage to Manet's

Balcony, this window opens onto nothing. Is it a dark interior? Or is it a depiction of black light, such as the shaft which pierces the *Path in the Woods at Clamart* in 1917? For the poet Louis Aragon at least, this painting symbolised the declaration of war. *The Yellow Curtain* is a much brighter restatement of the window theme, and with its almost abstract, indecipherable curves and the play of positive and negative shapes is an astonishing anticipation of Matisse's late cutouts.

Darkness and tenseness pervade the *Portrait of Mlle. Yvonne Landsberg,* her diminutive figure expanded by the 'lines of force' that spring dynamically from her body. While similar to the lines on the *tenture*-like *Large Nude* (and of course contemporary with the futurist presence in Paris) Matisse gives them the heart shape he would use so often in the 1930s, suggesting the sitter's inner expansiveness. His early use of *grattage* here recalls his contemporary engraving practice, and gives the surface an added anxiety and delicacy.

Many compositions of this period show great formal and colouristic daring, such as the emotionally charged *Piano Lesson* (Alfred Barnes commented upon the oriental love of lavender in evidence here).

However, two monumental compositions exemplify Matisse's achievement at this time. The *Variation on a Still Life by de Heem* in the Museum of Modern Art, New York, reverts to Matisse's subject matter of 1893. A careful preparatory drawing of the still life is perhaps the closest approach Matisse made to conventional Cubism. In the painting, striking compositional lines, the use of *passage,* even the emphasis of motifs such as the tassel and the musical instrument, have their echoes in classical cubist paintings, in particular those of Picasso and Gris. Even more original and imposing is the great Chicago *Bathers by a Stream,* 1916. Based on a 'Bathers' idea originally intended to complement *The Dance,* the tensions between these stocky, faceless, sculptural figures becomes almost Manichean, played out against strips of black and white, while both foliage and a white serpent's head suggest temptation and fall. The blockiness of the grey figures is intensely sculptural; it was at this period 1913–17, that Matisse was working on the second and third of his *Back* sculptures, where the transition is made from seminaturalistic to primitive: the figure becomes rigidly symmetrical: a column of hair splits the body in two.

Nice, 1917–1930

In 1920, Marcel Sembat concluded his monograph on Matisse with the following words:

> The Nice years will mark a supreme moment in Matisse's work... Without weakening his brutal strength, Matisse has disciplined it. A soft harmony blossoms over his power.

In late 1916 after painting a series of uncompromising portraits of Michael and Sarah Stein, and Greta Prozor, Matisse started to work with the model Laurette. Initially severe depictions softened: by 1917, the *Head of Laurette with Coffee Cup,* has the curvaceousness and abandonment of the future Odalisques. The disturbing inversion of the model refers the spectator back to the artist/lover's scrutinizing gaze from above.

Matisse moved to Nice in December 1917; early masterpieces such as *White Plumes,* 1919, and related, exquisitely detailed drawings can be placed securely within the contemporary 'return to order' in the arts, precipitated by Picasso's Ingresque period. The subsequent decade for Matisse was one in which harmony 'blossomed over power'. A comparison of *Interior with a Violin,* 1918, and *Interior with a Phonograph,* 1924, is revealing. In the first the overwhelming sense of counterpoint — light/shadow, white/black, inside/outside, open/closed, music/silence — condenses to a perfect equilibrium. In the second painting Matisse has created an orientalist decor with an Indian hanging: exoticism and opulence are suggested by the fruits and flowers, while the phonograph, not so eloquent as the violin, seems silent. The focus is again on the window but the sight of Matisse's tiny reflected head just off

centre introduces a note of anxiety into an otherwise fairly anodyne scene. Even so, these pretty, less demanding paintings found a market which constrained Matisse to repetition, as he became increasingly introspective, increasingly absorbed by his own décor, the familiar décor of Baudelaire's oriental splendour:

> Des meubles luisants,
> Polis par les ans,
> Décoreraient notre chambre
> Les plus rares fleurs
> Mélant leurs odeurs
> Aux vagues senteurs de l'ambre.
> Les riches plafonds,
> Les miroirs profonds,
> La splendeur orientale,
> Tout y parlerait
> A l'âme secret
> Sa douce langue natale
>
> Là, tout n'est qu'ordre et beauté,
> Luxe, calme et volupté.
>
> Baudelaire:
> *L'Invitation au voyage,* 1855

Matisse's Odalisques, generally inspired by the body of Henriette Darricarrère, were his major preoccupation during the years in Nice. They were painted largely in the years between two major colonial exhibitions, one held in Marseilles in 1922, one in Paris in 1931. Oriental splendour was now very fashionable — and Matisse, who had preserved his immunity while in Gustave Moreau's atelier, made up for lost time.

The context in which Moreau had painted was one formed by the generation educated from the mid-1830s to the late 1840s which proclaimed 'the intellectual necessity of the Orient for the Occidental scholar of languages, cultures and religions'.[14] While British imperialism reigned supreme in the Middle and Far East, French influence in Algeria had spread south in a series of military campaigns in the 1830s and 1840s. The painterly traditions, both topographic, descriptive and erotic, followed in train from Delacroix, whom Matisse hadstudied in 1898, to Renoir. Ingres' *Turkish Bath* of 1862, which had such an impact on Matisse in 1905 had nevertheless been painted entirely from the imagination or secondary sources; Renoir's 1870 *Odalisque* was likewise a simple studio costume piece.[15] The well-stocked colonial pavilions at the Universal Exhibitions that took place in Paris during the first part of Matisse's lifetime — 1878, 1889 and 1900 — presented their booty with pride.[16] However, the reassertion of French colonial power and possessions in the 1920s came in a period of redressment after the ravages of the First World War. The colonies were portrayed as a cornucopia of abundance extending France's boundaries and restocking her Metropolis.[17] Matisse bought oriental textiles and furniture for his studio and began dressing his French models with veils and harem pants. *Odalisque (The White Slave),* 1921–22, while indeed one of the most beautiful and delicate of the series, both emphasises the incongruities of this fancy dress situation, and prompts the question 'Slave to whom?' The situation is inverted in the lithograph of the naked Hindu woman, sitting over a chair in the most Western of erotic poses — a great contrast to the reserved depiction of the opulent *bourgeoise* in a white fox-fur wrap that he drew in 1929.

In Morocco in 1912, Matisse claims to have penetrated the harem, and to have based his later paintings on these memories:

> As for the odalisques, I had seen them in Morocco, and so was able to put them in my pictures back in France without playing make-believe.

Nonetheless, the harem of Western imagination was very much a make-believe. There are undoubted masterpieces of the genre, in particular *Odalisque with Raised Arms,* 1923, where the diaphanous veiling of flesh contrasts with the directness of the tufts of underarm hair. This painting, and related lithographs — (themselves derived from the powerful lithograph, *Large Nude* of 1906) were translated into sculpture in Matisse's *Large Seated Nude,* 1923–25, a work that appears far nobler bereft of the props and decorative elements that appear in the paintings.

The Odalisques become the sign for an imaginary Orient; from Flaubert onwards, the Oriental woman signified licentiousness, animality, eroticism without responsibility or indeed consequences. While Moreau's *Salomé* was at least self-willed, dangerous, and powerful, Matisse's nudes are beautiful but anodyne. Often formally overwhelmed by the boisterous patterning of the decor, as in *Odalisque with Grey Trousers* for ex-

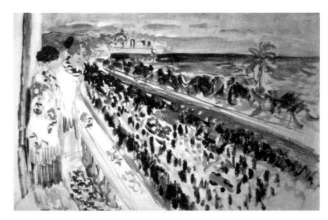

Flower Fête in Nice. 1921. Oil on canvas. Private Collection, Zurich.

ample, they become objects interchangeable with the artist's reclining sculptures that so often appear in his still lifes. The boredom of the model, so extraordinarily overt in *Woman with a Veil,* 1927, becomes one with Matisse's own melancholy, and his fear of failure, *le trac,* stagefright, which he later confessed to Lydia Delectorskaya. Moreover the white flesh that Matisse disguised in Oriental silks and satins was not always voluptuous: Delectorskaya recalls how the three patently underfed models who were asked to pose together in quasi-lesbian scenes, were kindly given extra rations by their benevolent taskmaster.[18]

To Matisse's annoyance Raoul Dufy was tapping the same wealthy Riviera market with his own scenes of Hindu women, the Promenade des Anglais and so on. Matisse's views from the balcony window such as *Flower Fête in Nice,* may be interestingly compared with Dufy, though the possible plagiarism that caused Matisse so much resentment is never discussed in Matisse studies. The Odalisques as a genre were particularly popular from the start: the State purchased Matisse's *Odalisque with Red Trousers,* a small and rather modest canvas in 1921, for the Musée du Luxembourg, corroborating the policy of the Colonial exhibition in Marseilles the following year, which specifically designed to give French citizens a 'colonial conscience'. The financial crisis generated by the Wall Street Crash was already affecting the art market in Paris by the time of the next Colonial exhibition, held just outside Paris in 1931, where an 'Imperial City' was constructed in the Vincennes forest, demonstrating a hierarchy for the metropolitan and provincial buildings. There was, however, vociferous protest against the very concept of French imperialism by Socialists, Communists and the Surrealists (the most visible new artistic grouping by this time). The future Popular Front leader, Léon Blum pointed out the contrasts between the temple at Angkor, the sacred dances performed in Paris, and the shootings, deportations and imprisonments in Indochina. In 1937 at the Exposition internationale, the Pavilion of 'France Outremer' (France beyond the seas), constructed on the Ile-des-Cygnes, represented the Colonial Empire in a Utopian mode, again reaffirming the Orientalist myth.[19]

Similarly, not a trace of the actual was allowed to

perturb the balmy harem decors of Matisse's world in Nice. As Henry Miller wrote in *Tropic of Cancer*, 1934:

> The world of Matisse is still beautiful in an old-fashioned bedroom way. There is not a ball-bearing in evidence, nor a boiler plate, nor a piston, nor a monkey wrench. It is the same old world that went gaily to the Bois in the days of wine and fornication.

In the autumn of 1926 Matisse moved from the third to the top floor of 1, Place Charles Félix, overlooking the Promenade des Anglais. One studio now had false-tile walls, and possibly as a result of this new purity of decor, some barer, more rigorous work began to be produced, such as *Woman with Turban (Portrait in a Moorish Chair)*, 1929–30.

The contemplation of expanse of white tiling would coincide with Matisse's study of Mallarmé's aesthetic of whiteness, and look forward to his tile decorations for the Vence Chapel.

Mallarmé Illustrations, the Barnes Murals, Female Sitters, 1930–1939

In 1930, having commissioned Picasso to illustrate Ovid's *Metamorphoses,* the enterprising Swiss publisher Albert Skira settled with Matisse on a commission to illustrate the *Poésies de Stéphane Mallarmé,* the final choice of poems being the artist's. Matisse's etchings are marvels of simplicity, unconfined by any margins 'so that the printed page remains almost as white as it was before the etching was printed'. Image is reduced to quintessence in the characteristically inverted visage: *La chevelure, vol d'un flamme,* (Hair, Flight of a Flame). The volume was published in Lausanne in 1932.

Matisse also sailed to Tahiti in 1930, via New York and San Francisco, staying for three months, drawing, taking photographs and acquiring a store of mental images for future works. These ranged from the small *Tiari* sculpture, half flower, half woman, of 1930, to Lagoon images in *Jazz,* and the hangings *Oceania* and *Polynesia* of 1946. The acme of exoticism, Tahiti was according to Matisse 'both superb and boring'. Matisse returned to the United States in October for the Carnegie Institute Exhibition Jury, after which he visited New York collectors, the Barnes Foundation, and the Cone Collection to see his own works, returning for discussions with Alfred Barnes about his proposed mural commissions at the end of the year.

Inside the Barnes Foundation at Merion, Matisse saw that his murals would both have to serve an architectural function and face the competition of Barnes' masterpieces: Cézanne's *Bathers,* Seurat's *Poseuses,* and many Renoirs. A drawing he made for Lydia Delectorskaya in 1934 shows how the murals fitted high up in the lunettes above the French windows. He said: 'My aim has been to translate paint into architecture, to make of fresco the equivalent of stone or cement'.

Rather than squaring up a design as most mural painters did Matisse decided to hire a disused film studio to live 'body-to-body' with the fifty-two square metres he would have to decorate. Preliminary sketches show Matisse's original ideas were based on the broken circle of the figures in *Dance* of 1910. Coloured versions show brownish flesh changing to blue; at one stage a black, yellow, blue, and white arrangement anticipated the *Etrange Farandole* ballet curtain of 1938. Eventually Matisse decided on a black, blue, pink, and grey scheme, using cut paper templates painted in gouache as compositional aids during the design process. After a year's labour, realising that he had been working to inaccurate measurements, Matisse was forced to abandon a full-scale version and start the exhausting project all over again. (During the same period he completed *Back IV,* his most severe, and most monumental bronze sculpture.)

As anticipated in the Chicago *Bathers,* where a figure is lopped in half by the picture frame, in these 1930 murals the dancing figures leap out of their lunettes, both imaginatively expanding the design and rendering figurative elements of the design itself more abstract. The violence of the tumbling figures has been seen to derive from studies of Pollaiuolo's *Hercules and Antaeus,* but these are distinctly female leapers and tumblers, anticipating the battling females in Matisse's *Calypso* illustration to James Joyce's *Ulysses.* The illustrations for this book were commissioned by telephone by George Macy in late 1933; unusually, Matisse was involved neither in the choice of typeface nor cover. Moreover he did not labour thoroughly through Joyce's dense and complicated text, once he had seized upon the fact that Joyce was attempting to remodel Homer's epic in a contemporary guise. Joyce immediately accepted the proposal for classical as opposed to modern subjects for Matisse's soft-ground etchings. Certain of these are strangely sculptural and abstract, in particular the brothel scene known as *Circe.* The theme of struggle and of imminent rape, derived from Pollaiuolo's famous engraving *Battle of the Nudes,* again transforms Matisse's pastoral fantasies in *Nymph in the Forest,* 1936–42. This was exhibited with a decorative border, as though it were a tapestry design, at Bernheim-Jeune in 1936, but reworked obsessively in 1941 and 1942, and finally abandoned, pale and mysterious, the border changed to a red and blue painted frame.

Lydia Delectorskaya, a beautiful blonde Russian emigrée, became Madame Matisse's companion, then Matisse's model, personal secretary, and confidant in October 1933 — and for the next twenty-two years. Lydia posed for the famous Baltimore *Pink Nude.* Its preliminary stages were photographed several times, showing Matisse's ruthless simplification and distortion; for many he was still the painter of ugliness. A

chequered blue blanket replaced the tiled walls of *Nice* in a severely grid-like squared background. However, the contemporary *Seated Pink Nude,* with its severe right angles and its surface almost entirely scraped away, reveals a ghost-like, more voluptuous image concealed in its *pentimenti.* Matisse has transformed a possibly abandoned work into the most daring evocation of Mallarmean absence.

In 1935, the balcony view snapshot taken in Tahiti, and already transposed into an etching for the *Poésies de Stéphane Mallarmé,* became the basis for the Beauvais silk-weave tapestry *Tahiti,* thanks to Madame Marie Cuttoli's initiatives in the renewal of this decorative art. Another version of the view with a stronger red, blue, and green colour scheme, painted in tempera, recreates the red balustrade of *Lady on the Terrace,* c. 1906–9.[20] This version of the Tahiti design was used as a background behind Lydia in *The Blue Blouse.*

Certain of Matisse's portraits at this time became increasingly historicist, following trends in contemporary fashion. In *Lady in Blue* (a reversal of Ingres' famous pose for *Madame Moitessier)* he reverts from the oriental mode to tight bodice, frilly blouse, pearls, and a demure frontality that recalls both François Clouet and Ingres at his most elaborate. The *Lady in Blue* is a *grande bourgeoise,* a flower of France, not an oriental slave. At the same time, however, Matisse found a delightful Roumanian blouse for Lydia, and reverted to loose, striped oriental robes in his portraits of Helène Gallatzine. The relatively recent introduction of white *sgrafito* marks becomes part of an obsessive patterning when this Russian princess is depicted in *Violet Robe with Buttercups* in 1937. The

sgrafito anticipates the cutout collages of 1938. The desire almost for obliteration of the figure in patterning — a feature of earlier Odalisques — seems more aggressive, more anxious here.

At the major Exposition internationale held in Paris in 1937, works by Clouet and Ingres were of course among the '100 masterpieces of French art' exhibited in the new Palais de Tokyo. They presented for the first time to both French artists and the public a specifically 'French' history of art (the Louvre had always focused its attention on the Italian School). The preeminence of modern French art was shown in the Petit Palais show 'Masters of Independent Art'; it included a retrospective of sixty-one works by Matisse.

The international political tensions of the late 1930s were highly visible at the Exposition. Confronting Albert Speer's Nazi pavilion, the triumphantly Stalinist-style Soviet pavilion rose on the Champ de Mars amidst international outcry at the show trials of Zinoviev and Kamenev. André Gide's long report *Return from the U.S.S.R.* convinced many former enthusiasts of the totalitarian nature of Stalinism. Paradoxically, in the light of the Zhdanovian socialist realist dictatorship exercised in the Soviet Union since 1934, a monograph on Matisse was published in 1935 in Moscow by Alexander Romm. Generally a well-informed account of Matisse's development, his conclusions cannot be dismissed:

It seems as if all the catastrophic and tragic events of the last few decades have passed him by and left him unchanged. He has remained true to his cult of tranquility. The twenty years that have passed since his first programme declaration have been filled with wars and revolutions.

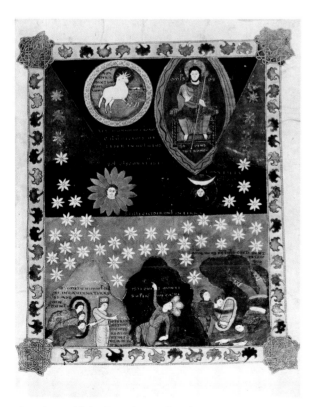

Apocalypse of Saint Sever. Stars Falling from Heaven.
Bibliothèque Nationale, Paris.

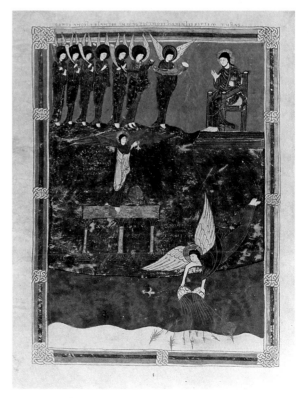

Apocalypse of Saint Sever. The Seventh Seal.
Bibliothèque Nationale, Paris.

Romm dismissed the turn to oriental mysticism as the 'search for a more suitable and profoundly hypnotic ideology' in the period of the 'decline of capitalism' — a decline accepted and discussed by most left-wing Western European intellectuals at the time. While any Marxist critique of Matisse's vivacious art must be inadequate, his return from the Orient to the French tradition from 1939 onwards nonetheless had profoundly ideological implications.

Prior to his espousal of the medieval values of *La Douce France,* however, he encountered a work of art crucial for his subsequent career. Leaves of the manuscript of the *Apocalypse of Saint Sever* were exhibited along with other treasures of the Bibliothèque Nationale during the Exposition internationale in 1937. The monk Beatus' commentary on the revelations of Saint John had been copied and painted in the Mozarabic monasteries of the kingdom of Leon, through Navarre and Catalonia, and across the Pyrenees as far as Saint Sever in Gascony, during the eleventh century. Emerging as a subject of scholarship in the 1920s, the *Apocalypse* reached an audience of contemporary artists and art lovers in 1929, with Georges Bataille's reproduction of some of the pages in *Documents,* no. 2, 1929. The editor Tériade published three plates in colour in *Verve* (Spring 1938), where the accompanying texts accrued tragic contemporary resonance in the light of the cataclysm in Spain and the ominous build up of political tensions all over Europe.[21]

Instantly the formal potential of the *Apocalypse of Saint Sever* inspired the most important artists: Picasso used the floating bodies from the *Flood* scene as an inspiration for *Guernica,* just as Fernand Léger would use them for his series of *Divers,* elaborated during his war-time stay in America.[22] Matisse's ultimate tribute to the *Apocalypse* would be *Jazz,* which would be published by Tériade in 1947; but almost a decade earlier, the impact of the work struggled with that of the Barnes murals in *L'Etrange Farandole.*

This ballet, preoccupied with the theme of man's destiny, was choreographed by Léonid Massine to the music of Shostakovich's *Second Symphony.* Matisse designed not only decor, flame-like costumes and the stage curtain, but worked with Massine on the evolution of the dance. Significantly, the paper cutout technique may have evolved from Matisse's first work for the ballet, *Le Chant du Rossignol* (Song of the Nightingale) of 1920. Back in 1916, Diaghilev's initial commission for costumes and decors had gone to the Futurist artist Fortunato Depero, many of whose vigorously geometric and zig-zagging designs, using a cut and pasted coloured paper technique, had been completed before the commission passed to Matisse.

Now in 1937–38, the balletic nature of the Barnes murals was amplified in scenery of vaulted arches, under which a couple in white, representing the poetic spirit, was menaced by figures in red and black representing evil and brutality. It was a *psychomachia,* symbolising the eternal struggle within man between spirit and matter, virtue and vice. The white figure in *Two Dancers,* a very large paper cutout composed for the ballet in February 1938 (repeated in blue as the tumbling tobbogannist of *Jazz*) derives its form from the wings of angels in the *Apocalypse of Saint Sever* in which flight symbolises grace, fall symbolises perdition.[23]

Stylistically, Visigothic, Mozarabic and Carolingian styles converge in the *Apocalypse,* a combination of indigenous and oriental influences that Matisse would have found congenial.[24] Initially, Matisse took only the very simplest elements as design ideas, but these were crucial for his later cutouts and their impact on the subsequent art of the twentieth century. He adopted the division of the background into broad, banded planes of colour and used thin vertical or horizontal strips along the sides of the image. Moreover the juxtapositions of colour in the *Apocalypse* are deployed in these earliest *Dancer* collages and later in *Jazz.* The original manuscript's colours were brilliant and were used, of course, for symbolic and decorative rather than naturalistic purposes. Vermilion was made from mercuric sulphide, azurite was used for the blues, arzica or 'weld' for yellow, and malachite for green, with lamp-black and white. For an equivalent impact, Matisse used papers coated with matt gouache; cutting these with scissors gave a sharpness and crispness of implied movement to the *Dancers.* The visible pinnings and adjustments of the figure in *The Dance,* and in the final maquette for the stage curtain, demonstrate Matisse's miniaturisation of his mural cartoon technique, anticipating *Jazz.* Conversely, the sight of the stage curtain itself, showing the design enlarged to monumental scale, was influential in the conception of the late paper cutouts.

War and After, 1940–1947

In 1936, the 'Apocalypse' number of *Verve* could be seen to reflect the turbulence of the Spanish Civil War. With the declaration of war in September 1939, the retreat to 'French' values was universal. It was no coincidence that Matisse's red, white and blue seated woman, *La France,* was painted in late 1939. Foreign artists in France now fled from certain persecution. Like Picasso, however, Matisse ultimately refused to leave France. He witnessed from Nice the humiliation of occupied Paris, and reworked a version of *The Roumanian Blouse* during 1940, until it made a perfect patriotic tricolour: it was the moment of the evolution of what was called 'red, white and blue' painting among younger artists.

Still Life with a Seashell on a Black Marble Table was one of Matisse's favourite pictures. It took thirty sessions to complete in November 1940. Based on many preparatory sketches, it is also related to the unusual

paper cutout still life in the Pierre Matisse collection. 'I think this is my most significant work for coloristic expression', Matisse said of the painting.[25] In some ways similar to *Pink Onions* of 1906, here the simplicity of the cheap, decorated pottery is offset by the erotic and spiky curves of the pink shell on the black ground where marble veining is suggested by a delicate *sgrafito* characteristic of the works of the early 1940s. It was reproduced in monographs that he arranged himself, appeared with him in a film, and was finally given to Lydia Delectorskaya in October 1952, in recognition of twenty years of faithful service.

The Occupation of Paris symbolised the humiliation of France. In the ideology of the collaborationist Vichy government, the war could be seen as punishment for the wild luxury of the 1920s and after. The required introspection and purification was to be achieved by the exaltation of work, the family and the fatherland: *Travail, Famille, Patrie.*

Matisse was seventy-two years old when, in 1941, an operation for intestinal occlusion lead to complications during which he almost died. His recovery was miraculous; he was called *le ressucité* (resurrected) by his nurse, and despite his bedridden and weakened state a new *joie de vivre* entered his work. *Jazz* (originally *Le cirque*), Matisse's masterpiece of book illustration using the paper cutout technique, begun in 1943, was both nostalgic and optimistic in its themes. It is not irrelevant that in 1943, at the moment of the conception of *Jazz,* twenty-nine plates of the *Apocalypse of Saint Sever* were published in facsimile by the Editions de Cluny, lithographed by Mourlot frères.[26] Matisse's paper cutout-based covers for *Cahiers d'Art* (1936) and *Verve* (from 1937) had also used the lithographic process. However, for *Jazz,* after some unsuccessful experiments, the *pochoir* technique of hand-stenciling, used so successfully in the 1920s, was adopted, Edmond Vairel using the same Linel gouaches that Matisse used for his original paper cutout designs. Apocalyptic analogies would now be made, not with the tragedy of Spain, but with events in the Second World War. *Icare* was compared by Matisse to a fighter pilot shot down in a sky filled with the flashes of gunfire — although the *Apocalypse* page *Stars Falling from Heaven* would also inspire Matisse's optimistic *Christmas Night* of 1952 (a stained glass window design executed for *Life* magazine by Paul Bony).

Much of the imagery of *Jazz* — *Le clown* and the ringmaster *Monsieur Loyal, Les Codomas* (trapeze artists), *L'avaleurs de sabres,* even *L'enterrement de Pierrot* — comes from Matisse's earliest Paris memories of the Medrano circus. The seaweed shapes of the three *Lagon* illustrations are souvenirs of Matisse's Tahitan voyage, and look forward to his postwar *tenture* designs of 1946 — and to the Vence Chapel windows. Conversely the almost abstract *Le destin* spread in *Jazz* has been convincingly explained by Lydia Delectorskaya as a *resumé* of the plot of *L'Etrange Farandole* (performed in Paris in 1939 and in New York in 1940–41 as *The Red and the Black*). Here the central white shape on the right-hand page is interpreted as a frightened female figure clinging to a male, threatened by lowering violet and black profiles to the left. To read the white shape as such is to read sculptural form back into silhouette; and here we have the whole ethos of *Jazz* — as Matisse explained in his text written in the summer of 1946:

> Cutting directly into colour reminds me of a sculptor's carving into stone. This book was conceived in that spirit.
> ...These images in vivid and violent tones, have resulted from crystallizations of memories of the circus, popular tales, or travel. I have written these pages to calm the simultaneous oppositions of my chromatic and rhythmic improvisations, to provide a kind of 'resonant background' which carries them, surrounds them, and thus protects their distinctiveness.

Amid reminiscences of air travel, of trees and flowers, artistic maxims and messages for younger painters, (*Jazz* is the sequel to *Notes of a Painter* in this respect), and in juxtaposition to constantly secular images, there are several references to God, so poignant in the light of Matisse's recent confrontation with death:

> In art, truth and reality begin when you no longer understand anything you do or know, and there remains in you an energy, that much the stronger for being balanced by opposition, white, pure, candid, your brain seeming empty in the spiritual state of a communicant approaching the Lord's table.

In conjunction with an understandable returning to religion in times of national disaster, the disappearance of the male sex from France lead to a feminisation of values, reinforcing the return to a 'pure' national tradition and a Catholic ideology of submission and repentance.[27] Thus, during the Occupation, Romanesque art was seen to represent the essence of France itself.[28]

> Turning to the Middle Ages we are certain to rediscover the very soul of France, in its pure state, at the moment of its Genesis, as it emerged, chaste, white and nude from the chaos of destiny.[29]

The cult of Our Lady, *Notre Dame,* flourished with the secular cult of courtly love; the 'poets of the Resistance' such as Louis Aragon adopted medieval pseudonyms, in his case 'Blaise d'Ambérieux', and he reverted to the easily memorable forms of rhyming quatrains and ballad forms. Aragon spent much time in Nice during this troubled period with his Russian wife Elsa Triolet, and developed a complex and curious relationship with Matisse which had great bearings upon the artist's post-1945 reputation.

The Communist poet's courtship of Matisse during the war may retrospectively be seen as an attempt to match the privileged relationship that his rival Paul Eluard had built up with Picasso, although an obvious paternal and filial affection and interest in painting and literature engaged the two men in Nice.

Aragon's text 'Matisse-en-France' which prefaced the magnificent volume of Matisse's drawings, *Thèmes et Variations,* published by Martin Fabiani in 1943, with its analogies between Matisse and the medieval 'painter-king René' is a long meditation upon the

return to the values of the French past. The elision made between Matisse's flat, brilliant symbolic colour and arabesque buttresses an attack on the Renaissance and the 'decadence' of its three-dimensional space. Michaelangelo, the 'secret dissector'; is the enemy; Matisse's palette is

> infinitely richer, imperial . . . his culture is greater . . . He is not far from saying — he said, in fact he said to me that the art of the Renaissance was a decadence, a terrible decadence.

During his convalescence Matisse immersed himself in the poetry of old France. He illustrated with extraordinary simplicity and eroticism the *Florilège des Amours de Ronsard,* using a sepia coloured line for twining lovers, leaves, even the tiny *Petit nombril* (Little navel). The insistence on love versus melancholy is repeated in Matisse's selection of the *Poèmes de Charles d'Orléans,* written out by hand with coloured crayons in 1942, and illustrated with schematised *fleurs-de-lis* and oak leaves, escutcheons, even rabbits like those in the Cluny tapestries. The poems trace the evolution of a courtly love from joy to despair. It was a nostalgic exercise for the bedridden artist. The *Poèmes,* ending with 'Go away, go, worries, cares and melancholy' were not published until 1950. Matisse's illustrations for Henri de Montherlant's *Pasiphaé* were published by Fabiani in 1944. For once the poem is a cry of female passion — although equally a cry of defiance: Pasiphae will be publically shamed for her coupling with the bull Minos. The poem gave rise to some of Matisse's simplest and most erotic works in white on black: witness the coupling lovers: *Borne up to the constellations*, or the single white profile: *The anguish growing and beating at your throat.* The simplest vignette on the page, traces splitting pomegranates or the contours of a female sex: (compare the still ambiguous yet more explicit rendering in Matisse's remarkable illustration to the Russian futurist Iliazd's anthology *Poésie de Mots inconnus* [Poems of unknown words] of 1949). The intensity of female desire would be illustrated with bursting pomegranates and their flowers, lilies, and the sad, sweet face of the abandoned nun Marianna Alcaforado in *Les Lettres Portugaises* (Love letters of a Portuguese Nun), published with Matisse's line drawings in 1946.

Matisse's public prominence as a repository of 'French' values during the Occupation contrasts with his rival Picasso's far more intransigent attitude. Articles on Matisse appeared in reviews such as *Comoedia, Le Rouge et le Bleu* or Drieu de la Rochelle's *Nouvelle Revue Française.* Moreover, Matisse was not loth to be interviewed for the Vichy-controlled radio.[30]

To what extent was the sense of rivalry still acute between Picasso and Matisse? Picasso's membership of the Communist Party in 1944 achieved international publicity at the height of its political prestige. The party of the heroes of the Resistance, it became an influential participant in government until 1947. Matisse's connection with Aragon, who controlled the pro-communist arts periodical *Les Lettres Françaises* during this period, gave him similar associations and not unwelcome publicity.[31] He was still working with Aragon in 1946 on a Skira book of colour plates (young women and still lifes), with the title *Apologie du luxe* — a 'dialectical' meditation — and on Baudelaire's *Les Fleurs du Mal.* Matisse chose only a quarter of Baudelaire's collection, elevating love at the expense of Baudelarian spleen. The heads of the Russian Lydia, the Dutch girl Annelies Nelck, and the Haitian Carmen interspersed with the faces of Matisse, Apollinaire, and Baudelaire himself had been drawn mostly in 1944.[32]

The Vence Chapel, Last Paintings and Paper Cutouts, 1947–1954

The expulsion of the Communists from Government in 1947, and the acceptance of American economic and then military aid by a radical socialist majority, heralded the cold war period in arts as well as politics. In August 1947, an article in *Pravda* officially condemned the formalist art of both Picasso and Matisse. The debate in the French press continued through to October, by which time the dictates of Andrei Zhdanov in favour of socialist realism had been announced with the constituitive meeting of the Cominform. French Communists were exhorted to follow the Soviet prescriptions: Louis Aragon recruited to his side one André Fougeron from the ranks of the 'Young painters of the French tradition', who had emerged in the wake of Matisse and Picasso during the Occupation. Fougeron spearheaded Aragon's hard-line socialist realist campaign and the focus changed from *le luxe* to worker-inspired miserabilism. At the same time, however, Aragon continued to court Matisse, Picasso, and Léger, all of whom were to exhibit in the prestigious, communist-backed venue opposite the Elysée palace, the Maison de la Pensée Française.

This invidious two-tier system was complicated by the Party's relationship with the Catholic Church, especially as both Matisse and Léger became prominently involved with the postwar regeneration of sacred art. The rejection of kitsch, so-called 'Saint-Sulpice' religious imagery, was an attempt to cleanse and purify a tarnished image. The Catholic Church in France had been heavily pro-Vichy during the war, while Rome had been almost entirely passive since 1937 — despite information about Nazi atrocities, including the concentration camps.[33] An initiative had been taken before the Second World War for the decoration of the church of Assy with a more modern sacred art. It was finally inaugurated in 1950, with an impressive ceramic façade by Fernand Léger, a Communist Party member and atheist, like Jean Lurçat who contributed tapestries. There were works by Lipchitz and Marc Chagall, both Jews, who had fled France

during the war, Bonnard, and the young Jean Bazaine. Germaine Richier's scarred and eroded Christ for the crucifix caused a national uproar. Father Marie-Alain Couturier, figurehead of the sacred art campaign, met Matisse in October 1948. He agreed to pose for an image of Saint Dominique, which was painted on yellow tiles as an alterpiece and installed at Assy in 1950. (Léger's windows for the Church at Audincourt, and Le Corbusier's church at Ronchamp were later initiatives in the same direction.)

In the burgeoning climate of the Cold War, the Communists attempted to remobilise their 'hand of friendship' policy towards the Catholics from the beginning of 1949, coinciding with their widely publicised Peace movement and the attempt to court the new female vote. However, on July 14th, 1949, the Catholic Holy Office forbade catholics to join the Communist party. This decision, a 'massive historical error' was an attempt by the Church to sabotage the new Party policy, which hoped to unite Communist intellectuals, Catholics such as the avant-garde Père Couturier, or the 'personalist' Emmanuel Mounier, and co-opt grass-roots Catholic working-class support.

That very year, the contrast between the Matisse exhibition of recent work at the Musée National d'Art Moderne in the summer, and the first room of the Salon d'Automne in September, completely dominated by socialist realist painting, demonstrated Aragon's now impossible position. Matisse however, asked Aragon to preface both his Philadelphia retrospective catalogue of 1948, and an exhibition of his painting and sculpture at the Maison de la Pensée Française which lasted from July to September, 1950. Besides the presentation to the public of almost the whole of Matisse's sculptural output for the first time, along with dramatic paper cutouts such as *Zulma* and *One Thousand and One Nights,* Matisse exhibited a scale model of the Vence Chapel. This was an ironic gesture in favour of dialogue — or a statement that he was not involved in the Catholic-Communist debate — that Aragon had not anticipated when writing his preface.[34]

Matisse's declaration in *Jazz* — 'Do I believe in God? Yes, when I create' — had been at once intensely personal and extremely circumspect. Invited by the Dominican novice, Sister Jacques (his nurse and the

model of *The Idol* in 1942) to decorate a new chapel at Vence in 1948, Matisse turned for inspiration to religious art. He studied Mantegna, he drew the praying hands by Grünewald, and must surely have recalled his own early copy of Philippe de Champaigne's *Dead Christ,* when reworking his heavily simplified drawings of the recumbent crucified body in 1949. Most moving, and most scandalous for the more conservative public, were his violent, sketchy diagrams for the Stations of the Cross, ultimately drawn on a large white ceramic panel, which exemplified his thoughts on the subject in action: 'You must know those events so well that you can draw them blindfold...'

Matisse's patron, Père Couturier declared:

I see it as a page covered in gestures which resemble the altered, scarcely legible letters which are written in haste under the influence of too great an emotion...

What other kind of writing would be appropriate when speaking of the Passion? These violent signs suffice me: they tell me the essential story. Why should I need anything else?

Matisse's black and white drawings of the Virgin and Child and Saint Dominic were worked out from his bed with a piece of charcoal on a bamboo cane, which allowed him to draw directly on to the wall. Once transferred to tiles and installed in the chapel they were coloured with light shed from the stained glass windows. Various purely geometric designs such as *Celestial Jerusalem* or the astonishing, optically vibrating *Bees* were abandoned in favour of yellow and blue seaweed and petal shapes on a green ground, representing the *Tree of Life*.

Architecturally the chapel, whose construction was supervised by Matisse's eminent contemporary, Auguste Perret, was designed to emphasise the sanctuary, place of the 'Real Presence' reserved for the priests. The choir stalls designed for approximately twenty Holy sisters looked onto the sanctuary and there was seating for about eighty members of the congregation. The tiled walls, blue-green harmonies, the perforated doors, even the crescent moons on the cross on the roof all recalled oriental influence. Matisse designed the vestments for the liturgical year, the crucifix, the metalwork ciborium and tabernacle. The

Praying Hands (after Grünewald). 1949.
Charcoal on paper,
16 × 10½ in. (40,5 × 26,5 cm).
Musée Matisse, Nice.

Study for the Entombment. 1949.
Charcoal, 18⅞ × 24¾ in. (48 × 63 cm).
Musée Matisse. Nice.

chapel was a total work of art, infused with a profound spirituality.

The continuity is evident between Matisse's over-celebrated words of 1908: 'What I dream of is an art of balance, of purity and serenity... a soothing calming influence of the mind, something like a good armchair', and their spiritual transformation over forty years later: 'I want those who enter my chapel to feel purified and relieved of their burdens'.

Matisse's statement read at the consecration of the Chapel in June 1951, declared:

> This work is the outcome of four years of exclusive and concentrated work, and it is the result of all my active life. Despite all its imperfections I consider it as my masterpiece.[35]

During the period of work on the Vence Chapel, Matisse continued to paint canvases as striking, as violent even, as *Interior with Egyptian Curtain,* where the jazzy design is complemented by the 'explosive palm tree with its branches whizzing like rockets from the point where the black window mullions cross' (Alfred Barr). Works such as *Large Red Interior,* or *Interior with Black Fern,* besides relating to the dynamic brush and ink drawings made at the time, abandon favourite antique props such as Matisse's rococo chair for distinctly contemporary furniture and interior decors. Moreover the impression of Matisse as an artist totally devoted to the spiritual is belied by the number of commercial, decorative projects he undertook after 1945: a Gobelins tapestry *Woman with a Lute*; his memories of Tahiti, transformed into *Polynesia — The Sky,* and *Polynesia — The Sea,* white forms on a blue-chequered background for Beauvais tapestries; related linen *tenture* wall panels on a sand-coloured ground for Ascher of London: *Oceania — The Sky* and *Oceania — The Sea,* done with silk-screen stencil, along with carpets based on the *Mimosa* design for Alexander Smith of New York.

The paper cutouts were first shown at Pierre Matisse's Gallery in New York in 1948–49 and the Matisse retrospective in Paris in 1949. *The Sorrow of the King,* 1952, is perhaps Matisse's most imposing full-scale work in this medium, with its brilliantly energetic, yet valedictory message. Evoking the story of David before Saul, of Salome before Herod, treatments by Rembrandt and Moreau, it is faithful indeed to Matisse's lifelong themes of music and dance, possibly to an actual ballet on the same David theme.[36] Baudelaire's king in *Spleen* 'his bed covered with *fleurs-de-lys* transformed to a tomb', was also present, perhaps, in Matisse's mind as an image. Yet Matisse's final works, the leaping, flying figures of the *Swimming Pool* mural for example, are perhaps his most youthful, revealing an astonishing formal and intellectual freedom at the age of eighty-three.

Officially honoured and with retrospectives held all over the world from 1946 onwards, Matisse died in November 1954. His legacy to Yves Klein in France, to Mark Rothko, Robert Motherwell or Richard Diebenkorn in America, was immediate.[37]

Each subsequent artistic generation has had to measure itself against Matisse's achievement. His approach to art was both Epicurean and spiritually contemplative, in contrast with the more anguished subject matter and stylistic plurality of Picasso, and the conceptual brilliance and sceptical minimalism of Marcel Duchamp.

In *Jazz,* Matisse copied out a phrase from Thomas à Kempis' *Imitation of Christ*. It serves as an epitaph which contains all the *joie de vivre* of his late *Blue Nudes,* swimmers and acrobats: 'He who loves flies, runs and rejoices; he is free and nothing holds him back'.

NOTES

Unreferenced quotations by Matisse are generally to be found in Matisse's writings edited by Jack Flam (1973).

1. An intermediate painting, *Breton Serving Girl*, in the tradition of Pieter de Hooch and Gerard Terborch, 'right down to devices such as the open door in the background' is discussed in Jack Flam: *Matisse: the Man and His Art, 1900–1918,* London, 1986, pp. 47–48 and colour plate 25.

2. Bernheim-Jeune also showed the Marseillais painter René Seyssaud regularly from 1901 to 1911; his works were thickly impastoed and often very brightly coloured indeed — another indication of the future 'fauvist' direction.

3. Letter from Signac to the anarchist Jean Grave, congratulating him on the publication of *La Société mourante et l'anarchie,* quoted in Catherine C. Bock: *Henri Matisse and Neo-Impressionism, 1898–1908.* U.M.I. Research Press, Ann Arbor, Michigan, 1981, p. 73.

4. Marcelin Pleynet's Freudian analysis of the importance for Matisse of the maternal face, the painted (harlot's) face, and colour as 'the sensual essence of men' opens interesting channels for discussion here. See *L'Enseignement de la peinture,* Seuil, 1977, translated as *Painting and System,* University of Chicago Press, 1984, pp. 42–52.

5. See Flam, 1986, p. 143, for a lengthier discussion.

6. The flattening of the *Green Line,* is probably a response to Manet, and an argument for dating the work to late 1905, after the Salon. See Flam, 1986, p. 145.

7. Maurice Ravel's ballet, *Daphnis and Chloe,* based on Longus' novel, (which with Virgil's *Eclogues* are the source of the pastoral idyll), was not performed until 1911.

8. See Alfred Barr: *Matisse His Art and His Public*, New York, 1951, pp. 132–35, for the full story.

9. *Interior with Three Aubergines* is reproduced without a border, together with the *Large Nude,* in an apparently different frame, in a studio photo captioned 1911, in Pierre Schneider, 1984, p. 346. Dominique Fourcade's lengthy speculations upon the *faux cadre* (false frame) in 'Rever à trois aubergines', *Critique*, May, 1974, p. 467 ff is conducted without reference to contemporary decorative arts, and *tentures* in particular.

10. Jean Clair: 'La Tentation de l'Orient', *Nouvelle Revue Française,* July, 1970, p. 69.

11. Ibid., p. 70.

12. I am indebted here to Jack Flam's article: 'Matisse in Morocco', *Conoisseur* 211, August, 1982, and the recent Washington, D.C. catalogue *Matisse in Morocco*, 1990.

13. Flam, op. cit., claims that the terrace of the Café Baba, Tangiers, is depicted with 'the languid dealers chatting at the end of the day'. Surely not.

14. See Edward W. Said: *Orientalism*, Routledge and Kegan Paul Ltd, London, 1978, p. 137. The Orientalist fantasy had started for France on a grand scale with Napoleon's invasion of Egypt in 1798. Subsequent explorations and publications continued, in particular historical investigations of the Holy Land, by Chateaubriand, among others, in the early nineteenth century. Ernest Renan, for example, published a major study of the Semitic languages in 1855, subsequent to the collapse of his faith. 'The French pilgrim was imbued with a sense of acute loss in the Orient. He came to a place in which France, unlike Britain, had no sovereign presence. The Mediterranean echoed with the sound of French defeats, from the Crusades to Napoleon', ibid., p. 169.

15. See *Orientalism from Delacroix to Matisse. European Painters in North Africa and the Near East*, Royal Academy of Arts, London, 1984, edited by MaryAnn Stevens.

16. In 1878 there were the Palaces of Persia and the Bosphorous and the Algerian exhibition in the Trocadero; Siam and Tonkin were added to the oriental pavilions in 1889, double the space of the 1889 displays was afforded to the colonial pavilions at the 1900 Exposition universelle. The impact of Japan at the exhibitions and on the art world in general is of course another question.

17. See Romy Golan: *A moralised landscape: the Organic Image of France between the two World Wars*, Ph. D. University of London, 1989, chapter VII: 'The Colonial Body of France between the Wars'.

18. Lydia Delectorskaya: *L'apparente facilité: Henri Matisse*. Adrien Maeght, editeur, Paris, 1986, p. 22.

19. See *Le Livre des Expositions Universelles, 1851–1989* Editions Arts Décoratifs — Hercher, Paris, 1983, in particular Catherine Hodeir: 'L'epopée de la décolonisation à travers les expositions universelles du XXᵉ siècle', pp. 305–6.

20. This work, called *Venice, Lady on the Terrace* in Shchukin's catalogue of 1913, and generally dated 1907, is revised as having been painted in Collioure in 1906, by A. Izerghina, in his monograph on works in Soviet collections. It seems clearly related to the red contours against green of the *Nymph and Satyr* of 1909.

21. 'Apocalypses: dix enluminures présentées par Emile A. Van Moé', *Verve*, Spring, 1938. From Saint Sever (Bibliothèque Nationale, Paris, Lat. Ms. 8878, acquired 1790) come *Babylone (Mulier)*, *Satan et les sauterelles (Terra)* and *L'inondation (Mare)*. The same issue included Matisse's text 'Divagations'.

22. The Pierpont Morgan Library, New York, also exhibited an Apocalypse by St Beatus of Liebana, Spanish 10th century (cat, no. 4) and another version, Spanish, 13th century (cat, no. 20) from May 16th to October 21st, 1939, which Léger probably studied.

23. See Avigdor Arikha, *Two Books: The Apocalypse of Saint-Sever ca. 1028–72; Henri Matisse: Jazz 1943–44*, Los Angeles County Museum of Art, Ahmanson Gallery — fourth level, April 11–May 28, 1972 (not in Pierre Schneider's bibliography, 1984). A modest six-page brochure published on this occasion was subsequently expanded in 'Matisse et l'*Apocalypse de Saint-Sever: Beatus* et *Jazz*' in *Peinture et Regard, Ecrits sur l'art, 1965–1990*, Paris, Editions Hermann, 1991. Arikha does not discuss the consequences of the 1938 *Verve* reproductions.

24. Émile Mâle said of sacred art in the twelfth century: 'The whole of Christian Europe bowed to the school of the Orient. The reign of oriental art would endure longer than that of the art of Greece. Quoted in Robert Briffaut: *Les*

Troubadours et le Sentiment Romanesque, Éditions du Chêne, Paris, April, 1945.

25. Letter to the Roumanian artist T. Pallady, December 7th 1940. See *Henri Matisse. Paintings and Sculptures in Soviet Collections*, Aurora Art Publishers, Leningrad, 1978, p. 183.

26. A reference to an exhibition related to the *Apocalypse* — or to the Cluny facsimile (prefaced by Emile A. Van Moé and lithographed by Mourlot Frères) gives the dates 10th December 1942–6th May 1943, for the show.

27. In addition to the continual deportation of Jews and Communists to concentration camps, the forced labour programme constantly sent able-bodied men to Germany. A small percentage of the male population retreated into the *maquis* and organised pockets of resistance. Meanwhile, the abrupt halt of international trade and the crushing war debt imposed by Germany enforced a return to the land, and to craft activities — the nation geared itself to 'making do'.

28. The investigation and preservation of the Romanesque heritage again dates from the 1930s. The work of historians such as Émile Mâle and Henri Foçillon was ratified by the State when in January 1937, it was decided to created a Musée de la Fresque in the Palais de Chaillot. This ambitious work continued throughout the Occupation of Paris; the mural painting section of the Musée des Monuments Français opened in June 1945.

29. G. Cohen: *La grande clarté du moyen age*, Paris, Gallimard, 1945, p. 9, 'Avant-dire', written from July 1st 1940, preface to the above.

30. Matisse's radio interviews with Nicole Vedrès such as 'Chez Matisse parmi ses toiles et ses oiseaux' and 'Matisse reclame le disparition du concours de Rome' were transcribed in *Le Rouge et le Bleu*, June 6th and July 11th, 1942. Two interviews with Gaston Diehl were published in *Comoedia* (one in *Peintres d'aujourd'hui*), 'Matisse et la pureté' by Andre Lhote was published in *La Nouvelle Revue Française* in 1941, and M. Bouvier's 'A Cimiez avec Henri Matisse' appeared in *Beaux-Arts* in 1942. Thanks to Dr Michèle Cone, author of *Art and Politics in France during the German Occupation, 1940–44*, U.M.I. Research Press, Ann Arbor, 1988 for these references, and her interpretation of Matisse's position, pp. 142–43.

31. Complementing the series of drawings of Aragon and Elsa Triolet, Matisse drew the portrait of the Franco-Soviet go-between Ilya Ehrenbourg in 1946 accompanying him to see a Soviet propaganda film... Aragon's 'Matisse ou la peinture française' appeared in the same number (no. 23–24 March 1949) of the Party-backed journal *Arts de France* as Jean Milhau's 'Pour un tribune du nouveau [socialist] réalisme'.

32. The original lithographs, ruined by heat and humidity, were reproduced photographically in the publication of 1947. Icarus was the theme of Baudelaire's poem 'Les plaintes d'un Icare'; Matisse opted for another Baudelarian title in 1942 for *L'Idole*. (The sitter, his nurse, would become a Dominican novice, Sister Jacques, and was responsible for involving Matisse in the decoration of the Vence Chapel in early 1948.)

33. From an internal point of view, France had been effectively divided into two nations ever since Leo X's refusal to recognise the French republic (before 1879), followed by the official division between Church and State in 1905. Catholic conservatism was symbolised by the sentimental and academic nature of sacred art. The problem had been articulated, however, as early as 1917, and artists such as Maurice Denis and Georges Desvallières had opened a modern academy for sacred art in 1919.

34. Aragon's 'Que l'un fût de la chapelle', 1969, in *Henri Matisse, roman*, Vol. II, p. 179ff, attempts to refute Alfred H. Barr's synopsis of the story written at the height of the Cold War in 1951. Aragon's collected writings and later interpolations which constitute *Henri Matisse, roman*, while certainly the most passionate, personal and beautifully written of all analyses of the artist's work, were designed nonetheless as an implicit 'autocritique' of the author's confused but intransigent commitment to the Stalinist line up to 1956.

35. Quoted in *Les Chapelles du Rosaire à Vence par Matisse et de Notre-Dame du Haut à Ronchamp par le Corbusier*. Paris, Les Éditions du Cerf, 1955.

36. See *David Triomphant*, performed in May 1937 at the Opera — a 'ballet du rythme', choreographed by Serge Ligar (libretto from the Book of Kings, but including Saul's daughter Melchola, who dances before Saul and David, her fiancé). Decors by Fernand Léger, music by Moussorgsky and Debussy who arranged *Icare* by Rieti (a suggestion to Matisse of the Icarus theme?)

37. See for example *After Matisse*, Independent Curators Incorporated; essays by Timothy Bell, Dore Ashton and Irving Sandler, Queens Museum, New York, March–May 1986, Worcester Art Museum, December 1987–February, 1988.

BIOGRAPHY

1869. Henri-Émile-Benoît Matisse is born on December 31st, in Le Cateau-Cambrésis, Northern France. His childhood is spent in Bohain-en-Vermandois where his father is a grain merchant; his mother supplies 'colours', paints china and makes hats.

1882–87. Attends the Lycée de Saint Quentin — much Latin and French literature. Leaves to study law in Paris.

1888. Returns to Picardy and works as a lawyer's clerk. Drawing classes (for training textile designers) at the École Quentin-Latour. Studies Quentin Latour's pastel drawings in the local museum.

1890. His mother gives him a box of paints during a long period of convalescence from appendicitis. Copying first from popular chromolithographs, and learning from Goupil's *La Manière de Peindre,* Matisse eventually signs his first still life painting 'Essitam. H. Juin 90'.

1891. Goes to Paris to study art, initially at the Académie Julian with Gabriel Ferrier and the acclaimed Salon painter Adolphe William Bouguereau.

1892. Moves to 19, Quai Saint Michel. Failing the entrance exam to the École des Beaux-Arts, he registers for courses at the École des Arts Décoratifs, where he meets Albert Marquet. He becomes a pupil of the symbolist painter Gustave Moreau, working with fellow students Georges Rouault and subsequently Henri Manguin, Charles Camoin, Simon Bussy and others.

1893–94. Copies Poussin, Watteau and Chardin at the Louvre.

1894. Birth of his daughter Marguerite Emilienne to Caroline Joblaud.

1895. Matisse is accepted at last as a regular student at the École des Beaux-Arts. Travels to Brittany with Émile Wéry in the summer and encounters Cézanne's painting at the exhibition in Ambroise Vollard's gallery.

1896. In April, exhibits with the Salon des Cent, under the auspices of the Symbolist journal *La Plume* and in the same month becomes associate member of the Société Nationale des Beaux-Arts where he exhibits five paintings. Summer in Brittany where he meets the English painter John Russell who gives him two Van Gogh drawings.

1897. The Caillebotte bequest, exhibited at the Luxembourg museum inspires Matisse to attempt Impressionist painting *sur le motif. The Dinner Table,* Matisse's 'masterpiece' is exhibited at the Salon de la Nationale. Meets Camille Pissarro. Summer in Brittany and Belle-Ile.

1898. Marries his companion Amélie-Noé-Alexandrine Parayre. Spends his honeymoon in London and studies the works of Turner. From February to August lives in Ajaccio, Corsica, where the impact of Turner comes together with the lessons of Paul Signac's 'D'Eugène Delacroix au Néo-Impressionnisme', serialised in *La Revue Blanche.* Returns to France and visits Beauzelle and Fenouillet, near Toulouse.

1899. Buys Cézanne's *Three Bathers* together with Gauguin's *Head of a Boy* and a plaster bust by Rodin of Henri Rochefort. Returns to Paris to the Quai Saint Michel. Leaves the Academy where Cormon has replaced the deceased Gustave Moreau, and works instead at the Académie Carrière. Meets André Derain and Jean Puy. Starts his first sculpture, a copy of Antoine Barye's *Jaguar Devouring a Hare.* Exhibits for last time at the Salon de la Nationale. Madame Matisse opens a hat shop. Birth of son Jean.

1900. The Exposition universelle includes a retrospective of the sculpture of August Rodin, to whom Matisse shows his drawings. Works with Albert Marquet on decorations for the Grand Palais. Severe financial difficulties: the Matisse's second son Pierre is born in June.

1901. Convalescing from an attack of bronchitis, Matisse goes with his father to Vallors-sur-Ollon in Switzerland. First exhibition at the Salon des Indépendants. At the Van Gogh exhibition at the Bernheim-Jeune gallery, André Derain introduces him to Maurice de Vlaminck. Matisse's father stops his allowance.

1902. Group show at the Galerie Berthe Weill.

1903. Matisse exhibits at the first Salon d'Automne, held in the Petit Palais. Possible contact with Oriental art at the Pavillon de Marsan of the Louvre, where Persian miniatures are exhibited. Copies Chardin's *The Ray.* First etchings and drypoints.

1904. First one person show at the Galerie Vollard, prefaced by Roger Marx. His friendship with Paul Signac results in an invitation to the South, where he spends time with Signac and Henri-Edmond Cross at Saint Tropez. A period of neo-impressionist experimentation culminates in *Luxe, Calme et Volupté.* Using the name 'Henri-Matisse', exhibits thirteen canvases at the Salon d'Automne, where Cézanne, Puvis de Chavannes, Odilon Redon, Renoir and Toulouse-Lautrec have retrospectives.

1905. *Luxe, Calme et Volupté* exhibited at the Salon des Indépendants and purchased by Signac. Summer in Collioure with André Derain. Visits Daniel de Monfreid's Gauguin collection nearby. The *cage aux fauves* (including Matisse's *Woman with a Hat*) at the Salon d'Automne heralds a new movement in painting. Meets the Steins from America: Gertrude, Leo, Michael and Sarah, who will number among his most faithful admirers and patrons. Rents a large studio in the Couvent des Oiseaux, 56, Rue de Sèvres, in order to paint *Le Bonheur de Vivre.*

1906. Exhibits *Le Bonheur de Vivre* alone at the Salon des Indépendants. First lithographs and *fauve* woodcuts. One person show at the Galerie Druet. Visits Biskra in Algeria and brings back rugs, shawls and pottery. Meets Picasso in April and the Russian collector Sergei Shchukin later in the year. Buys his first piece of African sculpture. Summer spent in Collioure, where he returns in November.

1907. *Reclining Nude 1* (sculpture) and the related painting *Blue Nude, Souvenir of Biskra* created in Collioure. The latter causes a furor at the Salon des Indépendants. Summer in Italy, visiting the Steins in Florence, then Arezzo, Sienna, Padua and Venice. Returns to Collioure. Matisse's *La Coiffeuse* is rejected by the Salon d'Automne, where the Cézanne retrospective heralds the demise of fauvism and inspires the first cubist experiments.

1908. Opens his academy at the Couvent des Oiseaux. Moves family, studio and school to the Hotel Bîron, 33 Boulevard des Invalides. Visits Speyer, Munich, Nuremberg and Heidelberg with Hans Purrmann. Drawings, lithographs and Collioure watercolours exhibited at Alfred Stieglitz's 291 Gallery in New York. His December exhibition at Paul Cassirer's Gallery in Berlin meets with a hostile reception. *Notes of a Painter* published in *La Grande Revue* on Christmas Day and is translated into German by Greta Moll.

1909. Shchukin commissions *Dance* and *Music* for the staircase of his private house in Moscow. *Notes of a Painter* translated into Russian. Summer in Cavalière. Contract with Bernheim-Jeune gallery. Moves to a house with large studio in the suburb of Issy-les-Moulineaux where he begins the first *Back* sculpture in the winter of 1909–10. Visits Berlin, Weimar and Hagen with Hans Purrmann.

1910. Retrospective, Galerie Bernheim-Jeune. Second exhibition at 291 in New York. Third trip with Purrmann to Germany. Impressed by the Islamic Art exhibition in Munich. Purrmann joins the Matisses in Collioure and Cassis. Matisse exhibits *Dance* and *Music* at the Salon d'Automne. Following the death of his father in October, he visits Seville, Granada and Cordoba in Spain. Three oils exhibited in Roger Fry's first Post-Impressionist exhibition, Grafton Galleries, London.

1911. Closure of the Académie Matisse. Begins large decorations. After a summer in Collioure visits Shchukin in Moscow.

1912. Visits Morocco in January. Sees the Persian Miniature exhibition at the Musée des Arts Décoratifs. Returns to Morocco in the Autumn, joined by Camoin. Matisse dominates the French contribution to Roger Fry's second Post-Impressionist exhibition in London where his plaster version of *Back I* is displayed.

1913. Returns to Paris via Corsica. Moroccan triptych exhibited at the Galerie Bernheim-Jeune. *Blue Nude* is exhibited at the Armory show in New York and is burned in effigy in Chicago. *Portrait of Madame Matisse.* Rents a studio again at 19 Quai Saint Michel. *Back II.*

1914. Engravings, etchings, monotypes. *Portrait of Mlle Yvonne Landsberg.* Major retrospective in July at the Gurlitt Gallery, Berlin precedes the outbreak of the first World War in August. Rejected for service, Matisse spends September in Collioure, meeting Juan Gris.

1915. Exhibition at the Montross Gallery, New York. Visits Marseilles with Albert Marquet at the end of the year.

1916. Works in Paris and Issy. *Piano Lesson, The Moroccans.* Finishes *Bathers by a Stream. Back III.* Starts to work with Laurette.

1917. Meets Monet. Paints *Music Lesson* in Issy. In December travels from Marseilles to reside in the Hôtel Beau-Rivage, Nice. Visits Renoir in Cagnes.

1918. Moves from the Quai du Midi, near the Hôtel Beau-Rivage to the Villa des Alliés. After trips to Issy and Cherbourg in the summer visits Bonnard in Antibes, Renoir in Cagnes. Resides in the Hôtel de la Mediterranée et de la Côte d'Azur, on the promenade des Anglais in Nice. Exhibits with Picasso at the Galerie Paul Guillaume. The collections of Shchukin and Morosov, including outstanding works by Matisse, are confiscated by the Soviet Government in the wake of the Revolution.

1919. Antoinette Arnoux models for the *Plumed Hat* series. Exhibitions at Bernheim-Jeune and the Leicester Gallery, London. Paints *Tea* in Issy in the Summer; then travels to London for the decors of Stravinsky's *Le Chant du Rossignol* by the Ballets Russes de Monte-Carlo under Diaghilev. Appliqué work on the costumes anticipates Matisse's paper cut-outs.

1920. The socialist deputy Marcel Sembat writes the first monograph on Matisse. Bernheim-Jeune exhibition. Visits London in June for *Le Chant du Rossignol* and Etretat in July. (Marine landscapes, seafood still lifes.) Begins work with Henriette Darricarrère, a seven-year relationship. Charles Vildrac prefaces Matisse's own publication of fifty drawings.

1921. Bernheim-Jeune exhibition. Summer in Etretat. Moves to a new apartment in the old town of Nice at 1, Place Charles Félix. The Musée du Luxembourg buys *Odalisque with Red Trousers.* Two-figure compositions with the model and Marguerite.

1922. Year in Nice and Paris, Bernheim-Jeune exhibition. Starts making lithographs again. The Museum of Modern Art in Grenoble accepts *Interior with Aubergines* as a gift from Matisse's wife and daughter.

1923. Marguerite Matisse marries the Byzantine scholar Georges Duthuit. The collections of Shchukin's and Morosov's paintings are united to form the Museum of Modern Western Art in Moscow.

1924. Retrospectives at Bernheim-Jeune, Paris, and the Ny Carlsburg Glyptotek, Copenhagen; the last influences a generation of Danish painters. Joseph Brummer, an ex-student of the academy, prefaces a Matisse exhibition at his galleries in New York.

1925. Exposition des Arts Décoratifs in Paris. Matisse travels to Italy with Amélie, Marguerite and Georges Duthuit. Finishes *Large Seated Nude* sculpture.

1927. Exhibition at the Valentine Dudensing Gallery, New York. First Prize awarded at the Carnegie International Exhibition, Pittsburgh, which secures Matisse's reputation. Ballet dancer lithographs.

1928–29. Drawings, etchings, drypoints, sculpture.

1930. Travels to Tahiti via New York and San Francisco. Returns via the Suez Canal to Marseilles. Returns to the United States in the autumn to serve on the Carnegie International Jury, where Picasso wins first prize. Visits private collections, New York, the Barnes Foundation in Merion, Pennsylvania and Etta Cone in Baltimore, Maryland. Alfred Barnes proposes a mural commission. Albert Skira commissions illustrations for *Poésies de Stéphane Mallarmé.* Retrospective Galerie Tannhäuser, Berlin. Roger Fry's monograph is published in Paris and New York, where Henry Macbride's monograph also appears.

1931. Retrospective, Galerie Georges Petit, Paris (mainly works from Nice). An expanded version of the exhibition is shown in Basel. Alfred Barr's first Matisse exhibition held at the Museum of Modern Art, New York. Work on the Barnes murals in an abandoned film studio, and on Mallarmé's *Poésies.*

1932. Is forced to make a second version of the Barnes murals because of mistake in measurements. *Poésies* published. Refuses a Rockefeller Center commission for RCA building murals.

1933. Installs second version of the Barnes murals in Merion. Takes a cure at Abano Bagni, near Venice, and studies Giotto's frescos in Padua. Alfred Barnes and Violette de Mazia publish *The Art of Henri-Matisse.*

1934. Illustrations for James Joyce's *Ulysses.* Etta Cone publishes the catalogue of the Cone collection, Baltimore. Alexander Romm's monograph is published in Moscow (second edition 1935, English edition 1937).

1935. Begins paintings of Lydia Delectorskaya, his model and secretary for the next two decades. *Pink Nude* (Baltimore). Beauvais tapestry with *Window at Tahiti* design for Marie Cuttoli.

1936. Exhibits recent paintings at the Galerie Paul Rosenberg Paris. Donates his *Three Bathers* by Cézanne to the Petit Palais. Special issue of *Cahiers d'Art* devoted to his drawings. First use of paper cut-outs for the cover.

1937. Decors and costumes for *L'Etrange Farandole*, Ballets Russes de Monte-Carlo, choreography by Massine to the music of Shostakovich. Matisse's work fills a room at the exhibition 'Maîtres de l'art Indépendant', at the Petit Palais during the Exposition internationale. Raymond Escholier works with Matisse on a monograph and purchases the first version of the Barnes mural.

1938. Moves to the Hotel Regina in Cimiez, a suburb of Nice. Nelson A. Rockefeller commissions a composition for an overmantel for his private apartment in New York (completed 1939).

1939. The ballet *L'Etrange Farandole* performed as *Rouge et Noir* in Paris. Four paintings by Matisse from German museums auctioned by the Nazis in Lucerne. Matisse travels to Geneva to see an exhibition of paintings from the Prado but returns to Paris the day war is declared. *La France*. Returns to Nice in October.

1940. Spring. Living at 132 Boulevard Montparnasse, Paris. Obtains a Brazilian visa but decides to remain in France. Trips to Bordeaux, Ciboure, Carcassone and Marseilles, settles again in Nice.

1941. Drawings exhibited at the Galerie Louis Carré, Paris. Serious operation in January for intestinal occlusion in Lyons. Miraculous recovery. Works from his bed in Nice on illustrations to the *Florilège des Amours de Ronsard* and Henri de Montherlant's *Pasiphaé*. Begins drawings for *Thèmes et Variations*.

1942. Illustrations for *Poèmes* by Charles d'Orléans. Exchanges paintings with Picasso.

1943. An air raid on Cimiez drives Matisse to the villa Le Rêve in Vence. Works on cutouts for *Le Cirque*, subsequently renamed *Jazz: Thèmes et variations* is published with a preface by Louis Aragon.

1944. Illustrates Baudelaire's *Les Fleurs du Mal*. Madame Matisse and Marguerite are arrested for their involvement with the French Resistance.

1945. Major postwar exhibition with Picasso at the Victoria and Albert Museum, London. Matisse follows Picasso with a retrospective at the Salon d'Automne. His work of the last four years is illustrated in 'De la couleur', *Verve, 1945*.

1946. Illustrations for *Lettres d'une réligieuse Portuguaise* and Pierre Reverdy's *Visages*. Cartoons for the tapestry *Oceania*.

1947. Tériade publishes *Jazz* to great acclaim. More paper cutouts. Aragon publishes *Apologie du Luxe* on Matisse, and starts promoting socialist realism.

1948. *Saint Dominic* painted on ceramic tiles for the Church of Notre-Dame de Toute-Grace, Assy. Begins work on the Chapelle du Rosaire for the Dominican nuns at Vence. Retrospective at the Philadelphia Museum of Art. *Florilège des Amours de Ronsard* published.

1949. Returns to the Hotel Regina, Cimiez. Recent paintings and cutouts are shown at the Pierre Matisse Gallery, New York. Retrospective in Lucerne. Recent work including the cutouts shown at the Musée National d'Art Moderne, Paris.

1950. Exhibits numerous sculptures and paper cutouts together with the Vence chapel model at the Maison de la Pensée Francaise in Paris. Grand Prix at the twenty-fifth Venice Biennale; Matisse requests that the prize be shared by the sculptor Henri Laurens. *Poèmes de Charles d'Orleans* is published.

1951. Vence Chapel consecrated in June. Retrospective at the Museum of Modern Art, New York, for which Alfred Barr publishes *Matisse: His Art and His Public*.

1952. Matisse receives a delegation from his home town: a generous donation leads to the creation of the Musée Matisse, Le Cateau-Cambrésis. *Blue Nudes, Sorrow of the King, The Swimming Pool, The Parakeet and the Mermaid, The Snail*. Finishes *Memory of Oceania* and *The Negress*.

1953. Paper cutout exhibition, Galerie Berggruen, Paris.

1954. Dies on November 3rd in Nice, and is buried at Cimiez. Various memorial exhibitions culminate with the retrospective held at the Musée National d'Art Moderne, Paris, in 1956.

SELECTED BIBLIOGRAPHY

Writings by Matisse

Jazz, Paris, Editions Tériade, 1947. Republished facsimile with English translation by Sophie Hawkes and introduction by Riva Castleman, George Braziller, Inc., New York, 1983.

Matisse, Écrits et propos sur l'art, ed. Dominique Fourcade, Collection Savoir, Hermann, Paris, 1972.

Matisse on Art, ed. Jack D. Flam, Phaidon Press, Oxford, 1973.

Principal works illustrated by Matisse

Pierre Reverdy: *Les Jockeys camouflés,* A la Belle Éditions, Paul Birault, 1918.

Stéphane Mallarmé: *Poésies de Stéphane Mallarmé,* Albert Skira, Lausanne, 1932.

James Joyce: *Ulysses,* The Limited Editions Club, New York, 1935.

Tristan Tzara: *Midis Gagnés: poèmes,* Éditions Denoël, Paris, 1939.

Louis Aragon: 'Matisse-en-France', *Dessins: Thèmes et Variations,* Martin Fabiani, Paris, 1943.

Henry de Montherlant: *Pasiphaé: Chant de Minos (Les Crétois),* Martin Fabiani, Paris, 1944 and with 90 (as opposed to 18) linocuts: Les heritiers de l'artiste, Paris, 1981.

Marianna Alcaforado: *Les Lettres Portugaises,* Tériade, Paris, 1946.

Charles Baudelaire: *Les Fleurs du mal,* Paris, 1946 and La Bibliothèque Française, 1947.

Henri Matisse: *Jazz,* Tériade, Paris, 1947.

André Rouveyre: *Repli,* Éditions du Bélier, Paris, 1947.

Pierre de Ronsard: *Florilège des Amours de Ronsard,* Albert Skira, Paris, 1948.

Charles d'Orléans: *Poemes de Charles d'Orléans,* Tériade, Paris, 1950.

André Rouveyre: *Apollinaire* 'Raisons d'être', Paris, 1952.

Georges Duthuit: *Une fête en Cimmérie,* Tériade, Paris, 1963.

John-Antoine Nau: *Poésies Antillaises,* Fernand Mourlot, Paris, 1972.

Catalogues raisonnés

Marguerite Duthuit-Matisse, Claude Duthuit: *Henri Matisse: Catalogue raisonné de l'œuvre gravé,* with the collaboration of Françoise Garnaud. Preface by Jean Guichard-Meili, Paris, 1983.

Claude Duthuit: *Henri Matisse: Catalogue raisonné des ouvrages illustrés,* with the collaboration of Françoise Garnaud. Introduction by Jean Guichard-Meili, Paris, 1988.

Museum collections and publications

Henri Matisse: Paintings and Sculptures in Soviet Museums, Introduction by A. Izerghina, Aurora Art Publishers, Leningrad, 1978.

Matisse in the Collection of the Museum of Modern Art, The Museum of Modern Art, New York, Introduction and entries by John Elderfield, 1978.

Henri Matisse. Exposition de la Donation Jean Matisse à la Bibliothèque Nationale, Françoise Woimant and Marie-Cécile Miessner, Bibliothèque Nationale, Paris, 1981.

Guide de visite du Musée Matisse, Le Cateau-Cambrésis, by Dominique Szymusiak, 1982.

Matisse dans les collections du Musée des Beaux-Arts de Lyon (in conjunction with the exhibition: *Matisse: L'Art du Livre*), Musée des Beaux Arts, Lyon, 1987.

Dessins de la donation Matisse, Musée Matisse, le Cateau-Cambrésis, by Dominique Szymusiak, 1989.

Matisse. Collections du Musée National d'Art Moderne, by Isabelle Monod-Fontaine, Éditions du Centre Georges Pompidou, Paris, 1989. Expanded and corrected edition of her *Matisse,* Centre Georges Pompidou, Paris, 1979.

Cahiers Henri Matisse, Musée Matisse, Nice, including: no. 1 *Matisse et Tahiti,* 1986, no. 2 *Matisse Photographies,* 1986, no. 3 *Matisse L'art du livre,* 1986, no. 4 *Matisse Ajaccio-Toulouse, un saison de peinture,* no. 5 *Matisse aujourd'hui* (Proceedings of colloquium held in 1987–88, unpublished), no. 6 *Henri Matisse Dessins de la collection du Musée.*

Matisse. Les plâtres originaux des bas-reliefs. Dos I, II, III, IV. Musée Matisse, Le Cateau-Cambrésis, introduction by Dominique Szymusiak, 1990.

Monographs

Albert C. Barnes and Violette de Mazia: *The Art of Henri-Matisse,* The Barnes Foundation Press, Merion, Pennsylvania, 1933 and subsequent reprintings.

Alfred H. Barr, Jr: *Matisse: His Art and His Public.* (Expanded version of 1931 MOMA catalogue), The Museum of Modern Art, New York, 1951 and subsequent reprintings.

John Russell: *The World of Matisse 1869–1954,* Time Life books, New York, 1969, *Matisse et son temps,* Time Life, Paris, 1973.

Louis Aragon: *Henri Matisse, Roman,* Paris, Gallimard, 1971, English edition translated by Jean Stewart, *Henri Matisse: A Novel,* Collins, London and New York, 1972.

Lawrence Gowing: *Matisse,* Thames and Hudson, London, 1979.

Bernard Noel: *Matisse,* Hazan, Paris, 1983.

Jean Guichard-Meili: *Les Gouaches découpées de Henri Matisse,* Fernand Hazan, Paris, 1983; published as *Matisse Paper Cutouts,* Thames and Hudson, London, 1984.

John Jacobus: *Matisse,* Thames and Hudson, London, 1984. French edition Ars Mundi, 1989.

Pierre Schneider: *Matisse,* Flammarion, Paris and Thames and Hudson, London, 1984.

Nicholas Watkins: *Matisse,* Phaidon Press, Oxford, 1984.

Jack Flam: *Matisse: the Man and His Art, 1869–1918*, Cornell University Press, Ithica, 1986.

Volkmar Essers: *Henri Matisse, Meister der Farbe/Henri Matisse Maître de la Couleur*, Verlag Benedikt + Aschen GmbH & Co/Medea Diffusion S. A. Fribourg, Switzerland, 1986, 1987.

Lydia Delectorskaya: *L'apparente facilité: Henri Matisse, Peintures de 1935–1939*, Adrien Maeght, éditeur, Paris, 1986. *Henri Matisse. With Apparent Ease*, English edition, Paris, 1988.

Margrit Hahnloser: *Matisse*, Series 'Maîtres de la gravure', Bibliothèque des Arts, Paris, 1987.

Marcelin Pleynet: *Henri Matisse Qui êtes-vous?*, La Manufacture, Lyon, 1988.

Gérard Durozoi: *Matisse*, Fernand Hazan, Paris, 1989. *Matisse, The Masterworks*, Studio Editions, London, 1989/1990.

Françoise Gilot: *Matisse and Picasso. A Friendship in Art*, Double-day, London, 1990.

Gilles Neret: *Matisse,* Nouvelles Éditions Françaises, Casterman, Paris, 1991.

Selected criticism

Jack Flam, ed. *Matisse, a retrospective*, (Selected writings and criticism, translated and chronologically presented), Hugh Lauter Levin Associates Inc., New York, 1988.

Recent academic research

Catherine C. Bock: *Henri Matisse and Neo-Impressionism, 1898–1908*, U.M.I. Research Press, Ann Arbor Michigan, 1981.

Roger Benjamin: *Matisse's "Notes of a Painter": Criticism, Theory and Context, 1891–1908*, U.M.I. Research Press, Ann Arbor, Michigan, 1987.

Recent exhibition catalogues

Henri Matisse, 1869–1954: Gravures et lithographies, Compiled by Margrit Hahnloser-Ingold and Roger Marcel Mayou. Musée d'art et d'histoire, Fribourg, 1982.

Henri Matisse, Kunsthaus, Zurich/Städtische Kunsthalle, Düsseldorf, 1982.

The Drawings of Henri Matisse. John Elderfield, with an introduction by John Golding, catalogue by Magdalena Dabrowski, *The Sculpture of Henri Matisse*, by Isabelle Monod-Fontaine, Concurrent exhibitions organised by the Arts Council of Great Britain, 1984, two catalogues/books published by Thames and Hudson, London, 1984.

Henri Matisse: The Early Years in Nice, 1916–1930, Jack Cowart, Dominique Fourcade, National Gallery of Art, Washington, D.C., 1986.

Jacqueline and Maurice Guillaud: *Matisse, le rythme et le ligne*, Monograph/catalogue of the exhibition at the École des Beaux Arts de Paris, Guillaud Editions, Paris, New York, 1987.

Henri Matisse: Matisse et l'Italie, Pierre Schneider et. al., Museo Correr, Venice, Arnoldo Mondadori Editore, Milan, 1987.

Henri Matisse: les chefs d'œuvre du Musée Matisse et les Matisse de Matisse, Musée Isetan, Tokyo, 1987.

Matisse in Morocco: The Paintings and Drawings, 1912–1913, texts by Jack Cowart, Pierre Schneider, John Elderfield, Albert Kostenevich, Laura Coyle and Beatrice Kernan, National Gallery of Art, Washington, D.C., 1990.

ILLUSTRATIONS

1. *Still Life with Books.* 1890.
 Oil on canvas, 15 × 18⅛ in. (38 × 46 cm).
 Signed "Essitam."
 Private Collection.
 Photo: Cauvin.

2. *Still Life after de Heem's Dessert.* 1893.
 Oil on canvas, 28¾ × 39⅜ in. (73 × 100 cm).
 Musée Matisse, Nice.

3. *Interior with Top Hat.* 1896.
 Oil on canvas, 31½ × 37⅜ in. (80 × 95 cm).
 Private Collection.
 Photothéque Henri Matisse.

4. *The Dinner Table.* 1897.
 Oil on canvas, 39⅜ × 51⅝ in. (100 × 131 cm).
 Private Collection.
 Photo: Artothek.

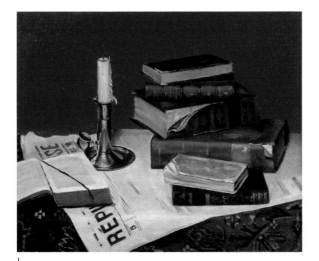

1

2

3

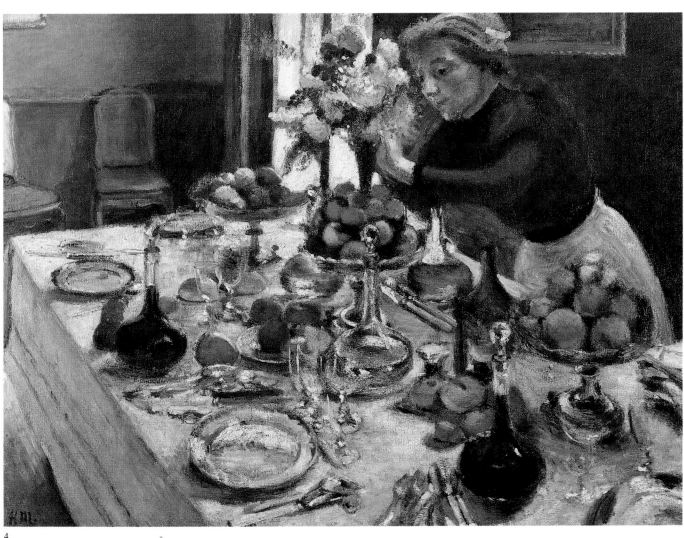

4

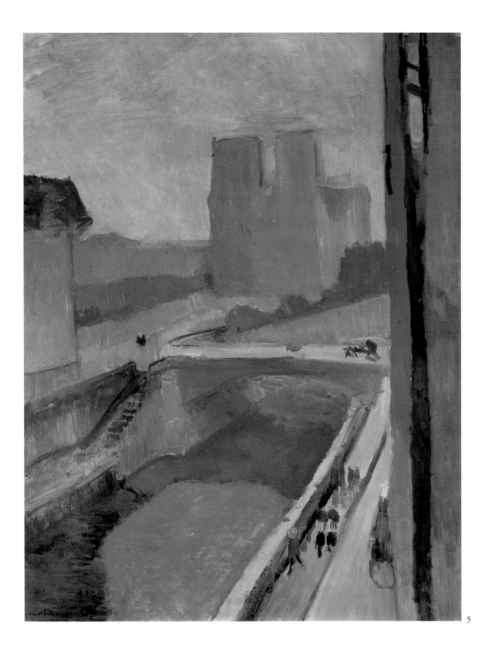

5

5. *A Glimpse of Notre Dame in the Late Afternoon*. 1902.
Oil on paper mounted on canvas, 28½ × 21½ in. (72.4 × 64.6 cm).
Albright-Knox Art Gallery, Buffalo, New York. Gift of Seymour H. Knox, 1927.

6. *The Luxembourg Gardens*. 1901–2.
Oil on canvas, 23⅜ × 32⅛ in. (59.5 × 81.5 cm).
The Hermitage, St. Petersburg. Photo: Artephot / A.P.N.

7. *Interior with a Harmonium*. 1900.
Oil on cardboard, 28¾ × 21⅞ in. (73 × 55.5 cm).
Musée Matisse, Nice.

6

8. *Male Model (The Slave)*. Paris, 1900.
Oil on canvas, 39⅛ × 28⅝ in. (99.3 × 72.7 cm).
Collection, The Museum of Modern Art, New York. Kay Sage
Tanguy and Abby Aldrich Rockefeller Funds.

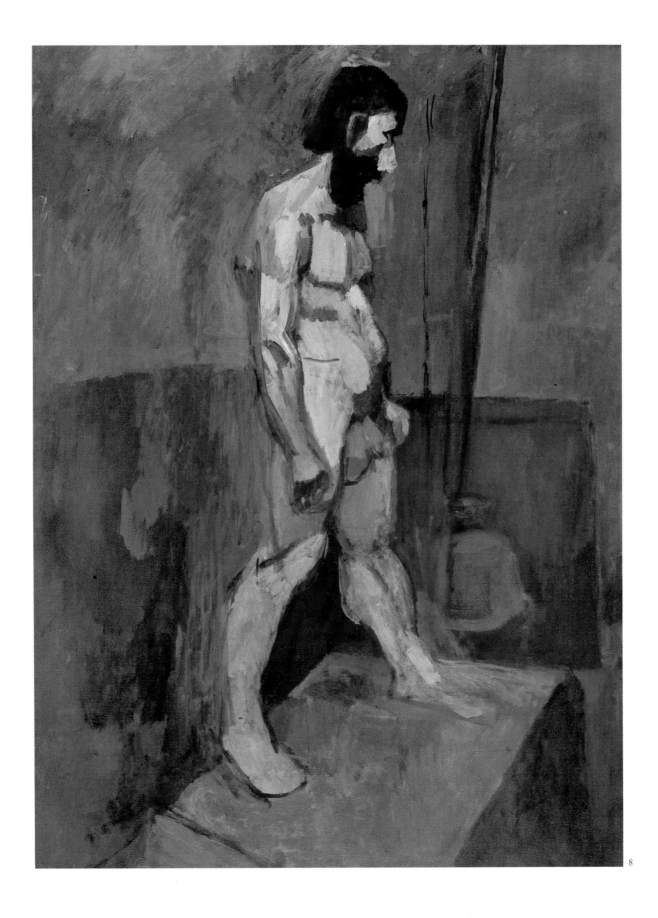

9. *Woman Weeping*. 1900–1903.
Engraving, 5⅞ × 3⅞ in. (14.9 × 9.8 cm).

10. *Carmelina*. 1903.
Oil on canvas, 32 × 23¼ in. (81.3 × 59 cm).
Museum of Fine Arts, Boston. Tompkins Collection.

9

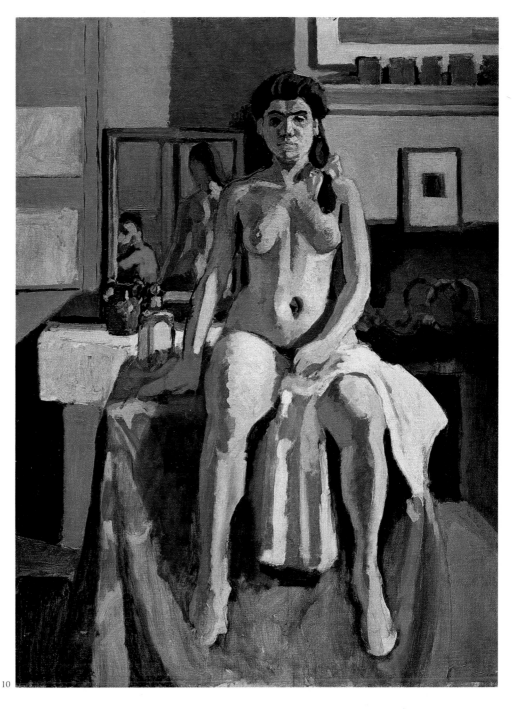

10

11. *Sideboard and Table*. 1899.
 Oil on canvas, 26⅝ × 32½ in. (67.5 × 82.5 cm).
 Private Collection, Switzerland.
 Photo: M. Plassart/Artephot.

12. *Still Life with Oranges*. 1899.
 Oil on canvas, 18⅜ × 21¾ in. (46.7 × 55.2 cm).
 Washington University Art Gallery, St. Louis, Missouri.
 Photo: Bridgeman/Artephot.

11

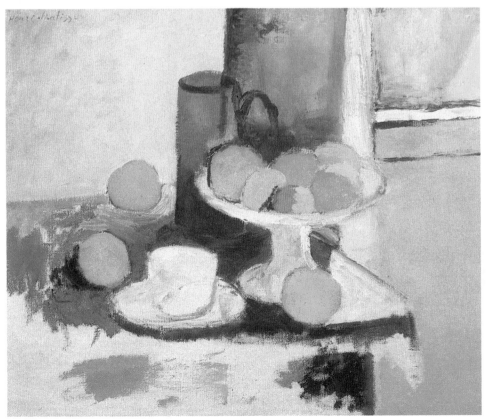

12

13. *Studio Under the Eaves*. 1903.
 Oil on canvas, 21¾ × 18⅛ in. (55.2 × 46 cm).
 The Fitzwilliam Museum, Cambridge.

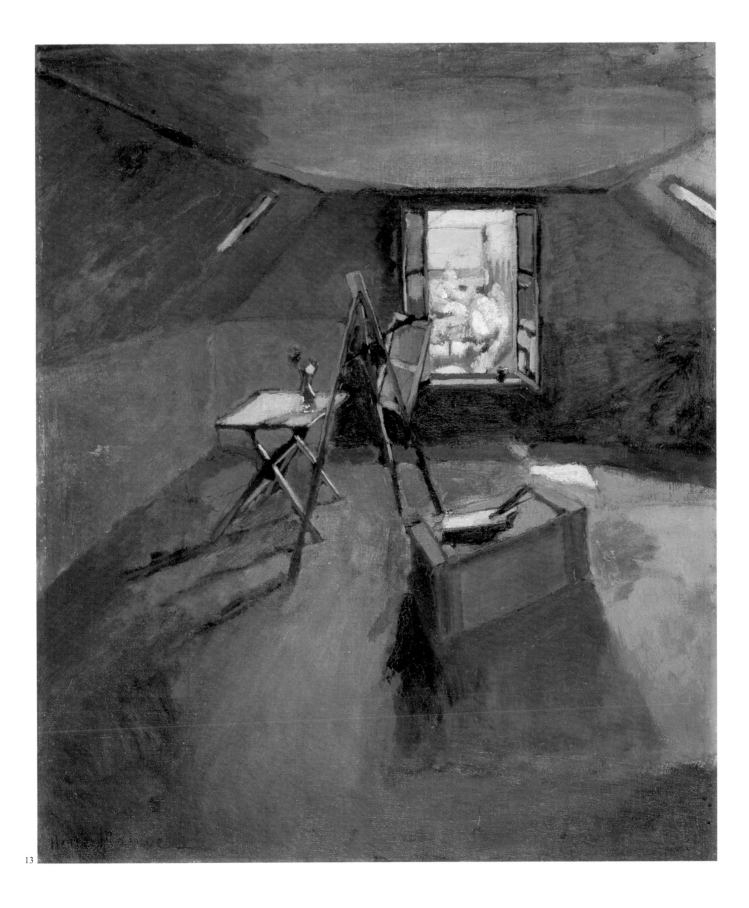

13

14

15

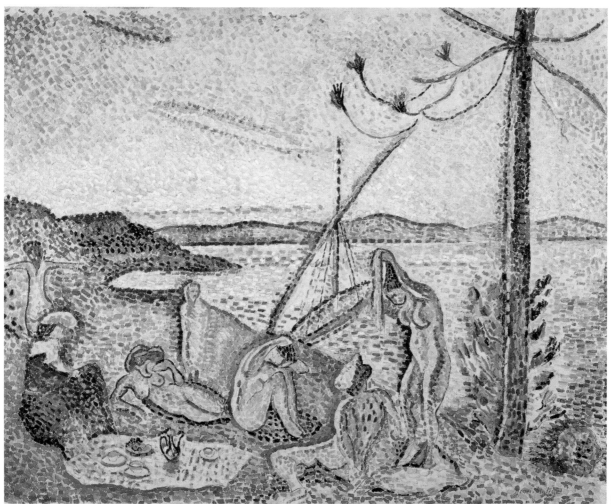

16

14. *Woman with a Parasol.* 1905.
Oil on canvas, 18⅛ × 15 in. (46 × 38 cm).
Musée Matisse, Nice.

15. *Woman Beside the Water.* Collioure, 1905.
Oil and pencil on canvas, 13⅞ × 11⅛ in. (35.2 × 28.2 cm).
Collection, The Museum of Modern Art, New York.
Purchase and partial anonymous gift.

16. *Luxe, Calme et Volupté.* 1904.
Oil on canvas, 38¾ × 46⅝ in. (98.3 × 118.5 cm).
Musée d'Orsay, Paris.
Photo: Réunion des Musées Nationaux.

17. *The Open Window, Collioure.* 1905.
Oil on canvas, 21⅝ × 18⅛ in. (55 × 46 cm).
Collection John Hay Whitney, New York.
Photothèque Henri Matisse.

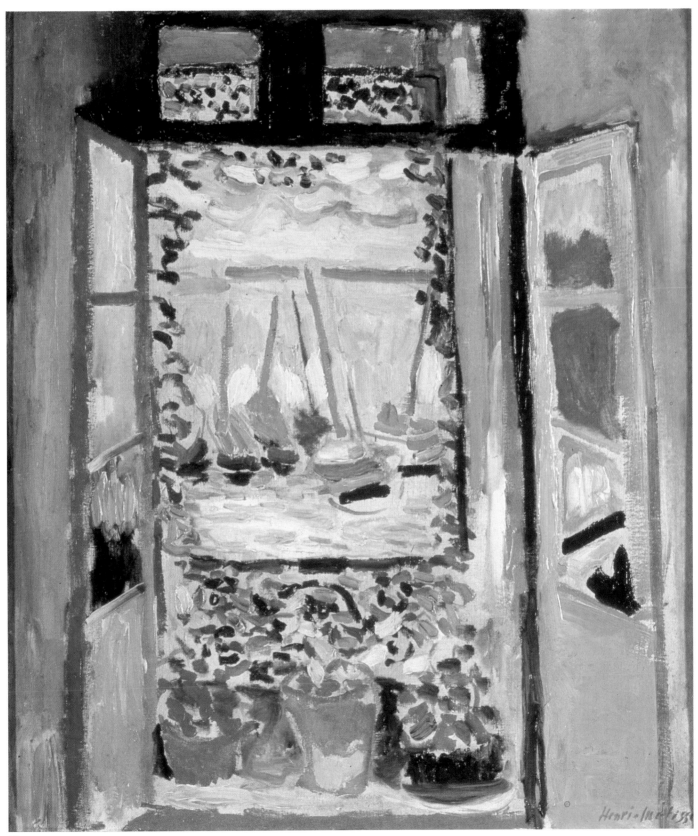

17

18

19

18. *The Terrace*. Saint Tropez, 1904.
 Oil on canvas, 28¼ × 22¾ in. (71.8 × 57.8 cm).
 Isabella Stewart Gardner Museum, Boston.

19. *View of Collioure (The Bell Tower)*. 1905.
 Oil on canvas, 13 × 16¼ in. (32.9 × 41.3 cm).
 Kate Steichen Collection.
 Photothèque Henri Matisse.

20. *Portrait of André Derain*. 1905.
 Oil on canvas, 15½ × 11⅜ in. (39.5 × 29 cm).
 Tate Gallery, London.
 Photo: John Webb.

21. *Madame Matisse: The Green Line*. 1905.
 Oil on canvas, 16¾ × 12¾ in. (42.5 × 32.5 cm).
 Statens Museum for Kunst, Copenhagen.
 Photo: Hans Petersen.

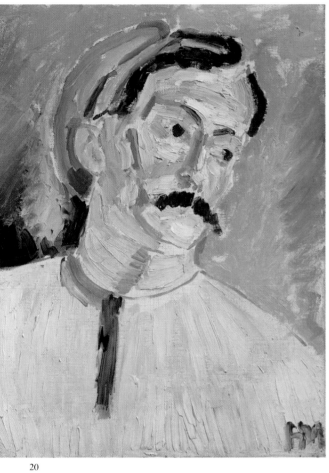

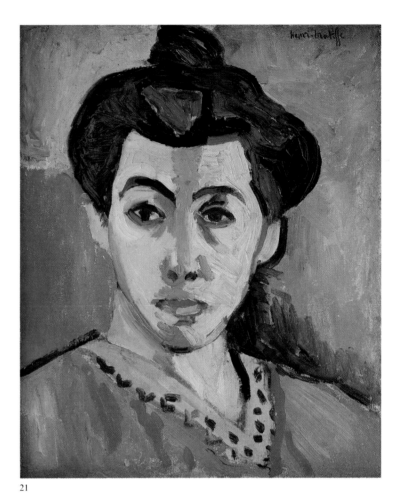

20

21

22. *Nude in Profile (Le Grand Bois).* 1906.
Woodcut, 18¾ × 15¼ in. (47.7 × 38.7 cm).
Bibliothèque d'Art et d'Archéologie, Fonds Jacques
Doucet, Paris.

23. *Jeanne Manguin.* Paris, 1905–6.
Brush and reed pen and ink on paper, 24½ × 18½ in.
(62.2 × 46.9 cm).
Collection, The Museum of Modern Art, New York. Given
anonymously.

24. *Nude in Armchair.* c. 1906.
India ink with brush, 25⅞ × 18⅜ in. (65.8 × 46.6 cm).
The Art Institute of Chicago. Gift of Mrs. Potter Palmer.

25. Henri and Amélie Matisse in Tangiers, 1912.
Photo: Succession H. Matisse / Archives Matisse.

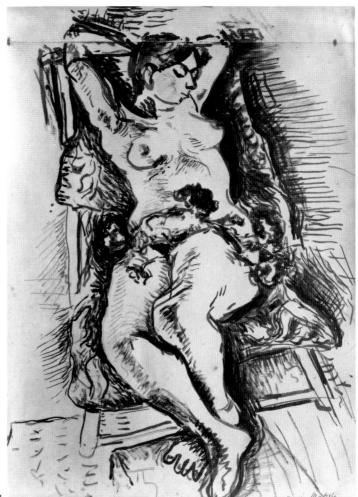

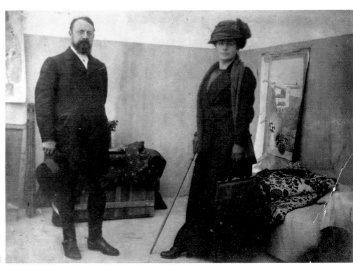

26. *Woman with a Hat*. 1905.
 Oil on canvas, 31⅞ × 25⅝ in. (81 × 65 cm).
 Private collection.
 Photo: Faillet/Artephot.

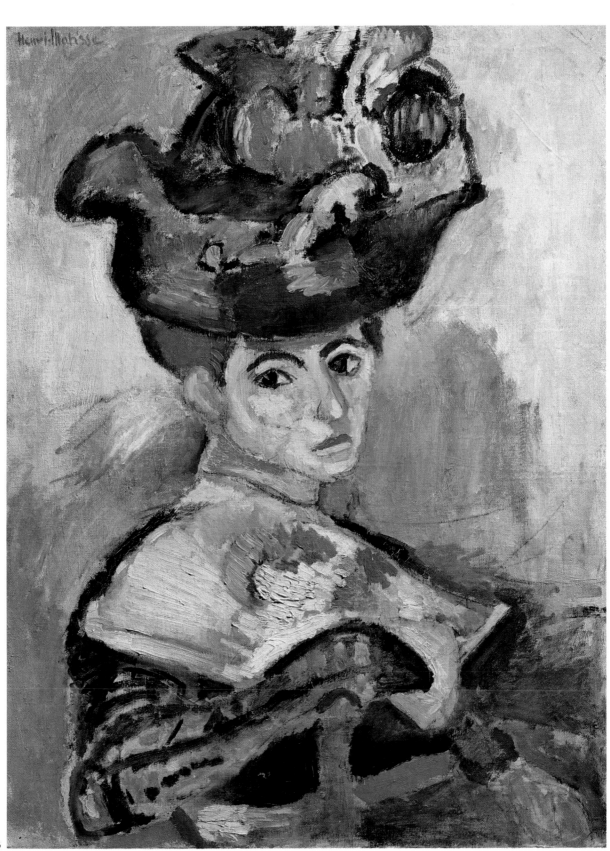

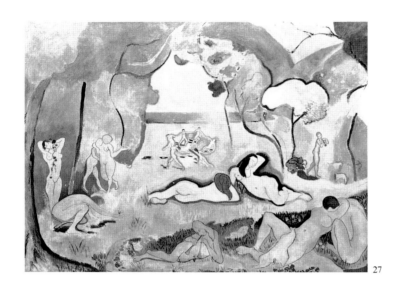

27

28

29

27. *Le Bonheur de Vivre.* 1906.
Oil on canvas, 68½ × 93¾ in. (174 × 238 cm).
The Barnes Foundation, Merion.
Photograph © 1991 by the Barnes Foundation.

28. *Seated Nude.* 1906.
Pastel and gouache on paper, 28¾ × 20⅛ in. (73 × 51 cm).
Collection Mrs. Tevis Jacobs, San Francisco.
Photo: R. Banish.

29. *La Joie de Vivre.* 1906.
Coloured crayon sketch for *Le Bonheur de vivre.*
The Hart Collection, U.S.A.

30. *Blue Nude (Souvenir de Biskra).* 1907.
Oil on canvas, 36¼ × 55¼ in. (92.1 × 140.4 cm)
The Baltimore Museum of Art. The Cone Collection, formed by
Dr. Claribel Cone and Miss Etta Cone of Baltimore, Maryland.

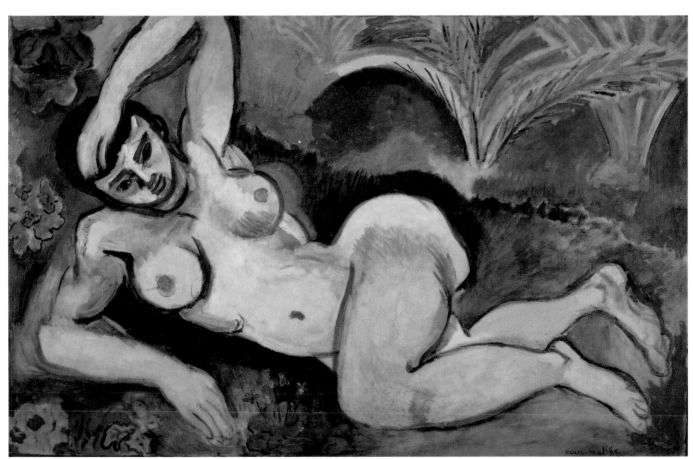

30

31. *Le Luxe I*. 1907.
Oil on canvas, 82⅝ × 54⅜ in. (210 × 138 cm).
Musée National d'Art Moderne, Centre Georges Pompidou, Paris.

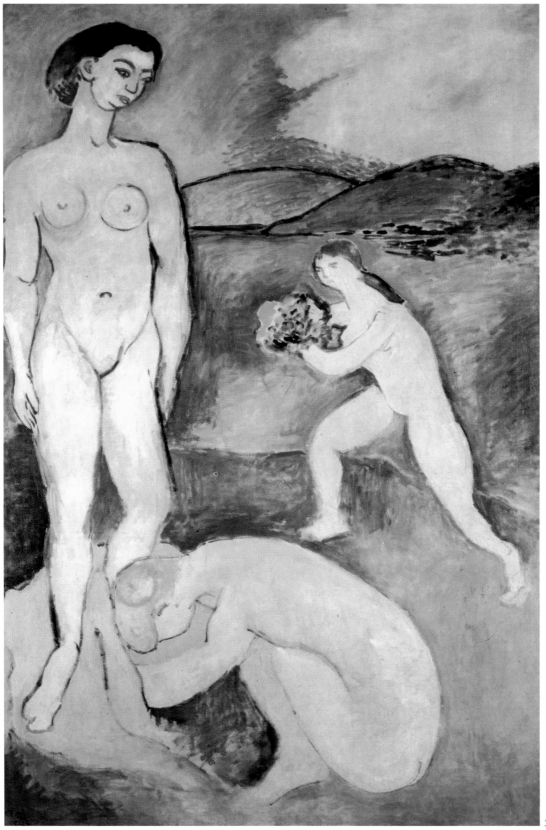

32. *Le Luxe II*. 1908.
 Casein on canvas, 82½ × 54⅜ in. (209.5 × 138 cm).
 Statens Museum for Kunst, Copenhagen.
 Photo: Hans Petersen.

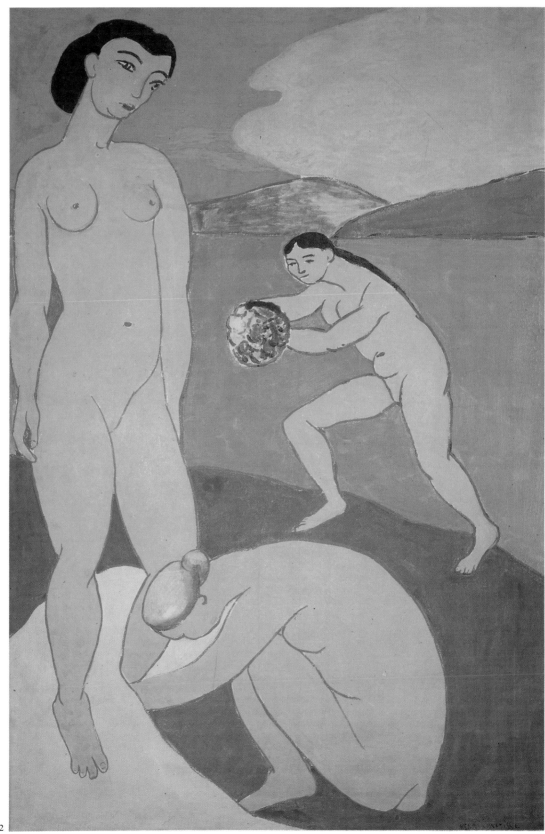

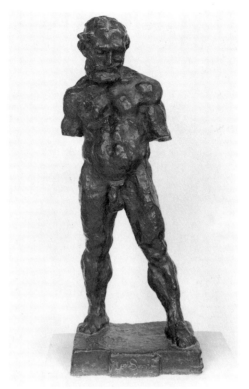

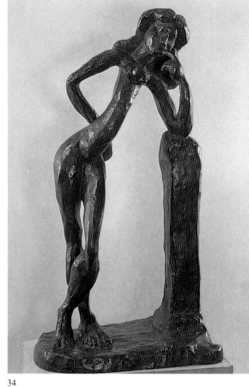

33 34

38

33. *The Slave.* 1900–1903.
Bronze 8/10, H. 36¼ in. (92 cm).
Musée Matisse, Le Cateau-Cambrésis.

34. *La Serpentine.* Issy-les-Molineaux (autumn 1909).
Bronze, 22¼ × 11 × 7½ in. (56.5 × 28 × 19 cm) including base.
Collection, The Museum of Modern Art, New York. Gift of Abby
Aldrich Rockefeller.

35. *Two Negresses.* 1908.
Bronze 6/10, H. 18½ in. (47 cm).
Musée Matisse, Nice.

36. *Female Torso (La Vie).* 1906.
Bronze, black onyx base, H. 9⅛ in. (23.2 cm); with base, 10⅝ in. (27 cm).
The Metropolitan Museum of Art, The Alfred Steiglitz Collection, 1949.

37. *The Dance.* 1907.
Wood, H. 17⅜ in. (44 cm).
Musée Matisse, Nice.
Photo: Claude Frossard.

38. *Large Nude.* 1906.
Lithograph, 11¼ × 10 in. (28.5 × 25.3 cm).
Bibliothèque Nationale, Paris.

39. *Reclining Nude I.* 1907.
Bronze, H. 13⅜ in. (34 cm).
Photothèque Henri Matisse.

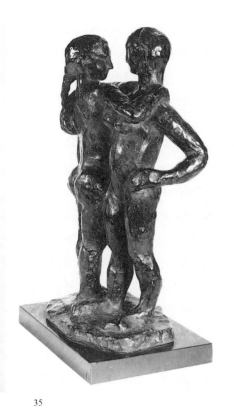

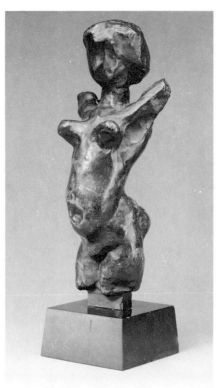

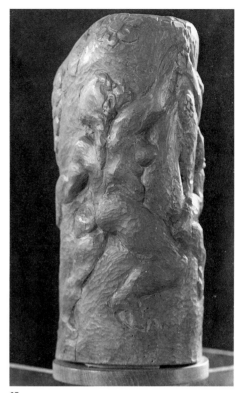

35

36

37

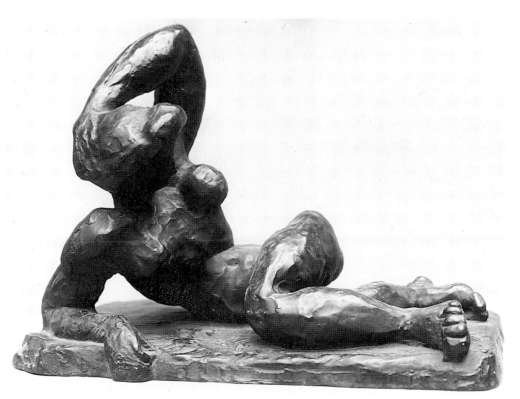

39

40. *Pink Onions*. 1906.
Oil on canvas, 18⅛ × 21⅝ in. (46 × 55 cm).
Statens Museum for Kunst, Copenhagen. J. Rump Collection.
Photo: Hans Petersen.

41. *Self-Portrait in Sailor Sweater*. 1906.
Oil on canvas, 21⅝ × 18⅛ in. (55 × 46 cm).
Statens Museum for Kunst, Copenhagen.
Photo: Hans Petersen.

42. *The Young Sailor I*. 1906.
Oil on canvas, 39 × 30½ in. (99 × 77.5 cm).
Collection Mrs. Sign Welhaven, Oslo.
Photo: Artephot.

43. *Young Sailor II*. 1907.
Oil on canvas, 39⅜ × 31⅞ in. (100 × 81 cm).
Private Collection.
Photo: Plassart/Artephot.

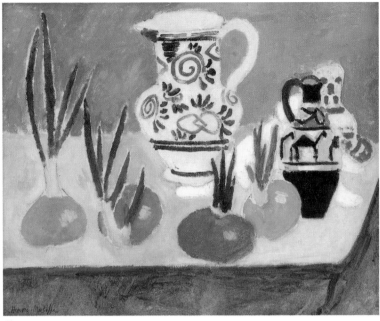

40

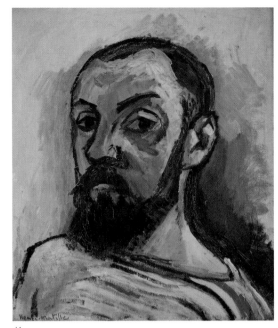

41

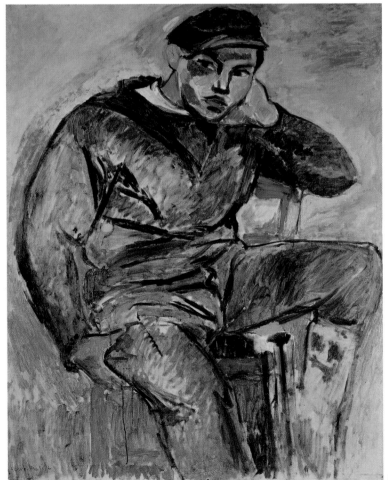

42

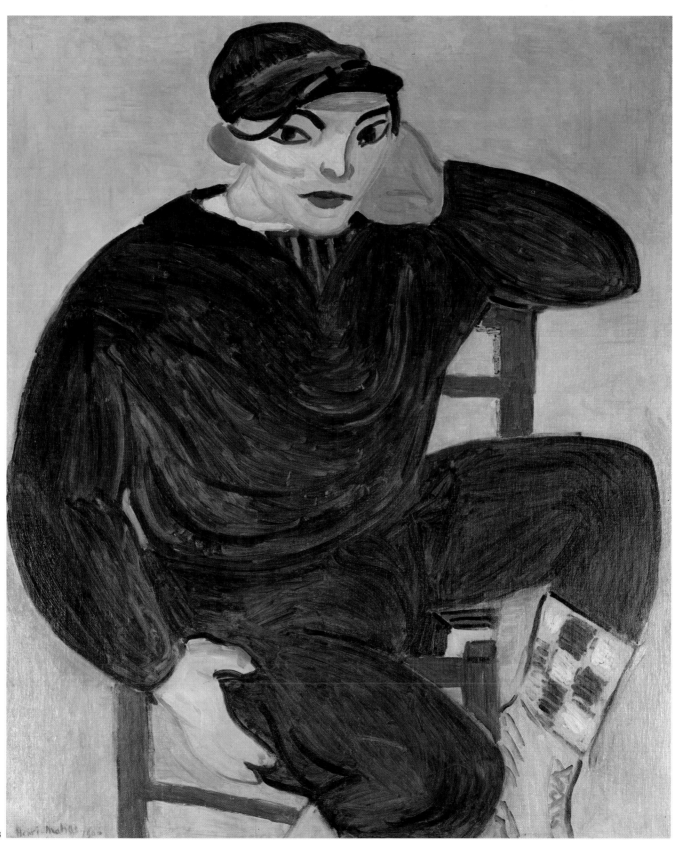

43 Henri Matisse

44. *Standing Nude*. 1907.
 Oil on canvas, 36 × 25 in. (91.4 × 63.5 cm).
 The Tate Gallery, London.

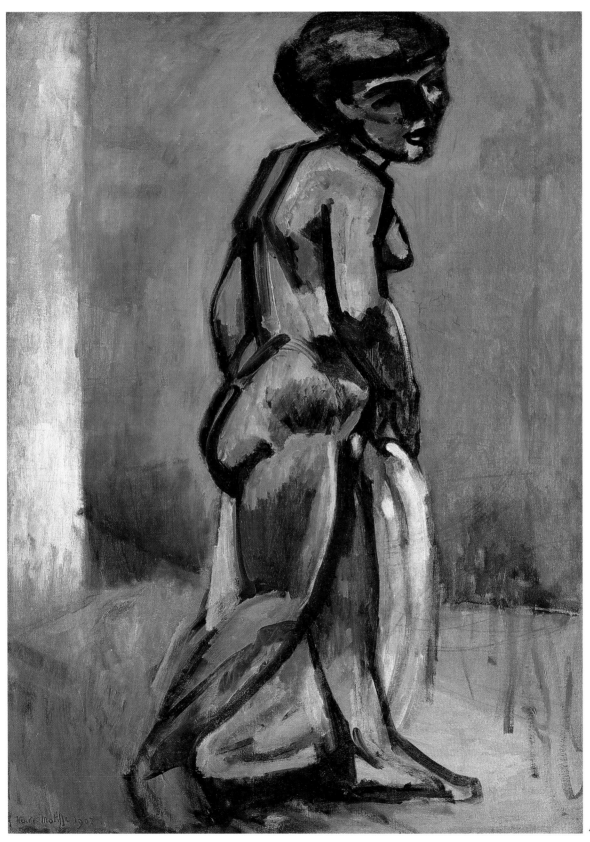

45. *The Osthaus Triptych*. 1907–8.
 Painted glazed tiles.
 Haus Hohenhof, Hagen, Westfalen.

46. *Plate with Nude Figure*. 1907.
 Ceramic, diam. 13¾ in. (35 cm).
 Private Collection.

45

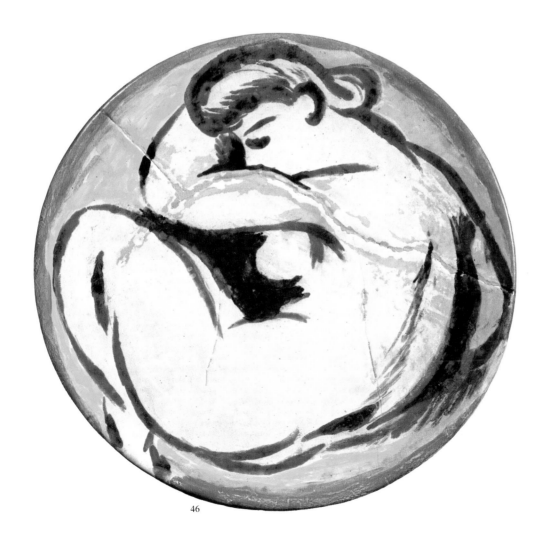

46

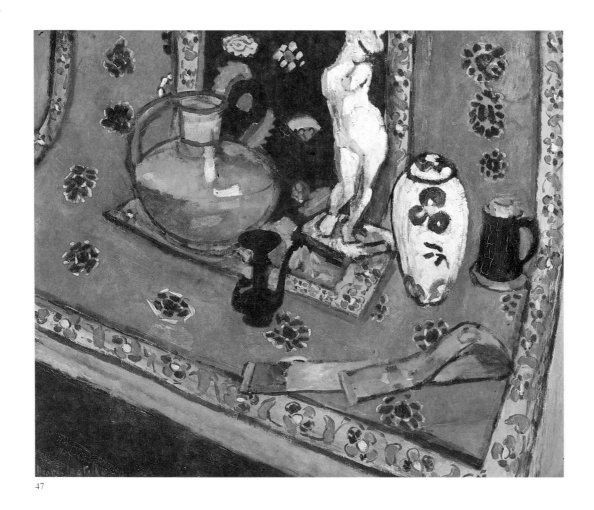

47

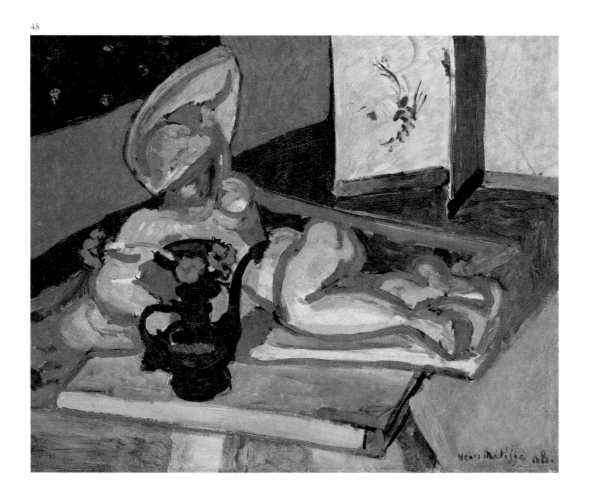

48

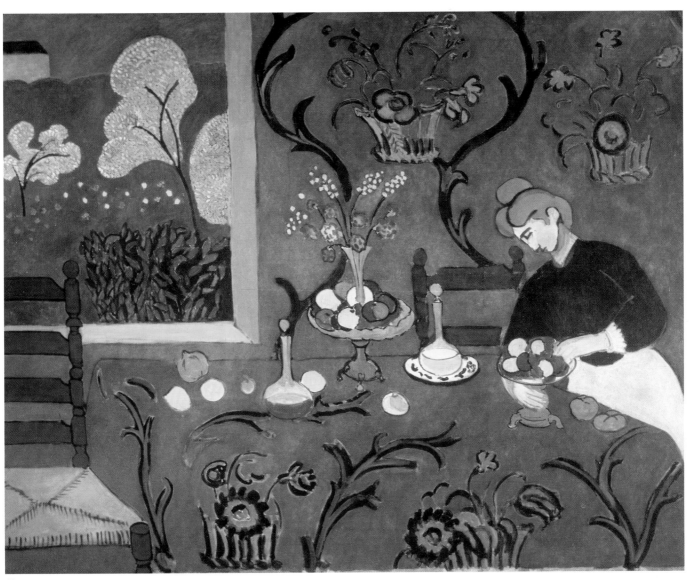

49

47. *Still Life in Venetian Red*. 1908.
Oil on canvas, 35 × 41⅜ in. (89 × 105 cm).
Pushkin Museum, Moscow.
Photothèque Henri Matisse.

48. *Sculpture and Persian Vase*. 1908.
Oil on canvas, 23⅞ × 29 in. (60.5 × 73.5 cm).
Nasjonalgalleriet, Oslo.
Photo: Jacques Lathion.

49. *Harmony in Red (La Desserte Rouge)*. 1908.
Oil on canvas, 70⅞ × 78¾ in. (180 × 200 cm).
The Hermitage, St. Petersburg.
Photothèque Henri Matisse.

50. *Nude in Black and Gold*. 1908.
 Oil on canvas, 31¾ × 20½ in. (80.5 × 52 cm).
 The Hermitage, St. Petersburg.
 Photothèque Henri Matisse.

51. *Marguerite*. 1906.
 Oil on wood, 28 × 21 in. (71.1 × 53.3 cm).
 Private Collection.

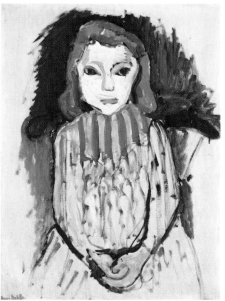

51

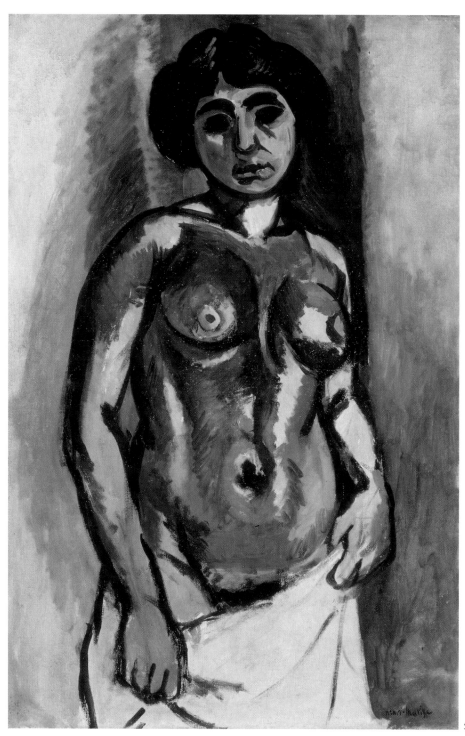

50

52. *Marguerite.* 1908.
 Oil on canvas, 25⅝ × 21¼ in. (65 × 54 cm).
 Musée Picasso, Paris.
 Photo: Réunion des Musées Nationaux.

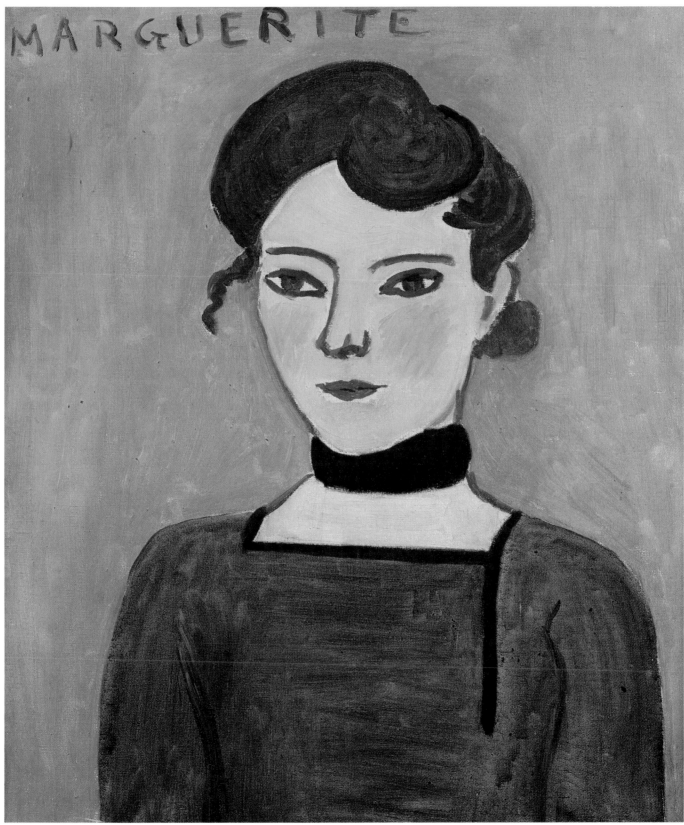

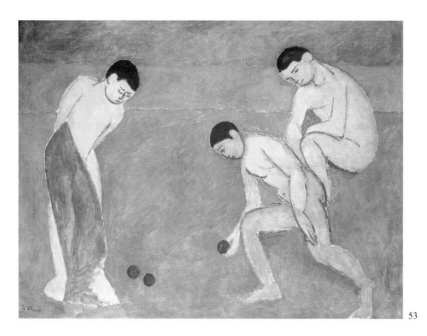

53

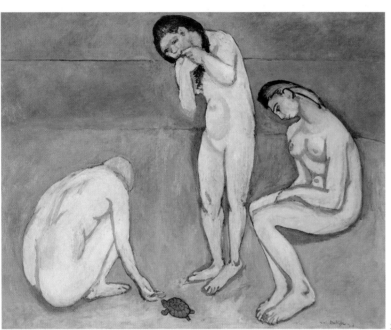

54

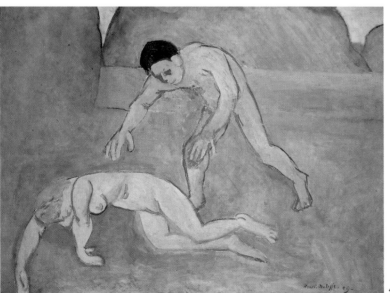

55

53. *The Game of Bowls*. 1908.
Oil on canvas, 44¾ × 57⅛ in. (113.5 × 145 cm).
The Hermitage, St. Petersburg.
Photothèque Henri Matisse.

54. *Bathers with a Turtle*. 1908.
Oil on canvas, 70½ × 86¾ in.
(179.1 × 220.3 cm).
The Saint Louis Art Museum. Gift of
Mr. and Mrs. Joseph Pulitzer, Jr.

55. *Nymph and Satyr*. 1909.
Oil on canvas, 35 × 46⅛ in. (89 × 117 cm).
The Hermitage, St. Petersburg.
Photothèque Henri Matisse.

56. *Dance I (first version)*. Paris (March 1909).
Oil on canvas, 102¼ × 153½ in.
(259.7 × 390.1 cm).
Collection, The Museum of Modern Art,
New York. Gift of Nelson A. Rockefeller in
honor of Alfred H. Barr, Jr.

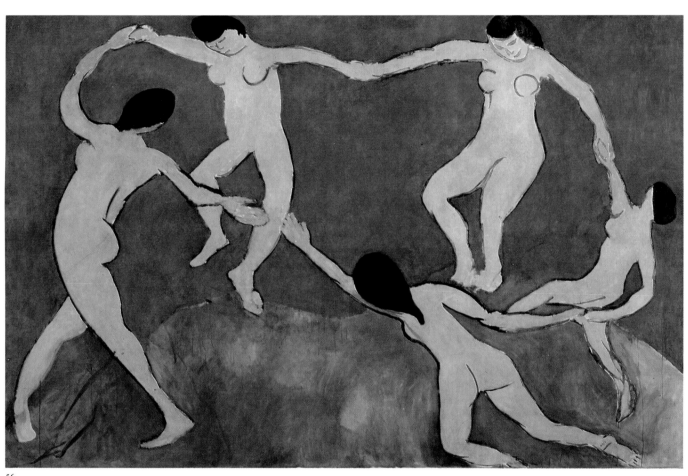

56

57. *Music*. 1910.
Oil on canvas, 102⅜ × 153⅛ in. (260 × 389 cm).
The Hermitage, St. Petersburg.
Photothèque Henri Matisse.

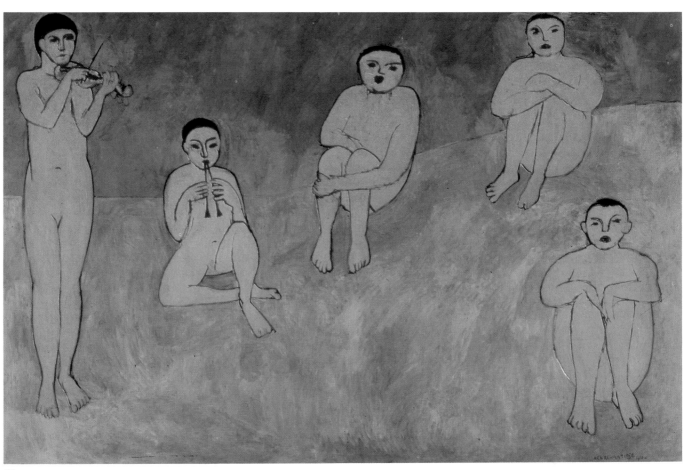

58. *Dance II*. 1910.
Oil on canvas, 102⅜ × 154 in. (260 × 391 cm).
The Hermitage, St. Petersburg.
Photo: Plassart/Artephot.

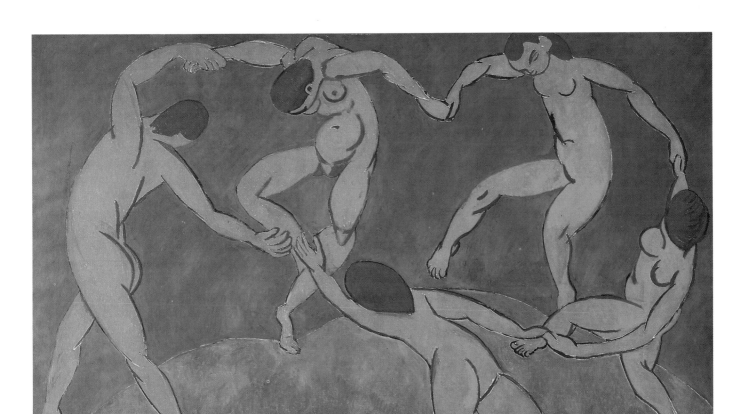

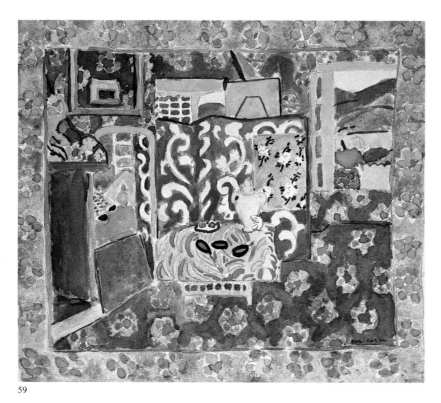

59

59. *Still Life with Aubergines.* 1911.
Watercolour on paper,
8⅜ × 9⅛ in. (21.4 × 23.2 cm).
Private Collection.

60. *Still Life with Aubergines.* 1911.
Tempera and mixed media on canvas,
82⅝ × 96½ in. (210 × 245 cm).
Musée de Peinture et de Sculpture, Grenoble.
Photo: Artephot / Photopress.

61. *Still Life with Geraniums.* 1910.
Oil on canvas, 37¼ × 45⅝ in. (94.5 × 116 cm).
Neue Pinakothek, Munich.
Photo: Blauel-Artothek.

62. *The Red Studio.* Issy-les-Moulineaux (1911).
Oil on canvas, 71¼ × 86¼ in. (181 × 219 cm).
Collection, The Museum of Modern Art,
New York. Mrs. Simon Guggenheim Fund.

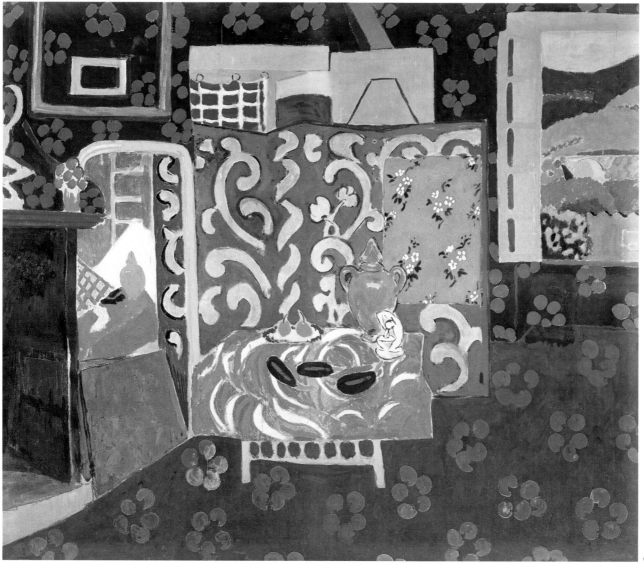

60

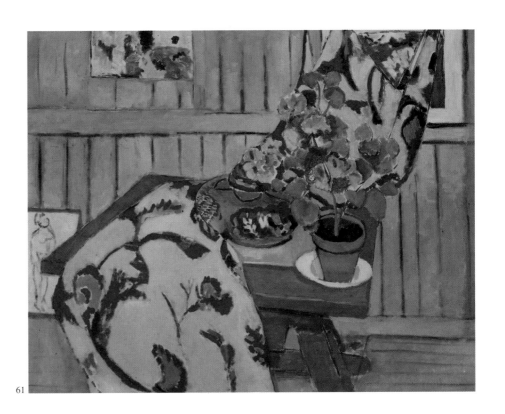

61

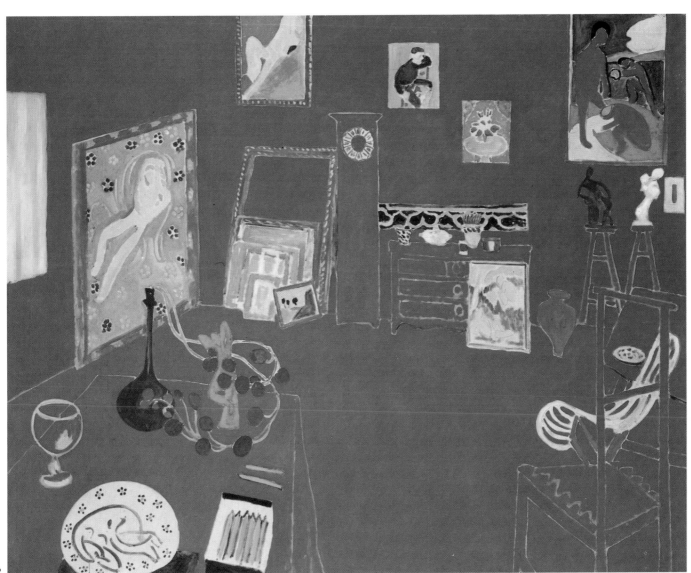

62

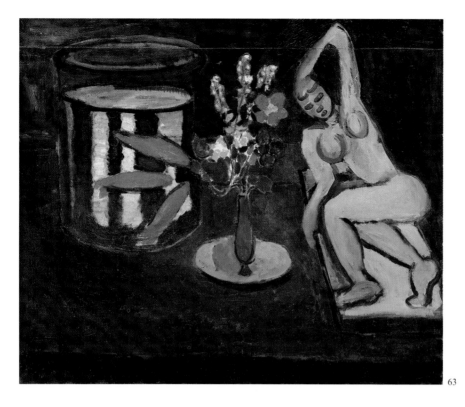

63

64

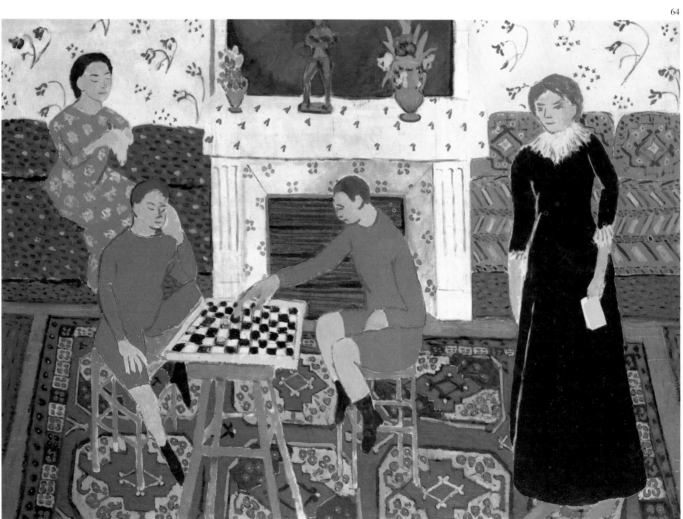

63. *Goldfish*. 1912.
 Oil on canvas, 32¼ × 36⅞ in. (82 × 93.5 cm).
 Statens Museum for Kunst, Copenhagen.
 Photo: Hans Petersen.

64. *The Painter's Family*. 1911.
 Oil on canvas, 56¼ × 76⅞ in. (143 × 194 cm).
 The Hermitage, St. Petersburg.
 Photothèque Henri Matisse.

65. *Portrait of Madame Matisse*. 1913.
 Oil on canvas, 57⅛ × 38¼ in. (145 × 97 cm).
 The Hermitage, St. Petersburg.
 Photothèque Henri Matisse.

66. *The Conversation*. 1911.
 Oil on canvas, 69¾ × 85⅓ in. (177 × 217 cm).
 The Hermitage, St. Petersburg.
 Photothèque Henri Matisse.

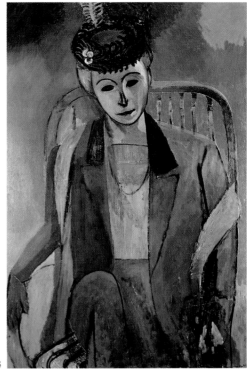

65

66

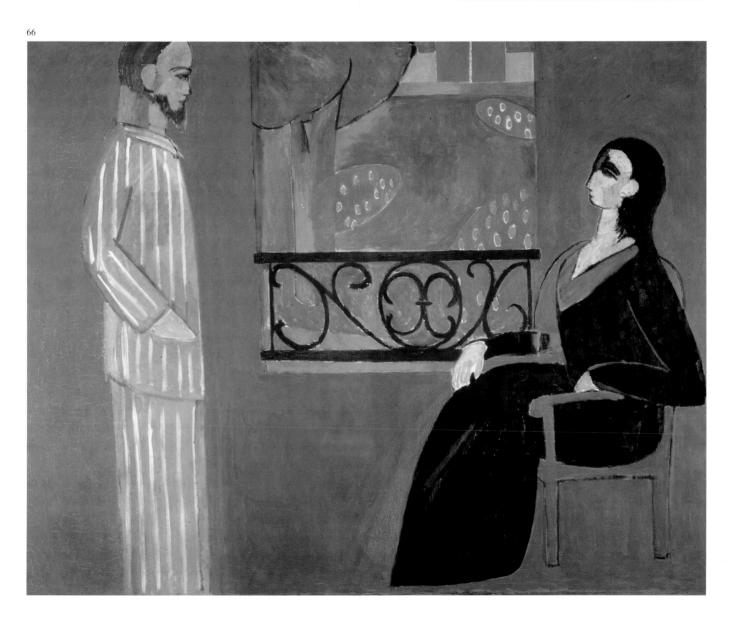

67. *Window at Tangier*. 1912.
 Oil on canvas, 45⅝ × 31½ in. (116 × 80 cm).
 The Pushkin Museum, Moscow.
 Photo: D.R.

68. *Zorah on the Terrace*. 1913.
 Oil on canvas, 45⅝ × 39⅜ in. (116 × 100 cm).
 The Pushkin Museum, Moscow.
 Photothèque Henri Matisse.

69. *The Casbah Gate*. 1912.
 Oil on canvas, 45⅝ × 31½ in. (116 × 80 cm).
 The Pushkin Museum, Moscow.
 Photothèque Henri Matisse.

70. *Arab Cafe*. 1913.
 Oil and mixed media on canvas, 69¼ × 82⅝ in. (176 × 210 cm).
 The Hermitage, St. Petersburg.
 Photothèque Henri Matisse.

71. *The Riffian (Half-length)*. 1913.
 Oil on canvas, 57⅛ × 38 in. (145 × 96.5 cm).
 The Hermitage, St. Petersburg.
 Photothèque Henri Matisse.

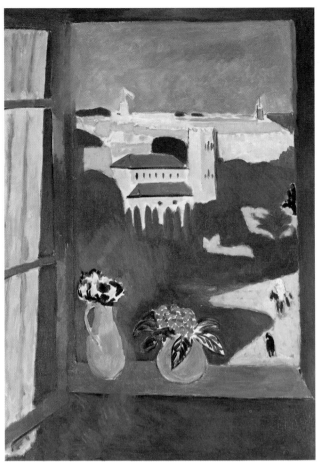

67

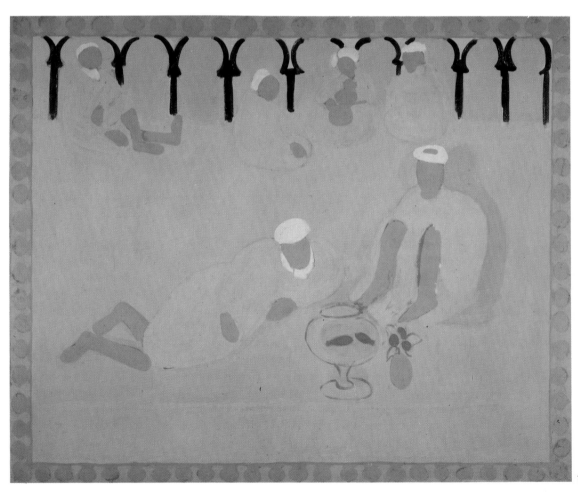

70

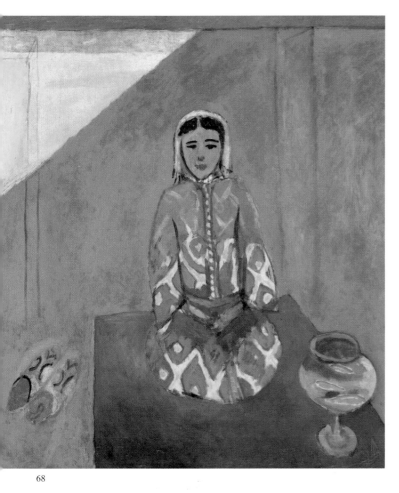

68

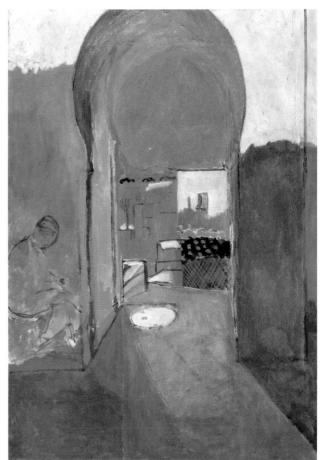

69

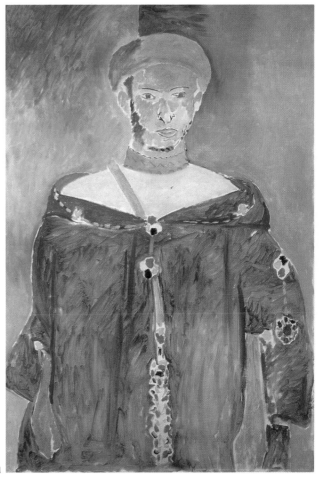

71

72. *Nude with a Ring*. 1914.
Monotype.
Bibliothèque Nationale, Paris.

73. *Nude (back view)*. 1916.
Monotype, 7¾ × 5⅞ in. (19.8 × 14.8 cm).
Bibliothèque d'Art et d'Archéologie, Fonds Jacques
Doucet, Paris.

74. *Seated Nude with Bracelet II*. 1914.
Monotype, 7 × 4¾ in. (17.9 × 12.2 cm).
Bibliothèque Nationale, Paris. Donation Jean Matisse.

75. *Portrait of Mlle. Yvonne Landsberg*. 1914.
Oil on canvas, 57⅝ × 37⅝ in. (146.5 × 95.5 cm).
Philadelphia Museum of Art. Louise and Walter Arensberg
Collection.

72

73

74

75

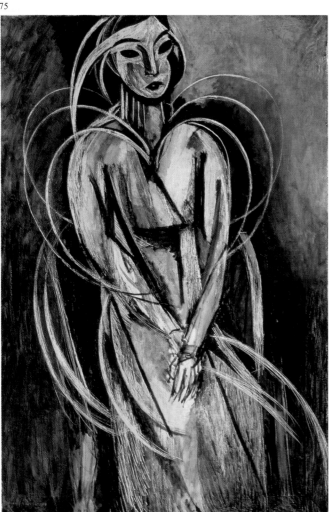

76

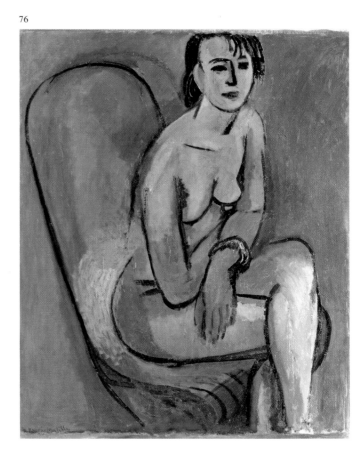

76. *Grey Nude with Bracelet*. 1913.
 Oil on canvas, 29½ × 24 in. (75 × 61 cm).
 Private Collection on loan to Kunsthaus Zürich.

77. *Still Life with Oranges*. 1913.
 Oil on canvas, 37 × 32⅝ in. (94 × 83 cm).
 Musée Picasso, Paris.
 Photo: Réunion des Musées Nationaux.

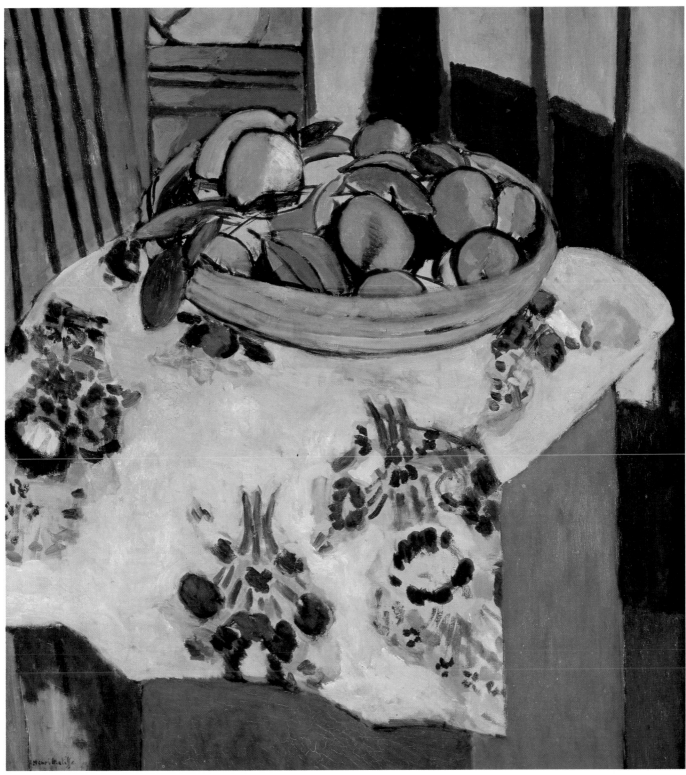

H. Matisse

78. *View of Notre-Dame*. Paris, spring 1914.
Oil on canvas, 58 × 37⅛ in. (147.3 × 94.3 cm).
Collection, The Museum of Modern Art, New York.
Acquired through the Lillie P. Bliss Bequest, and the Henry
Ittleson, A. Conger Goodyear, Mr. and Mrs. Robert
Sinclair Funds, and the Anna Erickson Levene Bequest
given in memory of her husband, Dr. Phoebus Aaron
Theodor Levene.

79. *The Open Window, Collioure*. 1914.
Oil on canvas, 45⅞ × 34⅝ in. (116.5 × 88 cm).
Musée National d'Art Moderne, Centre Georges
Pompidou, Paris.

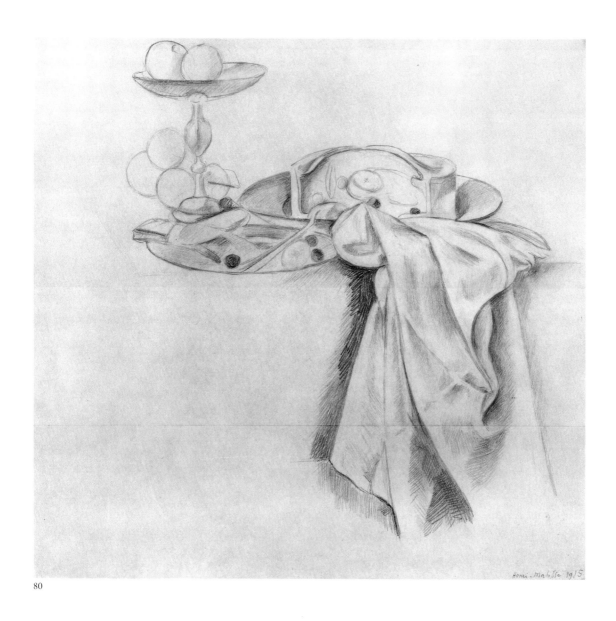

80

81

82

80. *Study for Still Life after de Heem*. 1915.
Pencil on paper, 20⅝ × 21¾ in. (52.3 × 55.2 cm).
Philadelphia Museum of Art. Louise and Walter Arensberg
Collection.

81. *Still Life with Oriental Tile*. Autumn 1915.
Pencil, 29⅛ × 21¼ in. (74 × 54 cm).
Private Collection.

82. *Vase with Geraniums*. 1915–16.
Black crayon on paper, 24¾ × 18⅞ in. (63 × 48 cm).
Musée Matisse, Nice.

83. *The Yellow Curtain*. 1914–15.
Oil on canvas, 59 × 38⅝ in. (150 × 98 cm).
Collection Stephen Hahn, New York.

83

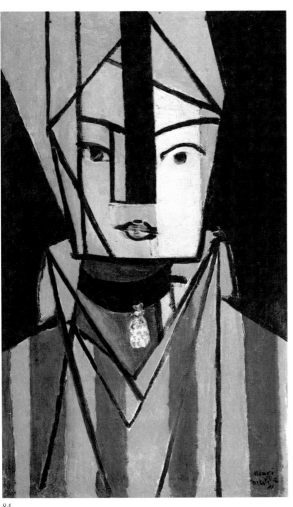

84. *Head, White and Rose*. 1914.
Oil on canvas, 29½ × 18½ in. (75 × 47 cm).
Musée National d'Art Moderne, Centre Georges Pompidou, Paris.

85. *The Moroccans*. Issy-les-Moulineaux (November 1915 and summer 1916).
Oil on canvas, 71⅜ × 110 in. (181.3 × 279.4 cm).
Collection, The Museum of Modern Art, New York. Gift of Mr. and Mrs. Samuel A. Marx.

86. *The Piano Lesson*. Issy-les-Moulineaux (late summer 1916).
Oil on canvas, 96½ × 83¾ in. (245.1 × 212.7 cm).
Collection, The Museum of Modern Art, New York. Mrs. Simon Guggenheim Fund.

87. *Bathers by a Stream*. 1916.
Oil on canvas, 102¼ × 153½ in. (259.7 × 389.9 cm).
The Art Institute of Chicago. Charles and Mary F.S. Worcester Collection.

84

85

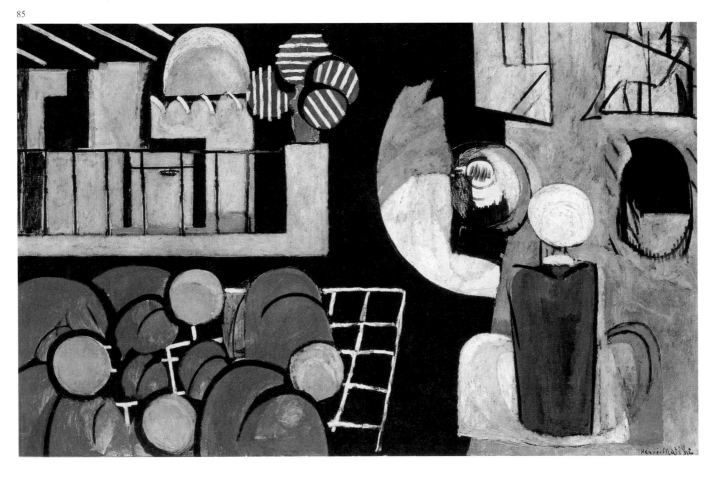

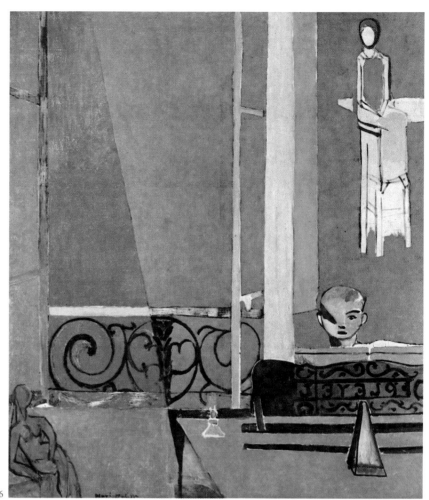

86

87

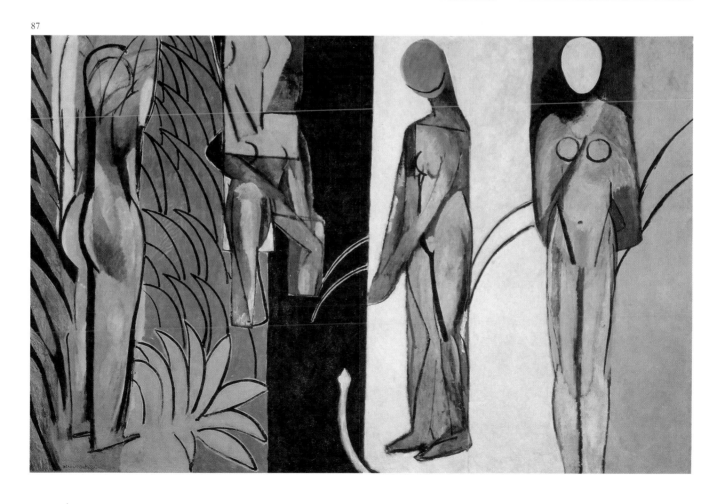

88. *Woman in a Turban (Laurette)*. 1917.
 Oil on canvas, 32 × 25¾ in. (81.3 × 65.4 cm).
 The Baltimore Museum of Art. The Cone Collection,
 formed by Dr. Claribel Cone and Miss Etta Cone of
 Baltimore, Maryland.

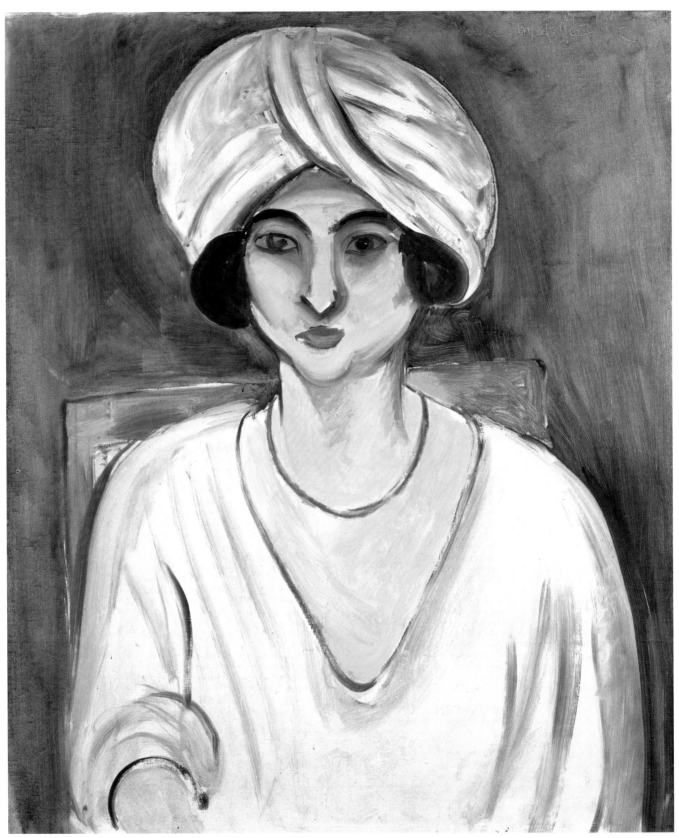

89. *Head of Laurette with Coffee Cup*. 1917.
Oil on canvas, 36¼ × 28¾ in. (92 × 73 cm).
Solothurn Kunstmuseum, Dubi-Muller collection.
Photo: Artothek.

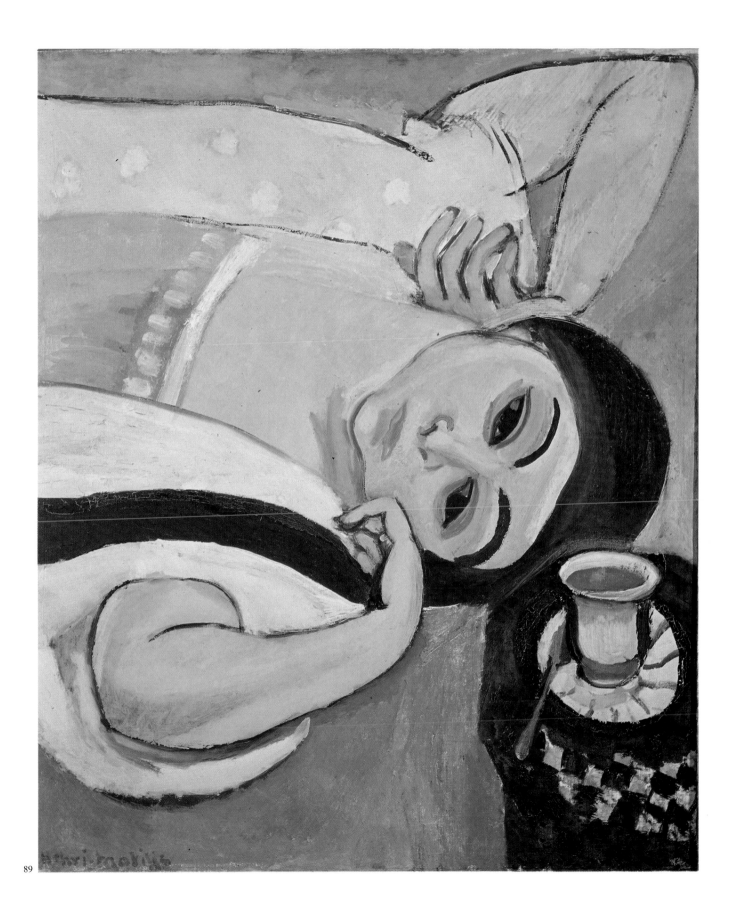

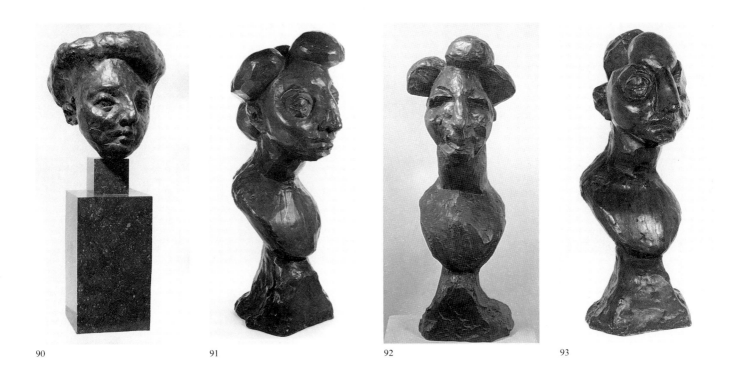

90 91 92 93

95

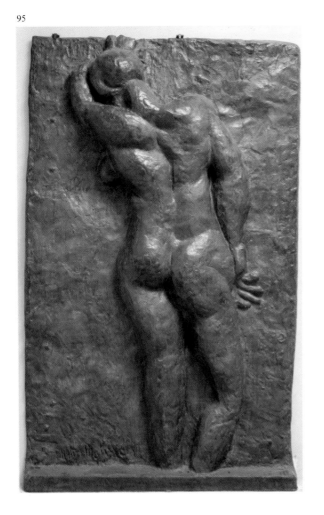

96

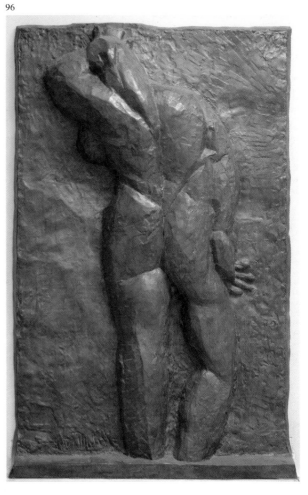

90. *Jeannette II*. 1910–13.
 Bronze, H. 10½ in. (26.5 cm).
 Photothèque Henri Matisse.

91. *Jeannette III*. 1910–13.
 Bronze, H. 23⅝ in. (60 cm). Musée Matisse, Nice.
 Photothèque Henri Matisse.

92. *Jeannette IV* (Jeanne Vaderin, 4th State).
 Issy-les-Moulineaux (1913).
 Bronze, 24⅛ × 10¾ × 11¼ in. (61.3 × 27.4 × 28.7 cm).
 Collection, The Museum of Modern Art, New York.
 Acquired through the Lillie P. Bliss Bequest.

93. *Jeannette V*. 1910–13.
 Bronze 6/10, H. 22⅞ in. (58 cm). Musée Matisse, Nice.

94. *Back I*. 1908–9.
 Relief, original plaster, 78¾ × 48⅞ in. (200 × 124 cm).
 Musée Matisse, Le Cateau-Cambrésis.

95. *Back I*. 1908–9.
 Bronze relief, 74⅞ × 46 in. (190 × 116.9 cm).
 Musée National d'Art Moderne, Centre Georges Pompidou, Paris.
 Photo: Artephot/Roland.

96. *Back II*. 1913.
 Bronze relief, 73¼ × 45½ in. (186 × 115.5 cm).
 Musée National d'Art Moderne, Centre Georges Pompidou, Paris.
 Photo: Artephot/Roland.

97. *Back III*. 1916–17.
 Bronze relief, 74 × 44½ in. (188 × 113 cm).
 Musée National d'Art Moderne, Centre Georges Pompidou, Paris.
 Photo: Artephot/Roland.

98. *Back IV*. 1930–31.
 Bronze relief, 74½ × 44½ in. (189.4 × 113.1 cm).
 Musée National d'Art Moderne, Centre Georges Pompidou, Paris.

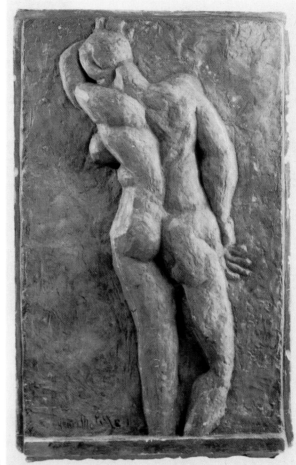

94

97

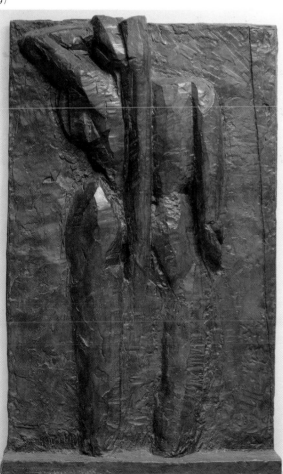

98

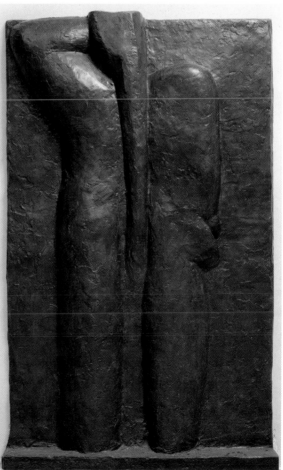

99. *Path in the Woods at Clamart*. 1917.
Oil on canvas, 35⅞ × 29⅛ in. (91 × 74 cm).
Private Collection.
Photothèque Henri Matisse.

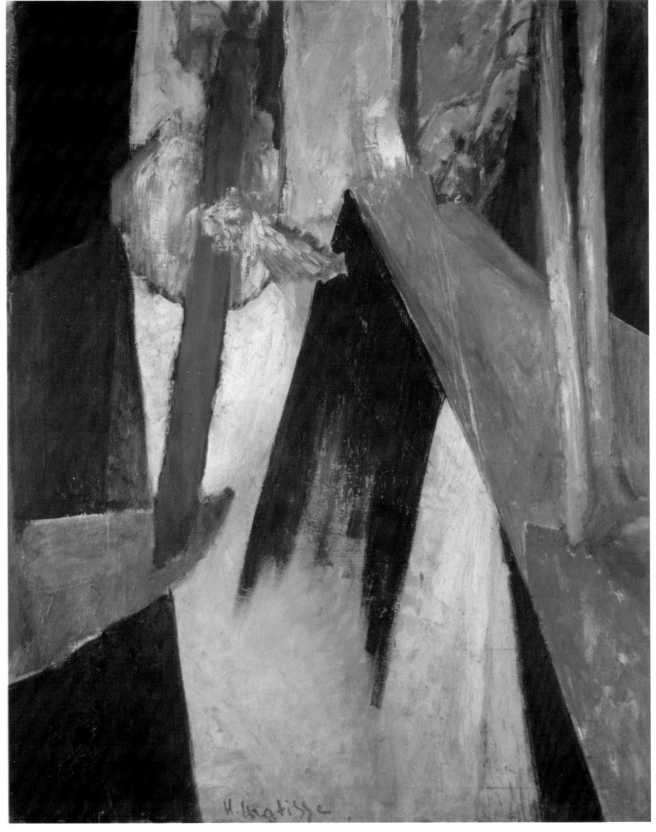

100. *Interior with a Violin.* 1917–18.
 Oil on canvas, 45⅝ × 35 in. (116 × 89 cm).
 Statens Museum for Kunst, Copenhagen.
 Photo: Hans Petersen.

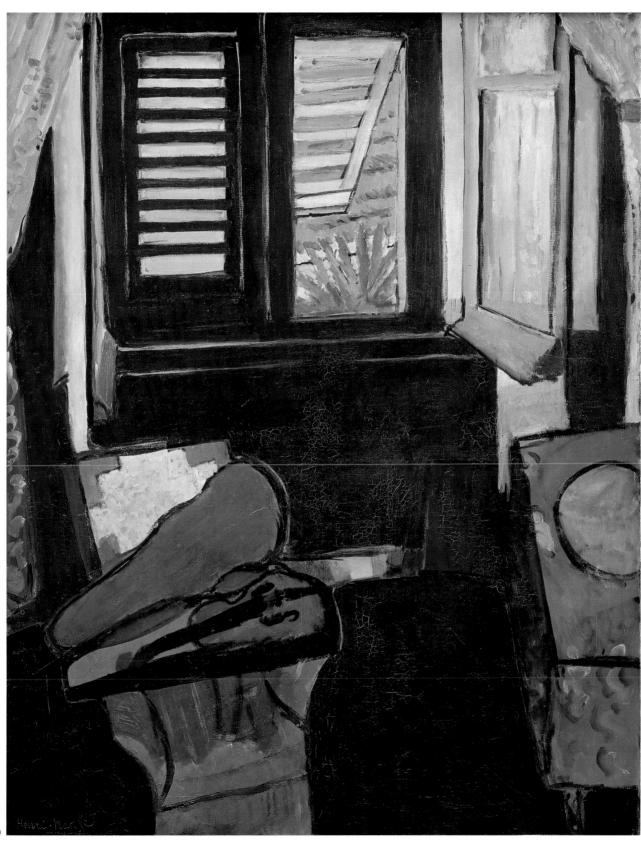

101. *Two Rays, Etretat*. 1920.
Oil on canvas, 36 × 28¼ in. (91.4 × 71.7 cm).
Norton Gallery and School of Art, West Palm Beach,
Florida.

102. *Woman with an Aquarium*. 1921.
Oil on canvas, 31¾ × 39⅜ in. (80.7 × 100 cm).
The Art Institute of Chicago. Helen Birch Bartlett
Memorial Collection.

103. Costume for *Le Chant du Rossignol*. 1920.
Appliqué work.
Insel Hombroich Museum, Neuss.

104. *Antoinette with Plumed Hat*. 1919.
Pen and black ink, 10⅝ × 14⅜ in. (26.9 × 36.5 cm).
The Art Institute of Chicago. Gift of the Arts Club of
Chicago.

101

102

103

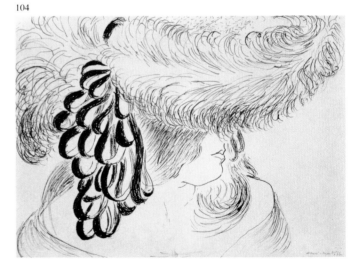

104

105. *White Plumes*. 1919.
Oil on canvas, 28¾ × 23¾ in. (73 × 60.3 cm).
The Minneapolis Institute of Arts.

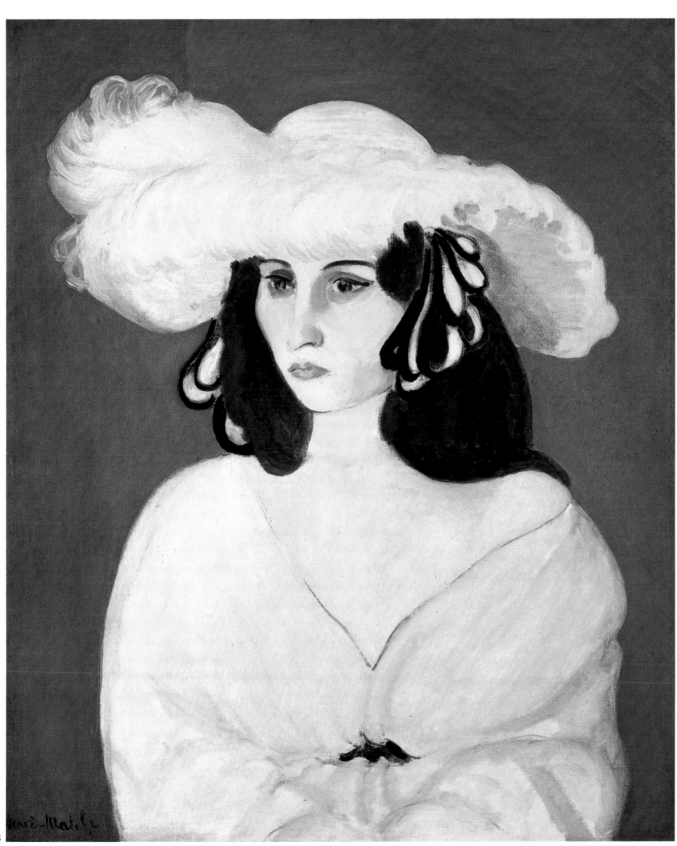

106. *Odalisque with Raised Arms.* 1923.
Oil on canvas, 25⅝ × 19¾ in. (65 × 50 cm).
National Gallery of Art, Washington, D.C. Chester Dale
Collection.

107. *Odalisque (The White Slave).* 1921–22.
Oil on canvas, 32¼ × 21¼ in. (82 × 54 cm).
Musée de l'Orangerie. Jean Walter and Paul Guillaume
Collection.
Réunion des Musées Nationaux.

108. *The Hindu Pose.* 1923.
Oil on canvas, 28½ × 23⅜ in. (72.3 × 59.3 cm).
Private Collection, New York.
Photothèque Henri Matisse.

109. *Young Hindu Girl.* 1929.
Lithograph, 11¼ × 14⅛ in. (28.5 × 35.8 cm).
Bibliothèque Nationale, Paris.

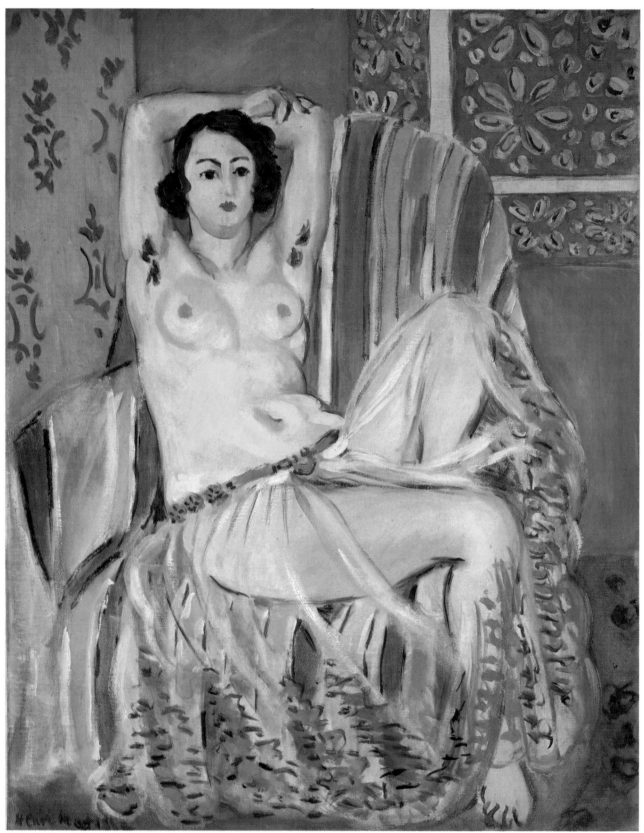

106

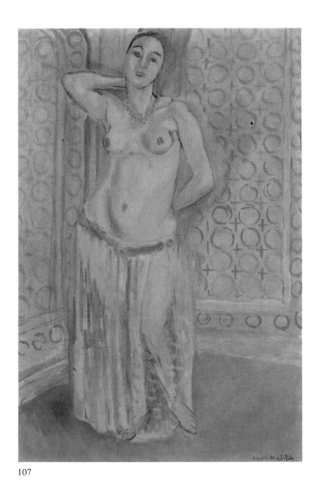

107

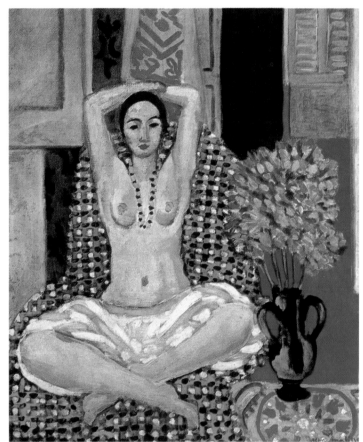

108

109

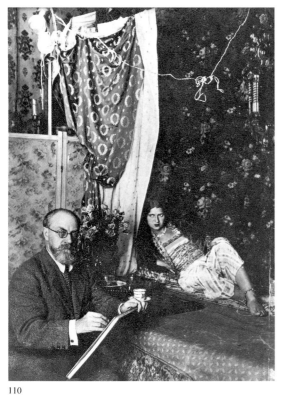

110

111

112

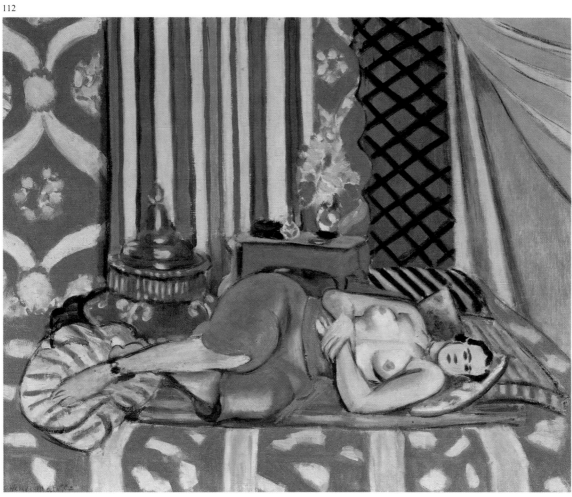

110. Matisse drawing from a model in his apartment on Place
 Charles Félix, Nice, c. 1928.
 Photograph courtesy, The Museum of Modern Art,
 New York.

111. *Head, the Buddha*. 1939.
 Charcoal on paper, 23⅝ × 15¾ in. (60 × 40 cm).
 Musée Matisse, Nice.

112. *Odalisque with Grey Trousers*. 1921.
 Oil on canvas, 21¼ × 25⅝ in. (54 × 65 cm).
 Musée de l'Orangerie. Jean Walter and Paul Guillaume Collection.
 Réunion des Musées Nationaux.

113. *Odalisque with Red Trousers*. 1921.
 Oil on canvas, 25⅝ × 35½ in. (65 × 90 cm).
 Musée National d'Art Moderne, Centre Georges
 Pompidou, Paris.

113

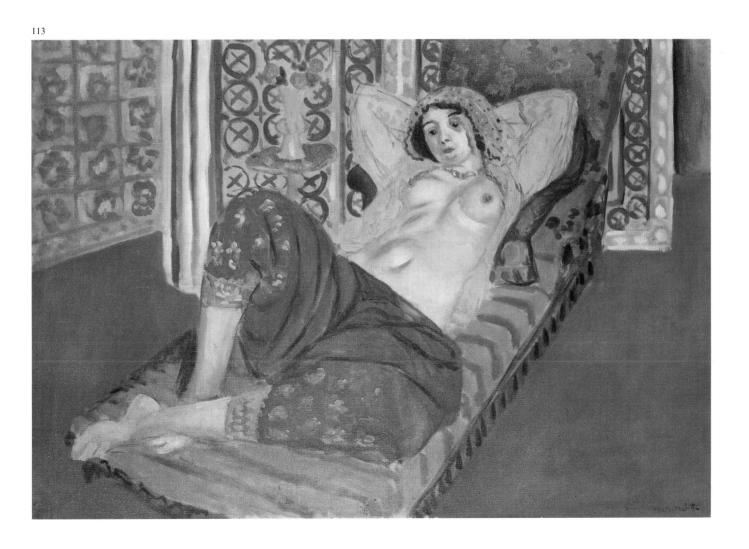

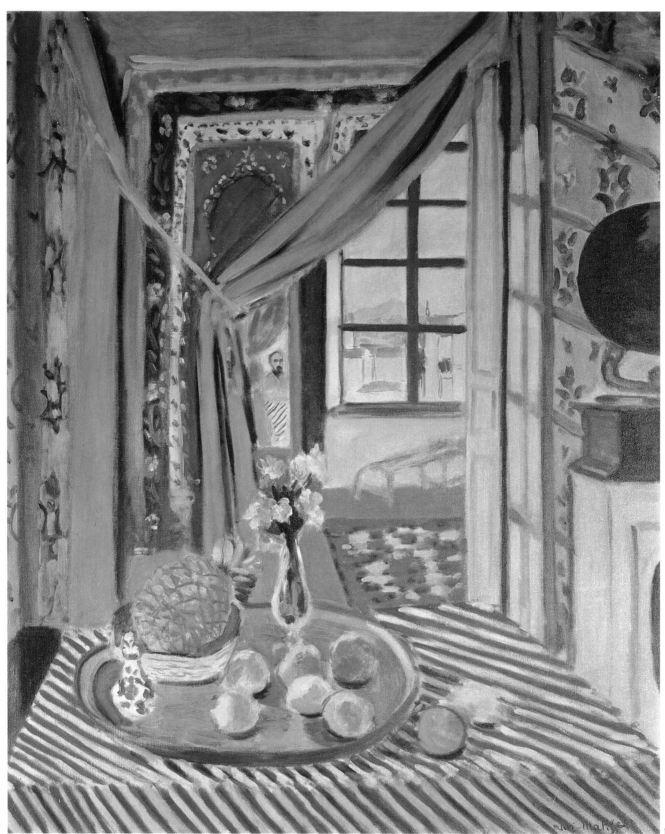

114

114. *Interior with a Phonograph.* 1924.
Oil on canvas, 39⅜ × 31⅞ in. (100 × 81 cm).
Private collection, New York.
Photo: Plassart/Artephot.

115. *Ballet Dancer Seated on a Stool.* 1927.
Oil on canvas, 31⅞ × 23⅞ in. (81 × 60.7 cm).
The Baltimore Museum of Art. The Cone Collection,
formed by Dr. Claribel Cone and Miss Etta Cone of
Baltimore, Maryland.

116. *Woman with a Veil.* 1927.
Oil on canvas, 24 × 19¾ in. (61 × 50 cm).
Mr. William S. Paley Collection, New York.
Photo: Plassart/Artephot.

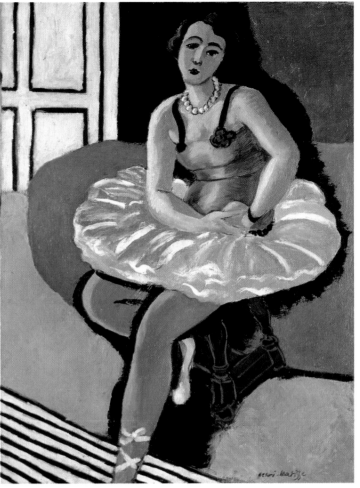

115

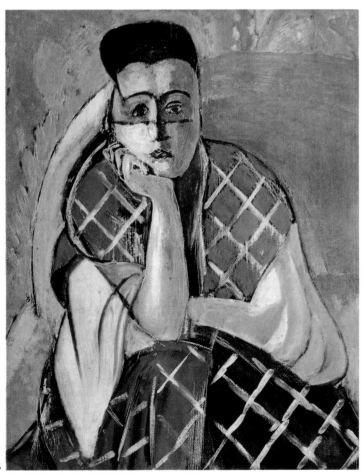

116

117. Illustrations for *Ulysses: Calypso (Battling Females)*. 1931.
 Soft-ground etching, 11⅝ × 9 in. (29.6 × 23 cm).
 Photothèque Henri Matisse.

118. Illustrations for *Ulysses: Polyphemus*. 1931–32.
 Soft-ground etching, 11⅛ × 8⅞ in. (28.4 × 22.5 cm).
 Photothèque Henri Matisse.

119. Illustrations for *Ulysses: Circe (Brothel Scene)*. 1931.
 Soft-ground etching, 11⅛ × 8⅝ in. (28.3 × 21.8 cm).
 Photothèque Henri Matisse.

120. *Woman in White Fox-Fur Wrap*. 1929.
 Lithograph, 20¼ × 15¼ in. (51.5 × 38.8 cm).
 Bibliothèque Nationale, Paris.

117

118

119

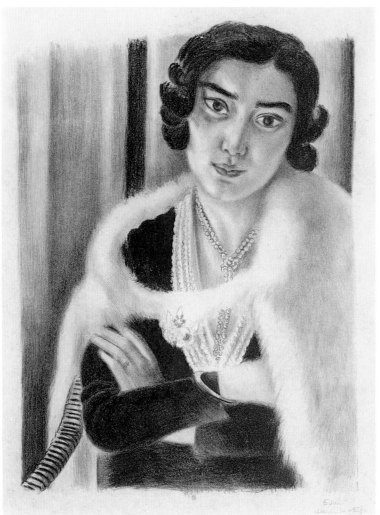

120

121. *Woman with Turban (Portrait in a Moorish Chair)*. 1929–30.
Oil on canvas, 70⅞×59⅞ in. (180×152 cm).
Private Collection.

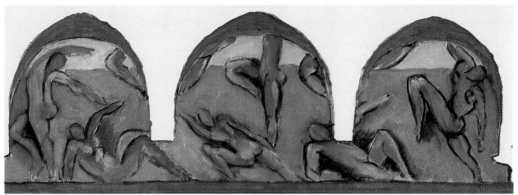

122

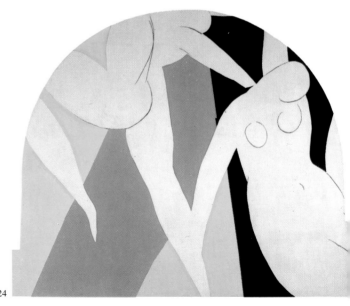

122. *Dance I* (Preliminary sketch, flesh colours). 1930.
Oil on canvas, 13 × 34¼ in. (33 × 87 cm).
Musée Matisse, Nice.

123. *Dance II*. 1931–32.
Mural. Oil, 11 ft. 8½ in. × 47 ft. (357 × 1,432 cm).
The Barnes Foundation, Merion, Philadelphia.
Photograph © 1991 by the Barnes Foundation.

124. *Dance I* (Rejected). 1931–32.
Oil on canvas (three panels),
133⅞ × 152⅜; 139¾ × 196; 131 × 154 in.
(340 × 387; 355 × 498; 333 × 391 cm).
Musée d'Art Moderne de la Ville de Paris.
Photo: Musées de la Ville de Paris.

124

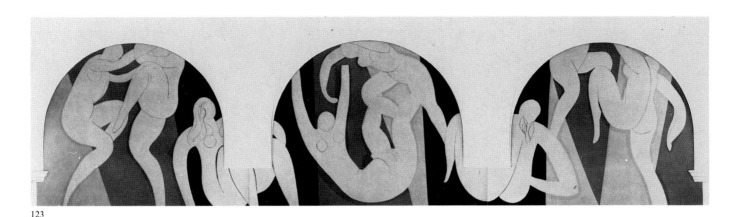

123

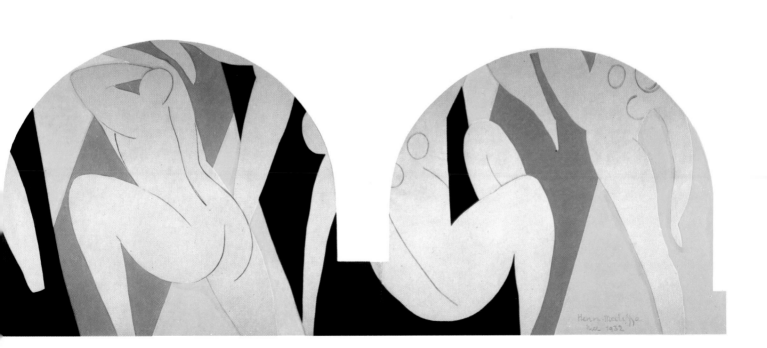

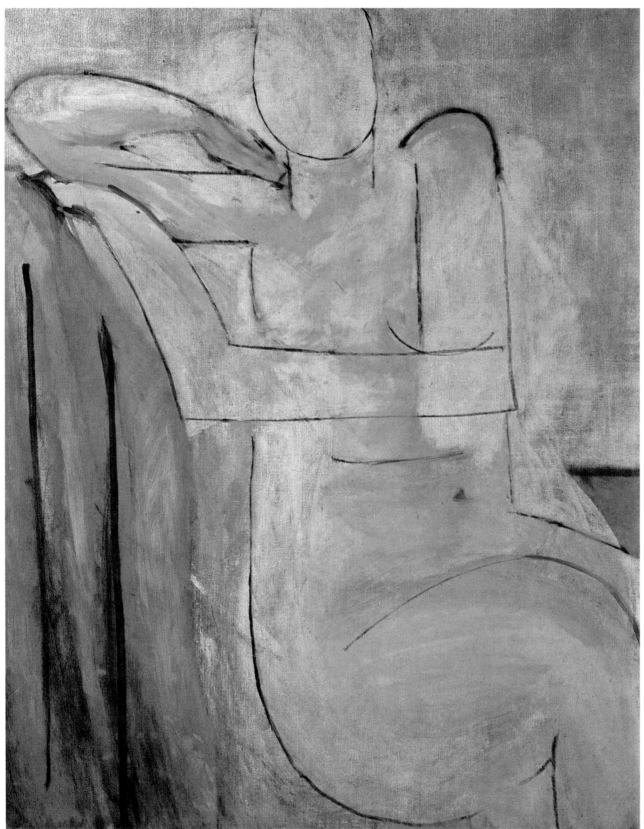

125. *Seated Pink Nude*. 1935.
Oil on canvas, 36¼ × 28¾ in. (92 × 73 cm).
Private Collection.
Photothèque Henri Matisse.

126. *La Chevelure (Hair)*. 1932.
Illustration for *Poésies* of Stéphane Mallarmé.
Etching.

127. *Pink Nude*. 1935.
Oil on canvas, 26 × 36½ in. (66 × 92.7 cm).
The Baltimore Museum of Art. The Cone Collection,
formed by Dr. Claribel Cone and Miss Etta Cone of
Baltimore, Maryland.

126

127

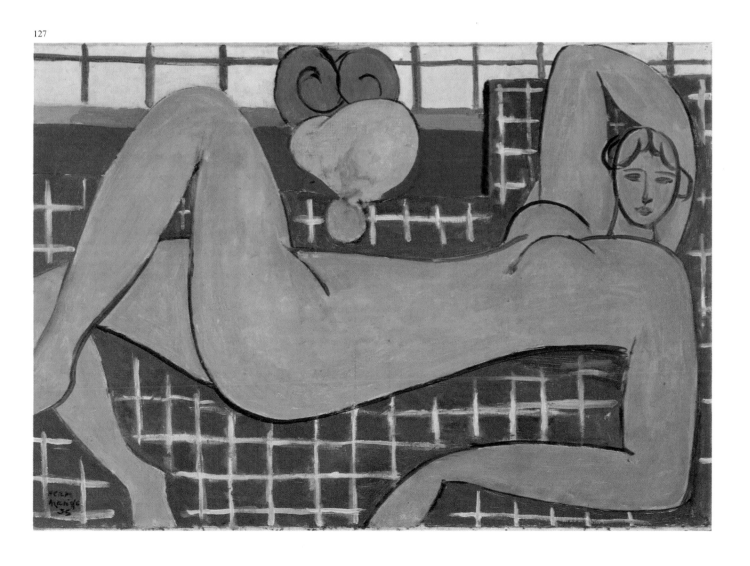

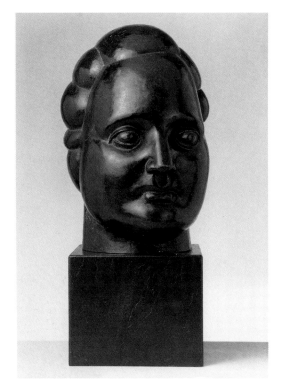

128

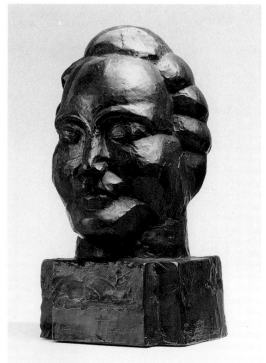

129

130

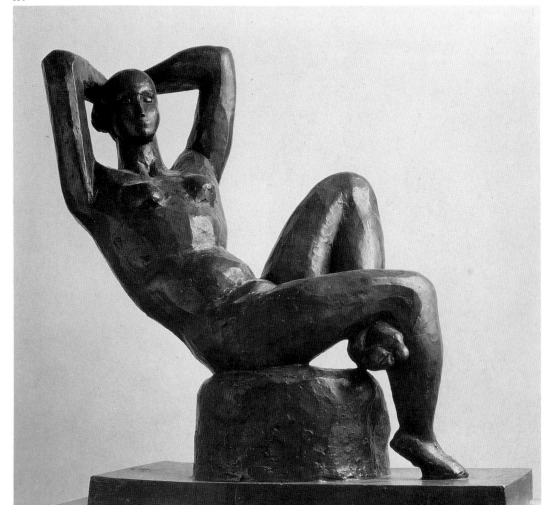

128. *Henriette II*. 1927.
Bronze 2/10, H. 14¾ in. (37.5 cm).
Musée Matisse, Le Cateau-Cambrésis.

129. *Henriette III*. 1925.
Bronze 10/10, H. 15¾ in. (40 cm).
Musée Matisse, Nice.

130. *Large Seated Nude*. 1923–25.
Bronze 7/10, H. 30⅞ in. (78.3 cm).
The Baltimore Museum of Art. The Cone Collection,
formed by Dr. Claribel Cone and Miss Etta Cone of
Baltimore, Maryland.

131. *Tiari*. 1930.
Bronze 1/10 with gold chain, H. 8 in. (20.3 cm).
The Baltimore Museum of Art. The Cone Collection,
formed by Dr. Claribel Cone and Miss Etta Cone of
Baltimore, Maryland.

132. *Venus in a Shell I*. 1930.
Bronze 5/10, H. 12¼ in. (31 cm).
Musée Matisse, Nice.

133. *Venus in a Shell II*. 1932.
Bronze, 12¾ × 8 × 9⅛ in. (32.4 × 20.3 × 23.2 cm).
Hirshhorn Museum and Sculpture Garden. Smithsonian
Institution. Gift of Joseph H. Hirshhorn, 1966.

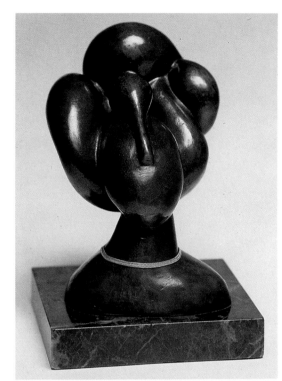

131

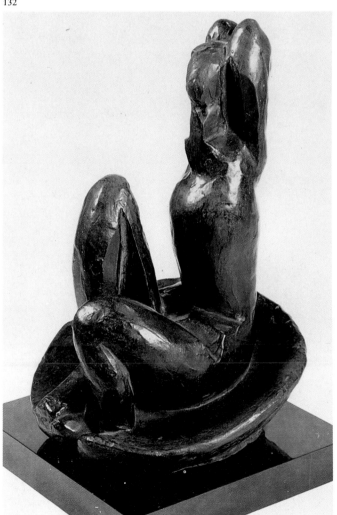

132

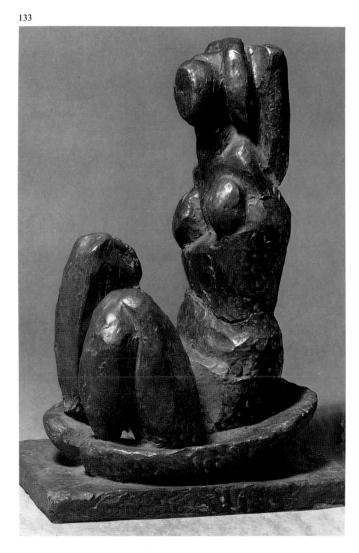

133

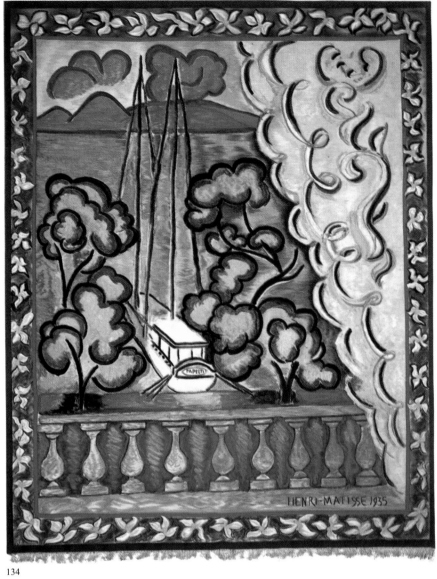

134

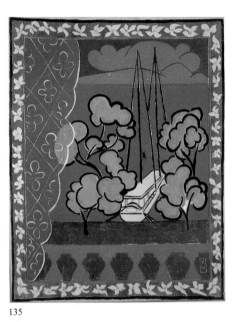

135

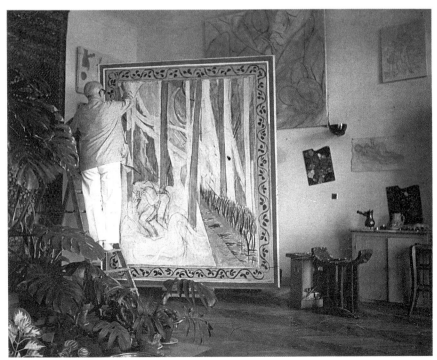

136

134. *Tahiti.* 1935.
Silk and wool Beauvais tapestry, 89 × 67¾ in.
(226 × 172.2 cm).
Private Collection, New York.
Photo: Phaidon Press Oxford.

135. *Window.* 1936.
Tempera on canvas, 93¾ × 72⅞ in. (238 × 185 cm).
Musée Matisse, Le Cateau-Cambrésis.
Photo: Benitez Valenciennes.

136. Matisse in his studio, working on *Nymph in the Forest*
(with decorative border). 1940–41.
Photo: Varian Fry.

137. *Nymph in the Forest (La Verdure).* 1936–42.
Oil on canvas, 95¼ × 76¾ in. (242 × 195 cm).
Musée Matisse, Nice. Gift of Jean Matisse,
to the French government.

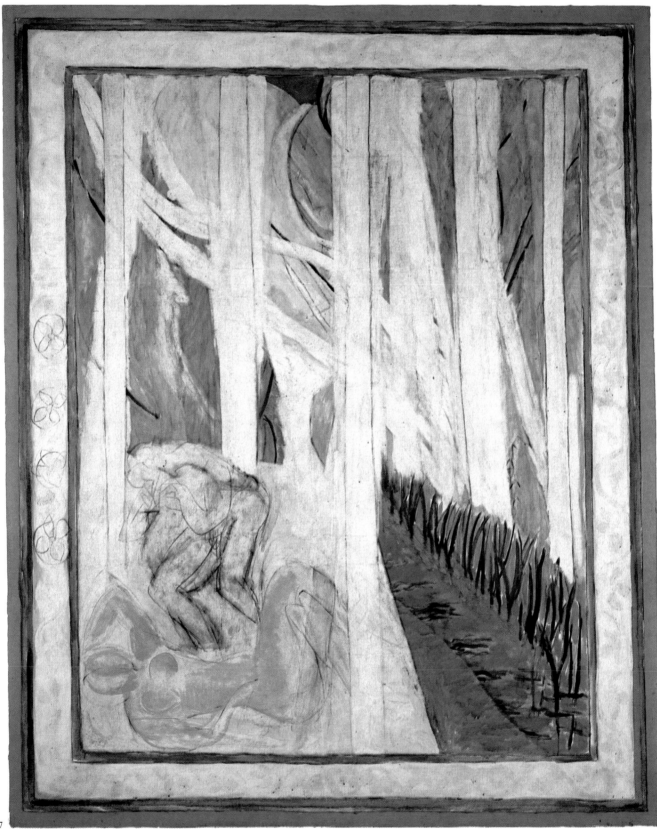

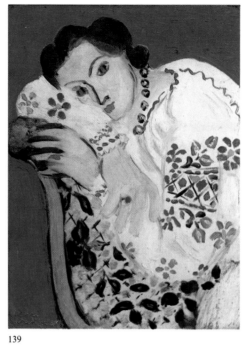

138

139

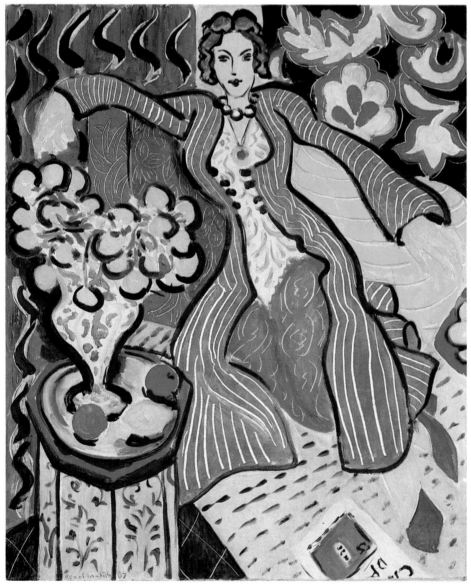

140

138. *The Blue Blouse*. 1936.
Oil on canvas, 36¼ × 23⅝ in. (92 × 60 cm).
Mr. and Mrs. Harry Bahwin Collection.
Photothèque Henri Matisse.

139. *Peasant Blouse*. 1936.
Oil on cavas, 8⅝ × 6¼ in. (22 × 16 cm).
Private collection.
Photothèque Henri Matisse.

140. *Violet Robe with Buttercups*. 1937.
Oil on canvas, 32 × 25¾ in. (81.3 × 65.4 cm).
John A. and Audrey Jones Beck Collection.
The Museum of Fine Arts, Houston.

141. *Lady in Blue*. 1937.
Oil on canvas, 36½ × 29 in. (92.7 × 73.6 cm).
Philadelphia Museum of Art. Gift of Mrs. John
Wintersteen.

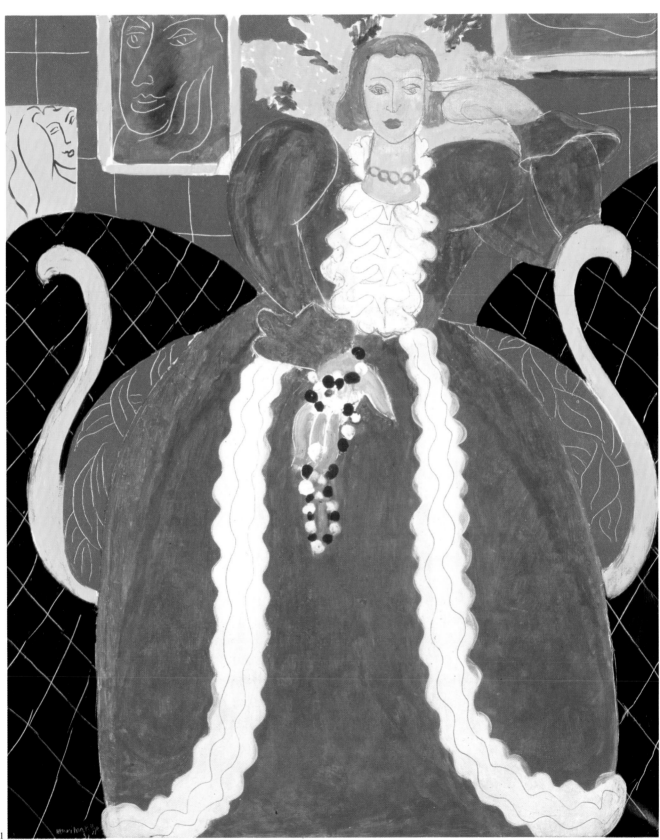

141

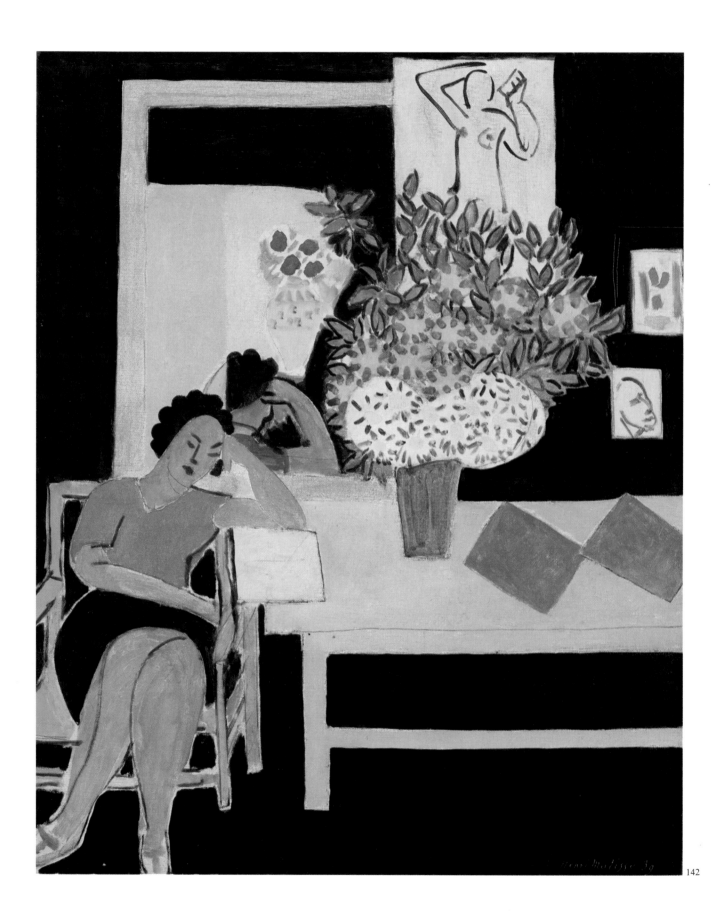

142

142. *Reader Against a Black Background*.
1939.
Oil on canvas, 36¼ × 28¾ in.
(92 × 73 cm).
Musée National d'Art Moderne,
Centre Georges Pompidou, Paris.

143. *The Roumanian Blouse*. 1940.
Oil on canvas, 36¼ × 28¾ in.
(92 × 73 cm).
Musée National d'Art Moderne,
Centre Georges Pompidou, Paris.

144. *The Idol*. 1942.
Oil on canvas, 20 × 24 in.
(50.8 × 60.9 cm).
Private Collection.

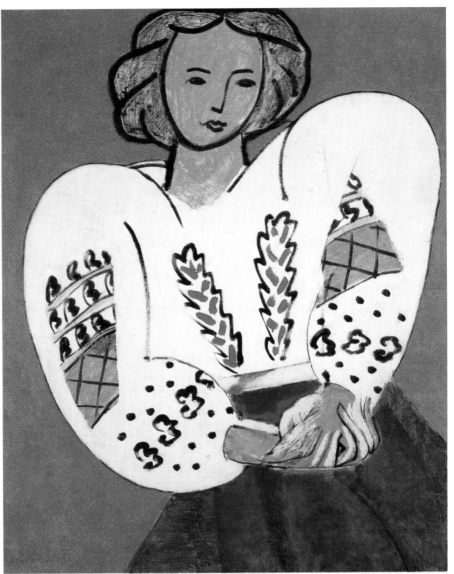

143

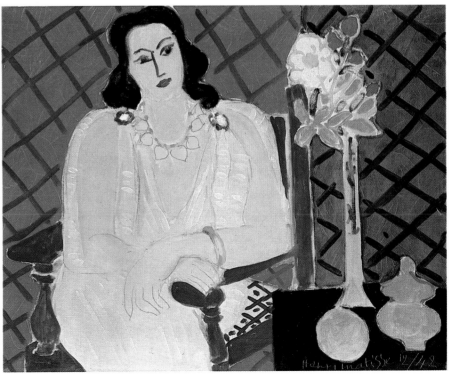

144

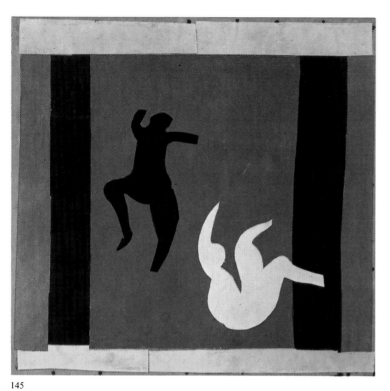

145

145. *Two Dancers.*
Sketch for curtain of *L'Etrange Farandole.* 1938.
Paper cutout, 32⅛ × 25⅝ in. (81.5 × 65 cm).
Private Collection.

146. *Little Dancer on Red Ground.* 1938.
Paper cutout, 14⅝ × 7½ in. (37 × 19 cm).
Mr. and Mrs. Fayez Sarofin.
Photo: Robert Miller Gallery, New York.

147. *The Dance.* 1938.
Paper cutout with pins, 31½ × 25⅝ in. (80 × 65 cm).
Private Collection.

148. *Still Life with Seashell and Coffee Pot.* 1941.
Paper collage on canvas, 23⅝ × 32 in. (60 × 81.3 cm).
Pierre Matisse Gallery, New York.

149. *Still Life with a Seashell on a Black Marble Table.* 1940.
Oil on canvas, 21½ × 32 in. (54.6 × 81.3 cm).
The Pushkin Museum, Moscow.

146

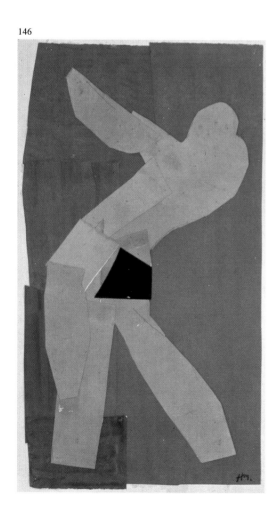

147

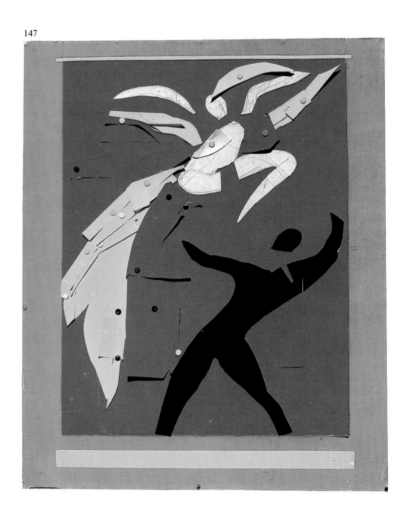

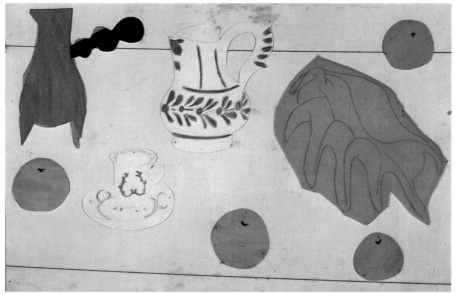

148

149

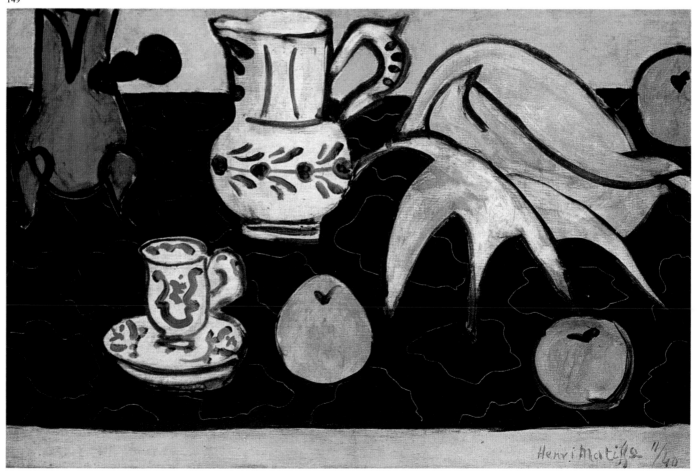

150. Illustration for *Jazz*: *Le cheval, l'écuyère et le clown*. 1947.
Paper cutout with gouache mounted on canvas,
16¾ × 25⅞ in. (42.5 × 65.6 cm).
Musée National d'Art Moderne, Centre Georges
Pompidou, Paris. Photothèque Henri Matisse.

151. Illustration for *Jazz*: *Formes*. 1944.
Paper cutout with gouache mounted on canvas,
17½ × 26⅜ in. (44.3 × 67.1 cm).
Musée National d'Art Moderne, Centre Georges
Pompidou, Paris. Photothèque Henri Matisse.

152. Illustration for *Jazz*: *L'enterrement de Pierrot*. 1943.
Paper cutout with gouache mounted on canvas,
17½ × 26 in. (44.5 × 66 cm).
Photothèque Henri Matisse.

153. Illustration for *Jazz*: *Le cow-boy*. 1943–44.
Paper cutout with gouache mounted on canvas,
16⅞ × 26¾ in. (43 × 68 cm).
Photothèque Henri Matisse.

150

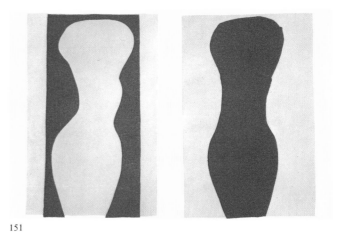

151

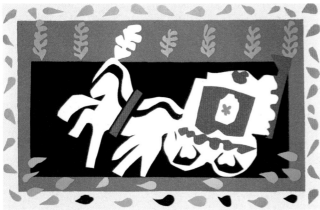

152

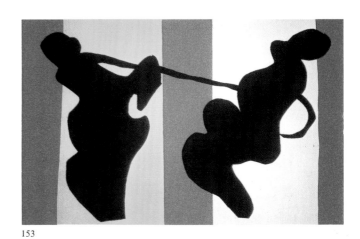

153

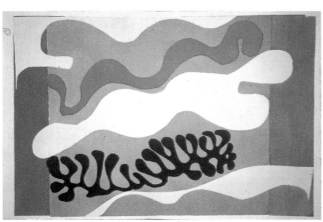

154

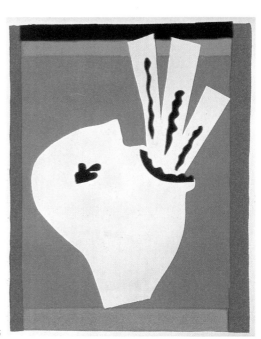

155

154. Illustration for *Jazz*: *Le lagon*. 1944.
Paper cutout with gouache mounted on canvas,
17⅛ × 26⅜ in. (43.6 × 67.1 cm).
Photothèque Henri Matisse.

155. Illustration for *Jazz*: *L'avaleur de sabres*. 1943–46.
Paper cutout with gouache mounted on canvas,
17 × 13½ in. (43.3 × 34.3 cm).
Photothèque Henri Matisse.

156. Double page from *Jazz*: *Icare*. 1943.
Pochoir with gouache, 17⅛ × 13½ in. (43.4 × 34.1 cm).
Photothèque Henri Matisse.

157. Double page from *Jazz*: *Le destin*. 1943–46.
Pochoir with gouache, 17⅝ × 26⅜ in. (44.6 × 67.1 cm).
Photothèque Henri Matisse.

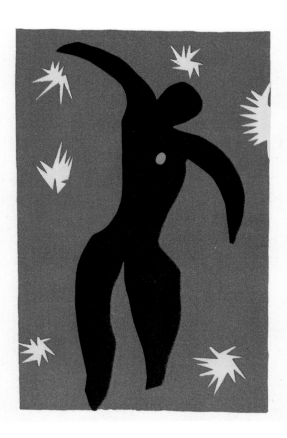

156

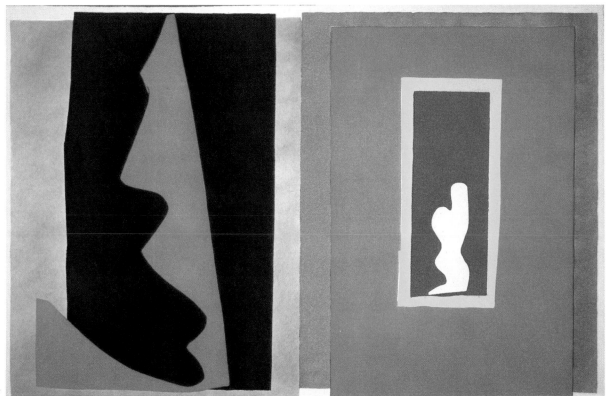

157

158. *Leda and the Swan*. 1944–45.
Oil on panel, 72 × 61⅞ in. (183 × 157 cm).
Private Collection, Paris.

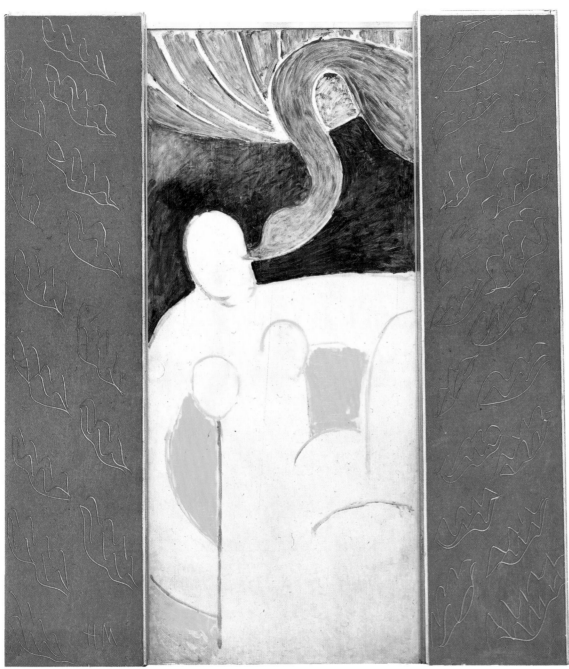

159. *Oceania—The Sky*. 1946.
Hanging printed on linen, 69¾ × 51¼ in. (177 × 130 cm).
Musée National d'Art Moderne, Centre Georges
Pompidou, Paris.

160. *Polynesia—The Sea*. 1946.
Paper cutout mounted on canvas,
77⅛ × 123⅝ in. (196 × 314 cm).
Musée National d'Art Moderne, Centre Georges
Pompidou, Paris.

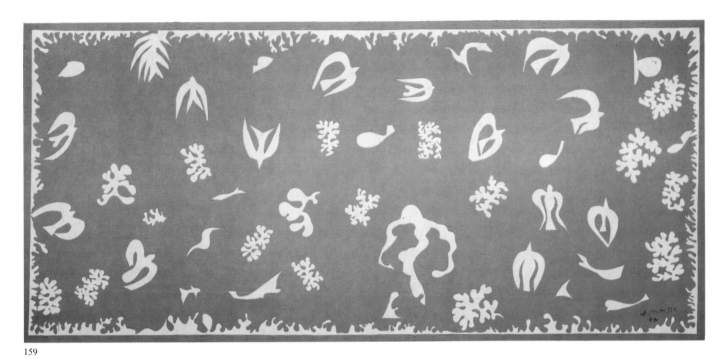

159

160

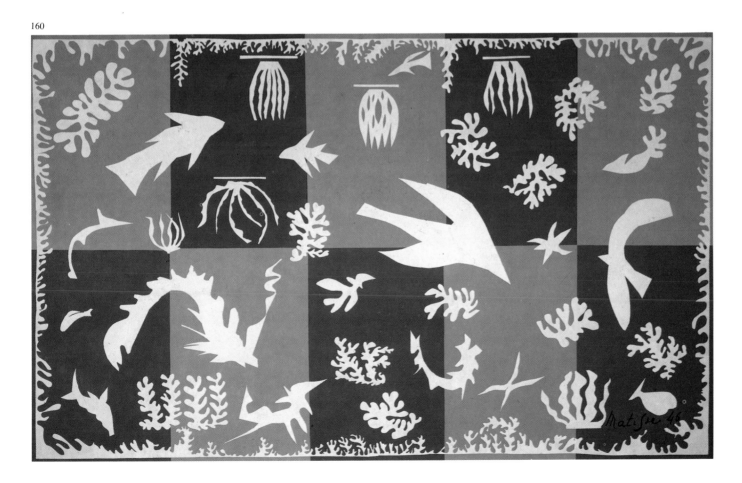

161. *The Silence Living in Houses*. 1947.
Oil on canvas, 24 × 19¾ in. (61 × 50 cm).
Photothèque Henri Matisse.

162. *Interior with Egyptian Curtain*. 1948.
Oil on canvas, 45¾ × 35⅛ in. (116.2 × 89.2 cm).
The Phillips Collection, Washington, D.C.

163. *Large Red Interior*. 1948.
Oil on canvas, 57½ × 38¼ in. (146 × 97 cm).
Musée National d'Art Moderne, Centre Georges
Pompidou, Paris.

164. *Interior with Black Fern*. 1948.
Oil on canvas, 45⅝ × 35 in. (116 × 89 cm).
The Beyeler Collection, Basel.

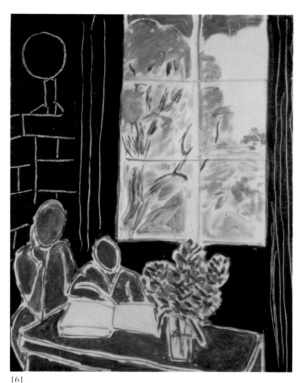

161

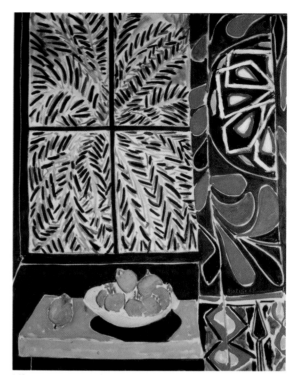

162

163

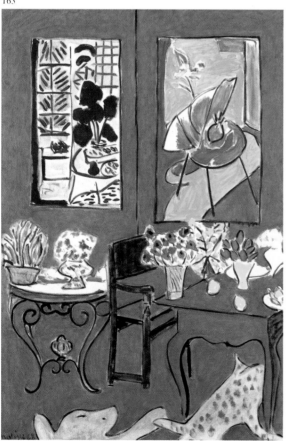

164

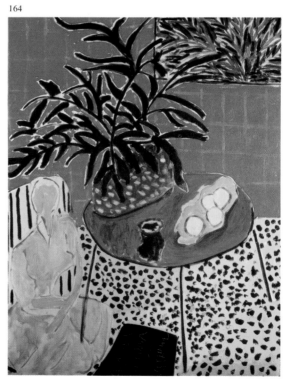

165. *Zulma*. 1949.
Paper cutout,
93¾ × 51¼ in.
(238 × 130 cm).
Statens Museum for
Kunst, Copenhagen.
Photo: Hans Petersen.

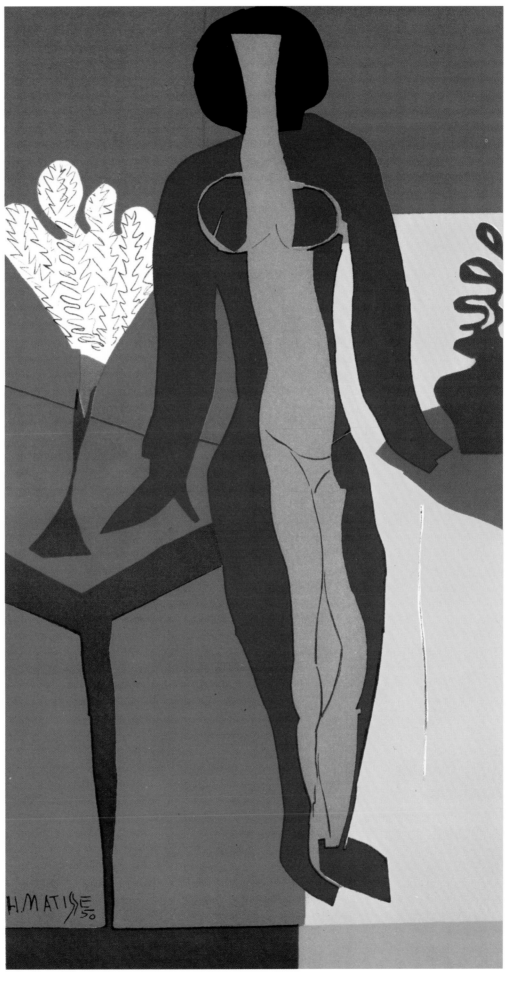

166. *Sea-Beasts*. 1950.
Paper cutout mounted on canvas,
116⅜ × 60⅝ in. (295.5 × 154 cm).
National Gallery of Art, Washington, D.C. Ailsa Mellon
Bruce Fund.

167. *Mimosa*. 1949–51.
Paper cutout, design for a carpet,
58¼ × 38 in. (148 × 96.5 cm).
Ikeda Museum of Twentieth Century Art, Itoh.

168. Illustration for Iliazd, *Poésie de Mots inconnus*.
Linocut.
Photothèque Henri Matisse.

169. Illustration from *Pasiphae*: *Borne up to the constellations*.
1944.
Linocut.

170. Illustration from *Pasiphae*: *The anguish growing and
beating at your throat*. 1944.
Linocut.

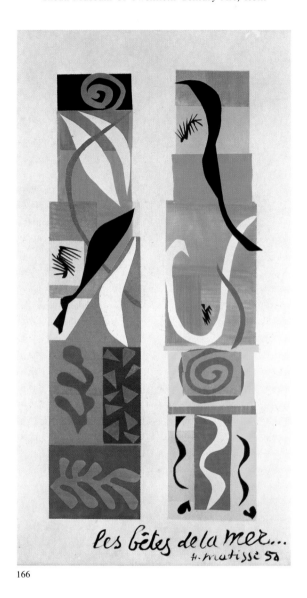

166

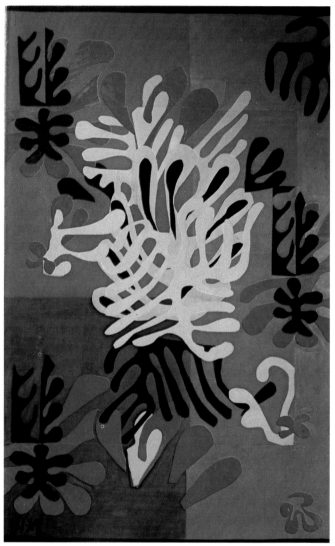

167

168

169

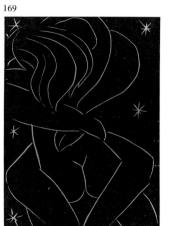

170

171. Illustrations for *Poèmes de Charles d'Orleans*. 1950.
Double page, lithographs made in 1943.

172. Illustrations for *Florilège des Amours de Ronsard*: *Petit nombril*. 1948.
Double page, lithographs made 1942–43.

173. Illustrations for Marianna Alcaforado, *Les Lettres Portugaises*. 1946.
Double page, lithographs made 1942–43.

174. *Interior with Black Fern*. 1948.
Brush and ink, 41⅜ × 29½ in. (105 × 75 cm).
Musée National d'Art Moderne, Centre Georges Pompidou, Paris.

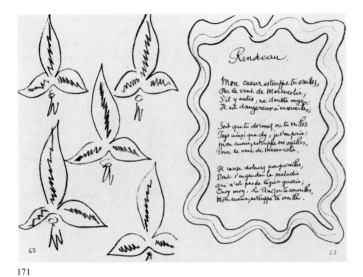

171

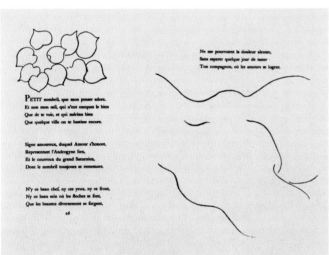

172

173

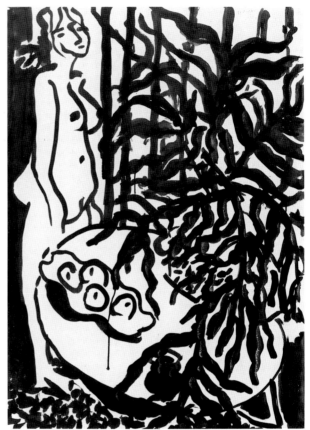

174

175. *The Thousand and One Nights*. 1950.
Paper cutout, 54¾ × 136⅝ in. (139.1 × 374 cm).
The Carnegie Museum of Art, Pittsburg. Acquired
through the generosity of the Sarah Mellon Scaife family,
1971.

176. *The Eskimo*. 1947.
Gouache on cut-and-pasted paper,
16 × 33⅞ in. (40.5 × 86 cm).
Der Danske Kunstindustrimuseet, Copenhagen.
Photo: Ole Woldbye.

177. *Chinese Fish*. 1951.
Gouache on cut-and-pasted paper,
75⅝ × 35⅞ in. (192 × 91 cm).
Vicci Sperry, Los Angeles.

178. Maquette for *Christmas Night*. Nice,
January–February 1952.
Gouache on cut-and-pasted paper, 123⅛ × 53½ in.
(312.8 × 135.9 cm).
Collection, The Museum of Modern Art, New York.
Gift of Time Inc.

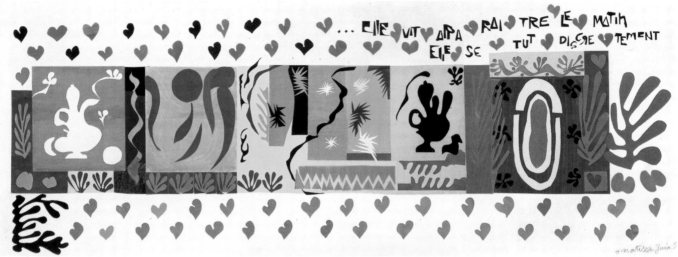

175

176

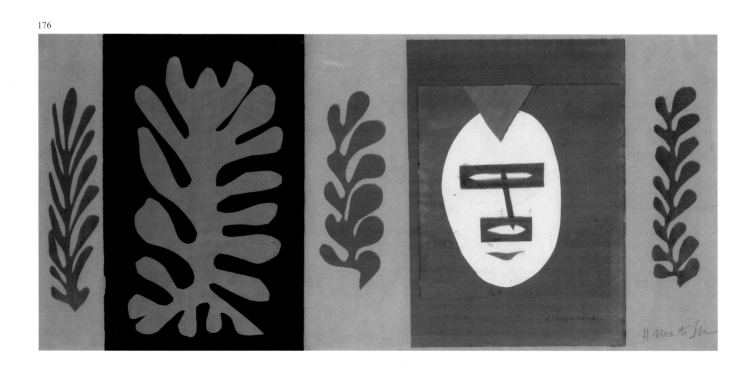

179. Design for jacket of *Matisse: His Art and His Public* by
 Alfred H. Barr, Jr. The Museum of Modern Art, New
 York, 1951.
 Gouache on cut-and-pasted paper,
 10⅝ × 16⅞ in. (27 × 42.9 cm).
 Collection, The Museum of Modern Art, New York.

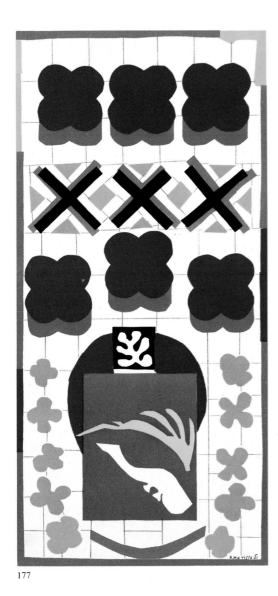

177

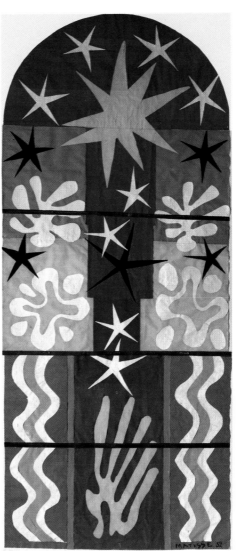

178

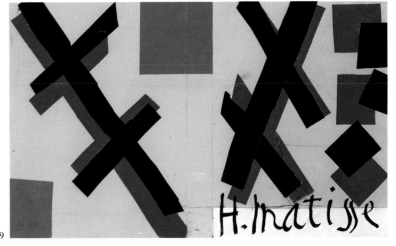

179

180. *The Virgin and Child*. 1949–50.
Painted and glazed tiles.
Vence Chapel.
Photo: Hélène Adant.

181. *The Stations of the Cross*.
Painted and glazed tiles.
Vence Chapel.
Photo: Hélène Adant.

182. *The Tree of Life*.
Stained glass window. Installation photograph.
Vence Chapel.
Photo: Hélène Adant.

183. *Saint Dominic*.
Painted and glazed tiles.
Vence Chapel.
Photo: Hélène Adant.

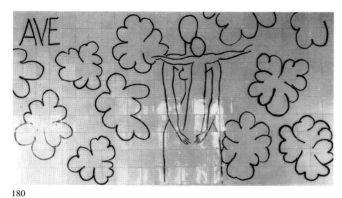

180

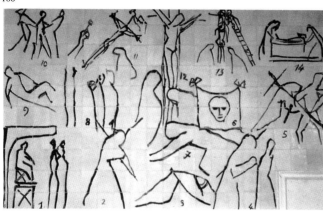

181

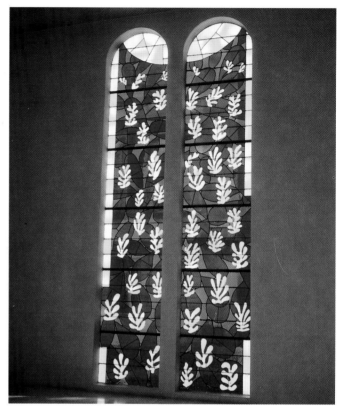

182

183

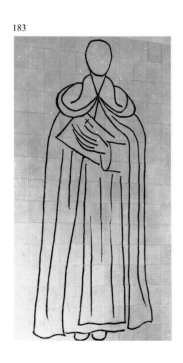

184

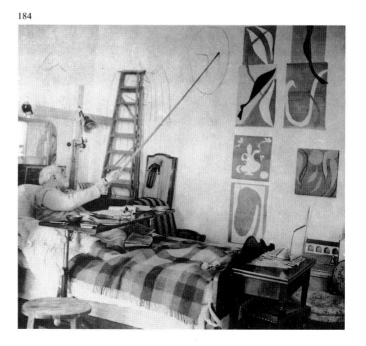

184. Matisse using a bamboo pole while bedridden in the Hotel
Regina, Nice, April 15th, 1950.
Photograph by *Paris–Match*.

185, 186. Interior.
Vence Chapel.
Photo: Hélène Adant.

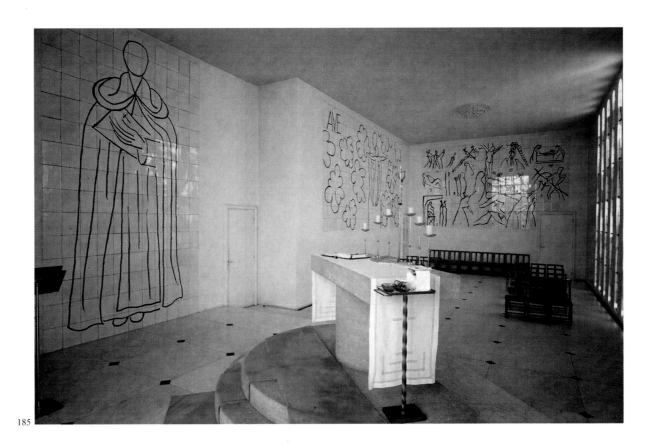

185

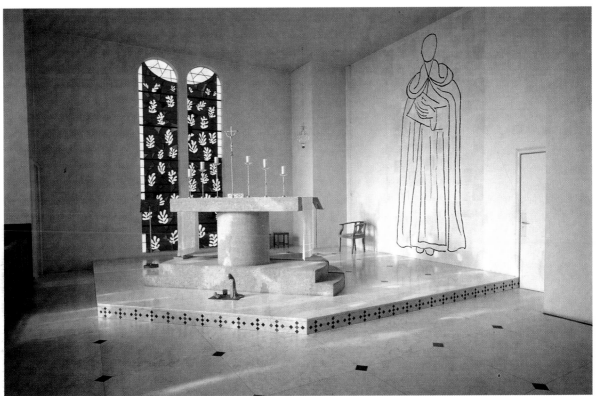

186

187. *The Bees*. 1948.
Paper cutout, 39¾ × 94⅞ in. (101 × 241 cm).
Musée Matisse, Nice.

188. *Design for Green Chasuble* (back maquette). 1950–52.
Paper cutout, 51⅞ × 77¾ in. (131.7 × 197.5 cm).
Musée Matisse, Nice.

189. *Design for Violet Chasuble* (front maquette). 1950–52.
Paper cutout, 50 × 78 in. (127 × 198 cm).
Musée Matisse, Nice.

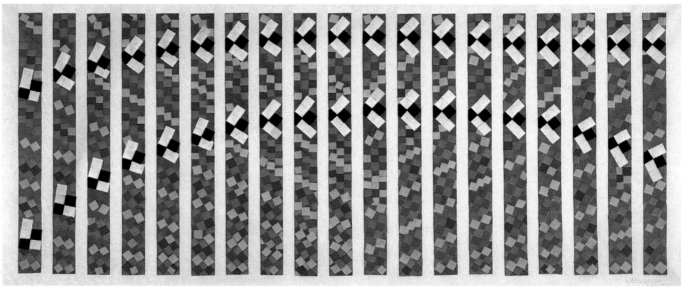

187

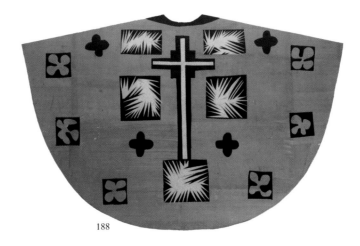

188

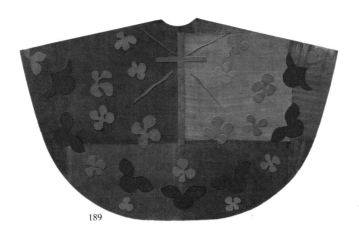

189

190. *The Sorrow of the King*. 1952.
 Paper cutout, 115 × 156 in. (292 × 396 cm).
 Musée National d'Art Moderne, Centre Georges
 Pompidou, Paris.

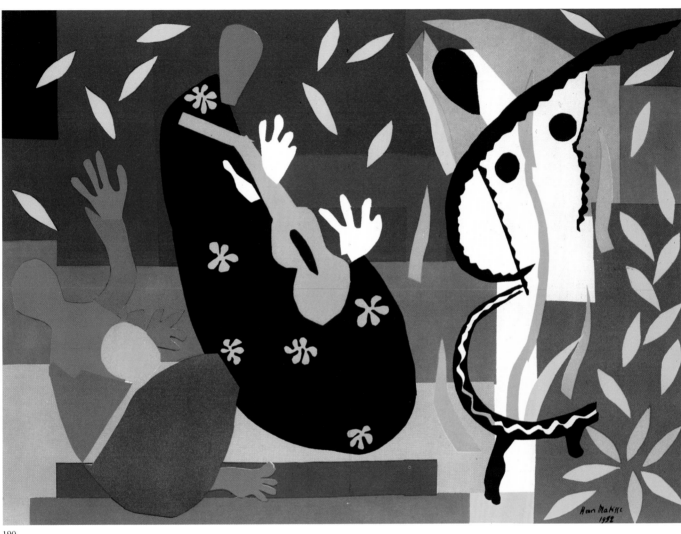

190

191. *Memory of Oceania*. Nice, summer 1952–early 1953.
Gouache and crayon on cut-and-pasted paper on canvas,
112 × 112¾ in. (284.4 × 286.4 cm).
Collection, The Museum of Modern Art, New York.
Mrs. Simon Guggenheim Fund.

192. *Acrobats*. 1952.
Paper cutout, 83⅞ × 81½ in. (213 × 207 cm).
Matisse Family Collection.
Photo: Artephot/Faillet.

193. *Nude with Flowing Hair*. 1952.
Paper cutout, 43¼ × 31½ in. (110 × 80 cm).
The Beyeler Collection, Basel. Photo: Artothek.

194. Partial installation view of *The Swimming Pool*. Nice (1952–53).
Nine-panel mural in two parts (one section shown).
Gouache on cut-and-pasted paper mounted on burlap,
a-e: 90⅜ × 333¾ in. (230.1 × 847.8 cm),
f-i: 90⅜ × 313½ in. (230.1 × 796.1 cm).
Collection, The Museum of Modern Art, New York.
Bernard F. Gimbel Fund.

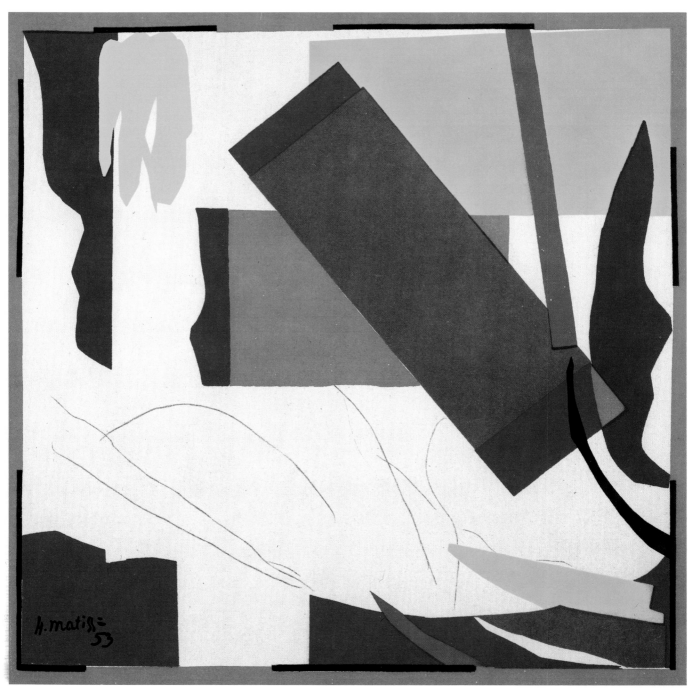

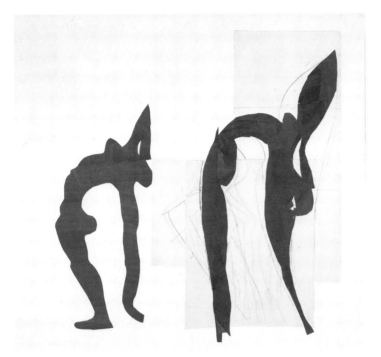

192

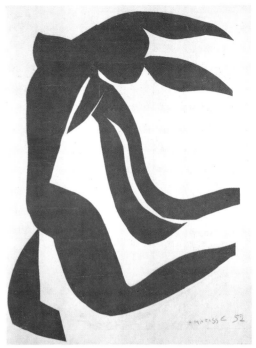

193

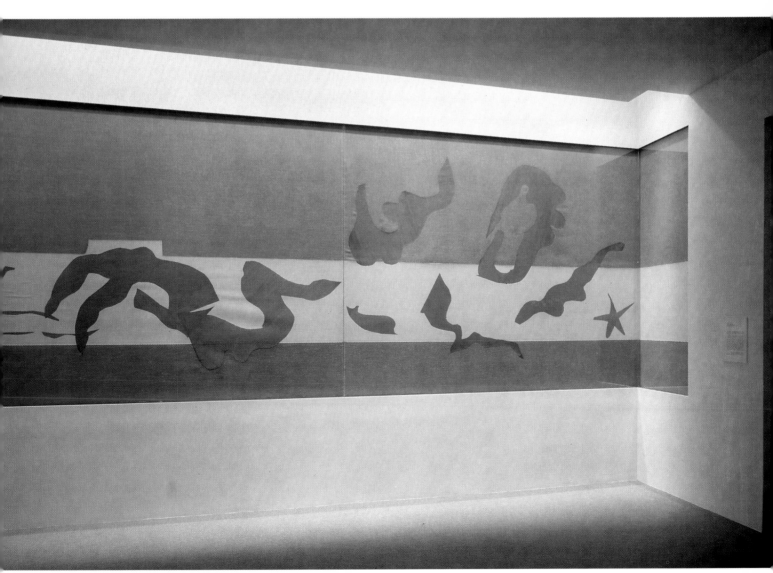

194

LIST
OF ILLUSTRATIONS

67. *Window at Tangier*. 1912.
Oil on canvas, 45⅝ × 31½ in. (116 × 80 cm).
The Pushkin Museum, Moscow.

68. *Zorah on the Terrace*. 1913.
Oil on canvas, 45⅝ × 39⅜ in. (116 × 100 cm).
The Pushkin Museum, Moscow.

69. *The Casbah Gate*. 1912.
Oil on canvas, 45⅝ × 31½ in. (116 × 80 cm).
The Pushkin Museum, Moscow.

70. *Arab Cafe*. 1913.
Oil and mixed media on canvas,
69¼ × 82⅝ in. (176 × 210 cm).
The Hermitage, St. Petersburg.

71. *The Riffian (Half-length)*. 1913.
Oil on canvas, 57⅛ × 38 in. (145 × 96.5 cm).
The Hermitage, St. Petersburg.

72. *Nude with a Ring*. 1914.
Monotype.
Bibliothèque Nationale, Paris.

73. *Nude (back view)*. 1916.
Monotype, 7¾ × 5⅞ in. (19.8 × 14.8 cm).
Bibliothèque d'Art et d'Archéologie,
Fonds Jacques Doucet, Paris.

74. *Seated Nude with Bracelet II*. 1914.
Monotype, 7 × 4¾ in. (17.9 × 12.2 cm).
Bibliothèque Nationale, Paris. Donation
Jean Matisse.

75. *Portrait of Mlle. Yvonne Landsberg*. 1914.
Oil on canvas, 57⅝ × 37⅝ in. (146.5 × 95.5 cm).
Philadelphia Museum of Art. Louise
and Walter Arensberg Collection.

76. *Grey Nude with Bracelet*. 1913.
Oil on canvas, 29½ × 24 in. (75 × 61 cm).
Private Collection on loan to
Kunsthaus Zürich.

77. *Still Life with Oranges*. 1913.
Oil on canvas, 37 × 32⅝ in. (94 × 83 cm).
Musée Picasso, Paris.

78. *View of Notre-Dame*. Paris, spring 1914.
Oil on canvas, 58 × 37⅛ in. (147.3 × 94.3 cm).
Collection, The Museum of Modern Art,
New York. Acquired through the Lillie P. Bliss
Bequest, and the Henry Ittleson, A. Conger
Goodyear, Mr. and Mrs. Robert Sinclair
Funds, and the Anna Erickson Levene Bequest
given in memory of her husband, Dr. Phoebus
Aaron Theodor Levene.

79. *The Open Window, Collioure*. 1914.
Oil on canvas, 45⅞ × 34⅝ in. (116.5 × 88 cm).
Musée National d'Art Moderne, Centre
Georges Pompidou, Paris.

80. *Study for Still Life after de Heem*. 1915.
Pencil on paper, 20⅝ × 21¼ in. (52.3 × 55.2 cm).
Philadelphia Museum of Art. Louise
and Walter Arensberg Collection.

81. *Still Life with Oriental Tile*. Autumn 1915.
Pencil, 29⅛ × 21¼ in. (74 × 54 cm).
Private Collection.

82. *Vase with Geraniums*. 1915–16.
Black crayon on paper,
24¾ × 18⅞ in. (63 × 48 cm).
Musée Matisse, Nice.

83. *The Yellow Curtain*. 1914–15.
Oil on canvas, 59 × 38⅝ in. (150 × 98 cm).
Collection Stephen Hahn, New York.

84. *Head, White and Rose*. 1914.
Oil on canvas, 29½ × 18½ in. (75 × 47 cm).
Musée National d'Art Moderne, Centre
Georges Pompidou, Paris.

85. *The Moroccans*. Issy-les-Moulineaux
(November 1915 and summer 1916).
Oil on canvas, 71⅜ × 110 in. (181.3 × 279.4 cm).
Collection, The Museum of Modern Art,
New York. Gift of Mr. and Mrs. Samuel
A. Marx.

86. *The Piano Lesson*. Issy-les-Moulineaux
(late summer 1916).
Oil on canvas, 96½ × 83¾ in. (245.1 × 212.7 cm).
Collection, The Museum of Modern Art,
New York. Mrs. Simon Guggenheim Fund.

87. *Bathers by a Stream*. 1916.
Oil on canvas, 102¼ × 153½ in. (259.7 × 389.9 cm).
The Art Institute of Chicago. Charles
and Mary F.S. Worcester Collection.

88. *Woman in a Turban (Laurette)*. 1917.
Oil on canvas, 32 × 25¾ in. (81.3 × 65.4 cm).
The Baltimore Museum of Art. The Cone
Collection, formed by Dr. Claribel Cone and
Miss Etta Cone of Baltimore, Maryland.

89. *Head of Laurette with Coffee Cup*. 1917.
Oil on canvas, 36¼ × 28¾ in. (92 × 73 cm).
Solothurn Kunstmuseum, Dubi-Muller collection.

90. *Jeannette II*. 1910–13.
Bronze, H. 10½ in. (26.5 cm).

91. *Jeannette III*. 1910–13.
Bronze, H. 23⅝ in. (60 cm).
Musée Matisse, Nice.

92. *Jeannette IV* (Jeanne Vaderin, 4th State).
Issy-les-Moulineaux (1913).
Bronze, 24⅛ × 10¾ × 11¼ in.
(61.3 × 27.4 × 28.7 cm).
Collection, The Museum of Modern Art,
New York. Acquired through the Lillie
P. Bliss Bequest.

93. *Jeannette V*. 1910–13.
Bronze 6/10, H. 22⅞ in. (58 cm).
Musée Matisse, Nice.

94. *Back I*. 1908–9.
Relief, original plaster,
78¾ × 48⅞ in. (200 × 124 cm).
Musée Matisse, Le Cateau-Cambrésis.

95. *Back I*. 1908–9.
Bronze relief, 74⅞ × 46 in. (190 × 116.9 cm).
Musée National d'Art Moderne, Centre
Georges Pompidou, Paris.

96. *Back II*. 1913.
Bronze relief, 73¼ × 45½ in. (186 × 115.5 cm).
Musée National d'Art Moderne, Centre
Georges Pompidou, Paris.

97. *Back III*. 1916–17.
Bronze relief, 74 × 44½ in. (188 × 113 cm).
Musée National d'Art Moderne, Centre
Georges Pompidou, Paris.

98. *Back IV*. 1930–31.
Bronze relief, 74½ × 44½ in. (189.4 × 113.1 cm).
Musée National d'Art Moderne, Centre
Georges Pompidou, Paris.

99. *Path in the Woods at Clamart*. 1917.
Oil on canvas, 35⅞ × 29⅛ in. (91 × 74 cm).
Private Collection.

100. *Interior with a Violin*. 1917–18.
Oil on canvas, 45⅝ × 35 in. (116 × 89 cm).
Statens Museum for Kunst, Copenhagen.

101. *Two Rays, Etretat*. 1920.
Oil on canvas, 36 × 28¼ in. (91.4 × 71.7 cm).
Norton Gallery and School of Art,
West Palm Beach, Florida.

102. *Woman with an Aquarium*. 1921.
Oil on canvas, 31¼ × 39⅜ in. (80.7 × 100 cm).
The Art Institute of Chicago. Helen Birch
Bartlett Memorial Collection.

103. Costume for *Le Chant du Rossignol*. 1920.
Appliqué work.
Insel Hombroich Museum, Neuss.

104. *Antoinette with Plumed Hat*. 1919.
Pen and black ink, 10⅝ × 14⅜ in. (26.9 × 36.5 cm).
The Art Institute of Chicago. Gift of the
Arts Club of Chicago.

105. *White Plumes*. 1919.
Oil on canvas, 28¾ × 23¾ in. (73 × 60.3 cm).
The Minneapolis Institute of Arts.

106. *Odalisque with Raised Arms*. 1923.
Oil on canvas, 25⅝ × 19¾ in. (65 × 50 cm).
National Gallery of Art, Washington, D.C.
Chester Dale Collection.

107. *Odalisque (The White Slave)*. 1921–22.
Oil on canvas, 32¼ × 21¼ in. (82 × 54 cm).
Musée de l'Orangerie. Jean Walter and
Paul Guillaume Collection.

108. *The Hindu Pose*. 1923.
Oil on canvas, 28½ × 23⅜ in. (72.3 × 59.3 cm).
Private Collection, New York.

109. *Young Hindu Girl*. 1929.
Lithograph, 11¼ × 14⅛ in. (28.5 × 35.8 cm).
Bibliothèque Nationale, Paris.

110. Matisse drawing from a model in his
apartment on Place Charles Félix, Nice, c. 1928.

111. *Head, the Buddha*. 1939.
Charcoal on paper, 23⅝ × 15¾ in. (60 × 40 cm).
Musée Matisse, Nice.

112. *Odalisque with Grey Trousers*. 1921.
Oil on canvas, 21¼ × 25⅝ in. (54 × 65 cm).
Musée de l'Orangerie. Jean Walter and
Paul Guillaume Collection.

113. *Odalisque with Red Trousers*. 1921.
Oil on canvas, 25⅝ × 35½ in. (65 × 90 cm).
Musée National d'Art Moderne,
Centre Georges Pompidou, Paris.

114. *Interior with a Phonograph*. 1924.
Oil on canvas, 39⅜ × 31⅞ in. (100 × 81 cm).
Private collection, New York.

115. *Ballet Dancer Seated on a Stool*. 1927.
Oil on canvas, 31⅞ × 23⅞ in. (81 × 60.7 cm).
The Baltimore Museum of Art. The Cone
Collection, formed by Dr. Claribel Cone and
Miss Etta Cone of Baltimore, Maryland.

116. *Woman with a Veil*. 1927.
Oil on canvas, 24 × 19¾ in. (61 × 50 cm).
Mr. William S. Paley Collection, New York.

117. Illustrations for *Ulysses: Calypso
(Battling Females)*. 1931.
Soft-ground etching, 11⅝ × 9 in. (29.6 × 23 cm).

118. Illustrations for *Ulysses: Polyphemus*.
1931–32.
Soft-ground etching,
11⅛ × 8⅞ in. (28.4 × 22.5 cm).

119. Illustrations for *Ulysses: Circe (Brothel
Scene)*. 1931.
Soft-ground etching,
11⅛ × 8⅝ in. (28.3 × 21.8 cm).

120. *Woman in White Fox-Fur Wrap*. 1929.
Lithograph, 20¼ × 15¼ in. (51.5 × 38.8 cm).
Bibliothèque Nationale, Paris.

121. *Woman with Turban (Portrait in a
Moorish Chair)*. 1929–30.
Oil on canvas, 70⅞ × 59⅞ in. (180 × 152 cm).
Private Collection.

122. *Dance I* (Preliminary sketch, flesh
colours). 1930.
Oil on canvas, 13 × 34¼ in. (33 × 87 cm).
Musée Matisse, Nice.

123. *Dance II*. 1931–32.
Mural. Oil, 11 ft. 8½ in. × 47 ft.
(357 × 1,432 cm).
The Barnes Foundation, Merion, Philadelphia.

124. *Dance I* (Rejected). 1931–32.
Oil on canvas (three panels),
133⅞ × 152⅜; 139¾ × 196; 131 × 154 in.
(340 × 387; 355 × 498; 333 × 391 cm).
Musée d'Art Moderne de la Ville de Paris.

125. *Seated Pink Nude*. 1935.
Oil on canvas, 36¼ × 28¾ in. (92 × 73 cm).
Private Collection.

126. *La Chevelure (Hair)*. 1932.
Illustration for *Poésies* of Stéphane Mallarmé.
Etching.

127. *Pink Nude*. 1935.
Oil on canvas, 26 × 36½ in. (66 × 92.7 cm).
The Baltimore Museum of Art. The Cone
Collection, formed by Dr. Claribel Cone and
Miss Etta Cone of Baltimore, Maryland.

128. *Henriette II*. 1927.
Bronze 2/10, H. 14¾ in. (37.5 cm).
Musée Matisse, Le Cateau-Cambrésis.

129. *Henriette II*. 1925.
Bronze 10/10, H. 15¾ in. (40 cm).
Musée Matisse, Nice.

130. *Large Seated Nude*. 1923–25.
Bronze 7/10, H. 30⅞ in. (78.3 cm).
The Baltimore Museum of Art. The Cone
Collection, formed by Dr. Claribel Cone and
Miss Etta Cone of Baltimore, Maryland.

131. *Tiari*. 1930.
Bronze 1/10 with gold chain,
H. 8 in. (20.3 cm).
The Baltimore Museum of Art. The Cone
Collection, formed by Dr. Claribel Cone and
Miss Etta Cone of Baltimore, Maryland.

132. *Venus in a Shell I*. 1930.
Bronze 5/10, H. 12¼ in. (31 cm).
Musée Matisse, Nice.

133. *Venus in a Shell II*. 1932.
Bronze, 12¾ × 8 × 9⅛ in. (32.4 × 20.3 × 23.2 cm).
Hirshhorn Museum and Sculpture Garden.
Smithsonian Institution. Gift of Joseph H.
Hirshhorn, 1966.

134. *Tahiti*. 1935.
Silk and wool Beauvais tapestry,
89 × 67¾ in. (226 × 172.2 cm).
Private Collection, New York.

135. *Window*. 1936.
Tempera on canvas,
93¾ × 72⅞ in. (238 × 185 cm).
Musée Matisse, Le Cateau-Cambrésis.

136. Matisse in his studio, working on
Nymph in the Forest (with decorative border).
1940–41.

137. *Nymph in the Forest (La Verdure)*.
1936–42.
Oil on canvas, 95¼ × 76¾ in. (242 × 195 cm).
Musée Matisse, Nice. Gift of Jean Matisse,
to the French government.

138. *The Blue Blouse*. 1936.
Oil on canvas, 36¼ × 23⅝ in. (92 × 60 cm).
Mr. and Mrs. Harry Bahwin Collection.

139. *Peasant Blouse*. 1936.
Oil on canvas, 8⅝ × 6¼ in. (22 × 16 cm).
Private collection.

140. *Violet Robe with Buttercups*. 1937.
Oil on canvas, 32 × 25¾ in. (81.3 × 65.4 cm).
John A. and Audrey Jones Beck Collection.
The Museum of Fine Arts, Houston.

141. *Lady in Blue*. 1937.
Oil on canvas, 36½ × 29 in. (92.7 × 73.6 cm).
Philadelphia Museum of Art. Gift of
Mrs. John Wintersteen.

142. *Reader Against a Black Background*. 1939.
Oil on canvas, 36¼ × 28¾ in. (92 × 73 cm).
Musée National d'Art Moderne,
Centre Georges Pompidou, Paris.

143. *The Roumanian Blouse*. 1940.
Oil on canvas, 36¼ × 28¾ in. (92 × 73 cm).
Musée National d'Art Moderne,
Centre Georges Pompidou, Paris.

144. *The Idol*. 1942.
Oil on canvas, 20 × 24 in. (50.8 × 60.9 cm).
Private Collection.

145. *Two Dancers*. Sketch for curtain of
L'Etrange Farandole. 1938.
Paper cutout, 32⅛ × 25¾ in. (81.5 × 65 cm).
Private Collection.

146. *Little Dancer on Red Ground*. 1938.
Paper cutout, 14⅝ × 7½ in. (37 × 19 cm).
Mr. and Mrs. Fayez Sarofin.

147. *The Dance*. 1938.
Paper cutout with pins,
31½ × 25⅝ in. (80 × 65 cm).
Private Collection.

148. *Still Life with Seashell and Coffee Pot*. 1941.
Paper collage on canvas,
23⅝ × 32 in. (60 × 81.3 cm).
Pierre Matisse Gallery, New York.

149. *Still Life with a Seashell on a Black
Marble Table*. 1940.
Oil on canvas, 21½ × 32 in. (54.6 × 81.3 cm).
The Pushkin Museum, Moscow.

150. Illustration for *Jazz: Le cheval, l'écuyère
et le clown*. 1947.
Paper cutout with gouache mounted on canvas,
16¾ × 25⅞ in. (42.5 × 65.6 cm).
Musée National d'Art Moderne,
Centre Georges Pompidou, Paris.

151. Illustration for *Jazz: Formes*. 1944.
Paper cutout with gouache mounted on canvas,
17½ × 26⅜ in. (44.3 × 67.1 cm).
Musée National d'Art Moderne,
Centre Georges Pompidou, Paris.

152. Illustration for *Jazz: L'enterrement de
Pierrot*. 1943.
Paper cutout with gouache mounted on canvas,
17½ × 26 in. (44.5 × 66 cm).

153. Illustration for *Jazz: Le Cow-boy*.
1943–44.
Paper cutout with gouache mounted on canvas,
16⅞ × 26¾ in. (43 × 68 cm).

154. Illustration for *Jazz: Le lagon*. 1944.
Paper cutout with gouache mounted on canvas,
17⅛ × 26⅜ in. (43.6 × 67.1 cm).

155. Illustration for *Jazz: L'avaleur de
sabres*. 1943–46.
Paper cutout with gouache mounted on canvas,
17 × 13½ in. (43.3 × 34.3 cm).

156. Double page from *Jazz: Icare*. 1943.
Pochoir with gouache,
17⅛ × 13½ in. (43.4 × 34.1 cm).

157. Double page from *Jazz: Le destin*. 1943–46.
Pochoir with gouache,
17⅝ × 26⅜ in. (44.6 × 67.1 cm).

158. *Leda and the Swan*. 1944–45.
Oil on panel, 72 × 61⅞ in. (183 × 157 cm).
Private Collection, Paris.

159. *Oceania—The Sky*. 1946.
Hanging printed on linen,
69¾ × 51¼ in. (177 × 130 cm).
Musée National d'Art Moderne,
Centre Georges Pompidou, Paris.

160. *Polynesia—The Sea*. 1946.
Paper cutout mounted on canvas,
77⅛ × 123⅝ in. (196 × 314 cm).
Musée National d'Art Moderne,
Centre Georges Pompidou, Paris.

161. *The Silence Living in Houses*. 1947.
Oil on canvas, 24 × 19¾ in. (61 × 50 cm).

162. *Interior with Egyptian Curtain*. 1948.
Oil on canvas, 45¾ × 35⅛ in. (116.2 × 89.2 cm).
The Phillips Collection, Washington, D.C.

163. *Large Red Interior*. 1948.
Oil on canvas, 57½ × 38¼ in. (146 × 97 cm).
Musée National d'Art Moderne,
Centre Georges Pompidou, Paris.

164. *Interior with Black Fern*. 1948.
Oil on canvas, 45⅝ × 35 in. (116 × 89 cm).
The Beyeler Collection, Basel.

165. *Zulma*. 1949.
Paper cutout, 93¾ × 51¼ in. (238 × 130 cm).
Statens Museum for Kunst, Copenhagen.

166. *Sea-Beasts*. 1950.
Paper cutout mounted on canvas,
116⅜ × 60⅝ in. (295.5 × 154 cm).
National Gallery of Art, Washington, D.C.
Ailsa Mellon Bruce Fund.

167. *Mimosa*. 1949–51.
Paper cutout, design for a carpet,
58¼ × 38 in. (148 × 96.5 cm).
Ikeda Museum of Twentieth Century Art,
Itoh.

168. Illustration for Iliazd, *Poésie de Mots
inconnus*. Linocut.

169. Illustration from *Pasiphae: Borne up to
the constellations*. 1944.
Linocut.

170. Illustration from *Pasiphae: The anguish
growing and beating at your throat*. 1944.
Linocut.

171. Illustrations to *Poèmes de Charles
d'Orleans*. 1950.
Double page, lithographs made in 1943.

172. Illustrations to *Florilège des Amours de
Ronsard: Petit nombril*. 1948.
Double page, lithographs made 1942–43.

173. Illustrations to Marianna Alcaforado,
Les Lettres Portugaises. 1946.
Double page, lithographs made 1942–43.

174. *Interior with Black Fern*. 1948.
Brush and ink, 41⅜ × 29½ in. (105 × 75 cm).
Musée National d'Art Moderne,
Centre Georges Pompidou, Paris.

175. *The Thousand and One Nights*. 1950.
Paper cutout, 54¾ × 136⅝ in. (139.1 × 374 cm).
The Carnegie Museum of Art, Pittsburg.
Acquired through the generosity of the
Sarah Mellon Scaife family, 1971.

176. *The Eskimo*. 1947.
Gouache on cut-and-pasted paper,
16 × 33⅞ in. (40.5 × 86 cm).
Der Danske Kunstindustrimuseet, Copenhagen.

177. *Chinese Fish*. 1951.
Gouache on cut-and-pasted paper,
75⅝ × 35⅞ in. (192 × 91 cm).
Vicci Sperry, Los Angeles.

178. Maquette for *Christmas Night*. Nice,
January–February 1952.
Gouache on cut-and-pasted paper,
123⅛ × 53½ in. (312.8 × 135.9 cm).
Collection, The Museum of Modern Art,
New York. Gift of Time Inc.

179. Design for jacket of *Matisse: His Art and
His Public* by Alfred H. Barr, Jr. The Museum
of Modern Art, New York, 1951.
Gouache on cut-and-pasted paper,
10⅝ × 16⅞ in. (27 × 42.9 cm).
Collection, The Museum of Modern Art,
New York.

180. *The Virgin and Child*. 1949–50.
Painted and glazed tiles. Vence Chapel.

181. *The Stations of the Cross*.
Painted and glazed tiles. Vence Chapel.

182. *The Tree of Life*.
Stained glass window. Installation photograph.
Vence Chapel.

183. *Saint Dominic*.
Painted and glazed tiles. Vence Chapel.

184. Matisse using a bamboo pole while bedridden
in the Hotel Regina, Nice, April 15th, 1950.
Photograph by *Paris–Match*.

185, 186. Interior.
Vence Chapel.

187. *The Bees*. 1948.
Paper cutout, 39¾ × 94⅞ in. (101 × 241 cm).
Musée Matisse, Nice.

188. *Design for Green Chasuble*
(back maquette). 1950–52.
Paper cutout, 51⅞ × 77¾ in. (131.7 × 197.5 cm).
Musée Matisse, Nice.

189. *Design for Violet Chasuble*
(front maquette). 1950–52.
Paper cutout, 50 × 78 in. (127 × 198 cm).
Musée Matisse, Nice.

190. *The Sorrow of the King*. 1952.
Paper cutout, 115 × 156 in. (292 × 396 cm).
Musée National d'Art Moderne,
Centre Georges Pompidou, Paris.

191. *Memory of Oceania*. Nice, summer
1952–early 1953.
Gouache and crayon on cut-and-pasted paper
on canvas, 112 × 112¾ in. (284.4 × 286.4 cm).
Collection, The Museum of Modern Art,
New York. Mrs. Simon Guggenheim Fund.

192. *Acrobats*. 1952.
Paper cutout, 83⅞ × 81½ in. (213 × 207 cm).
Matisse Family Collection.

193. *Nude with Flowing Hair*. 1952.
Paper cutout, 43¼ × 31½ in. (110 × 80 cm).
The Beyeler Collection, Basel.

194. Partial installation view of *The Swimming
Pool*. Nice (summer 1952–53).
Nine-panel mural in two parts (one section shown).
Gouache on cut-and-pasted paper mounted on
burlap, a-e: 90⅜ × 333¾ in. (230.1 × 847.8 cm),
f-i: 90⅜ × 313½ in. (230.1 × 796.1 cm).
Collection, The Museum of Modern Art,
New York. Bernard F. Gimbel Fund.